Henri Matisse

Titles in the series Critical Lives present the work of leading cultural figures of the modern period. Each book explores the life of the artist, writer, philosopher or architect in question and relates it to their major works.

In the same series

Henri Matisse

Kathryn Brown

REAKTION BOOKS

For Alan Thomas

Published by
REAKTION BOOKS LTD
Unit 32, Waterside
44–48 Wharf Road
London N1 7UX, UK

www.reaktionbooks.co.uk

First published 2021

Printed and bound in Great Britain by Bell & Bain Ltd, Glasgow

A catalogue record for this book is available from the British Library

ISBN 978 1 78914 381 2

Contents

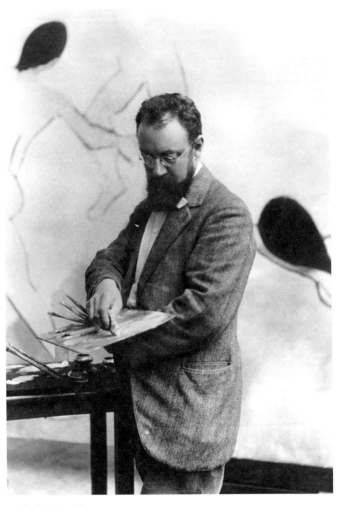

Matisse in his studio, 1909.

Introduction

On 7 December 1899 the 29-year-old Henri Matisse acquired a painting titled *Three Bathers* from the Paris art dealer Ambroise Vollard. Measuring 55 × 52 cm, the work was modestly sized, but its value to Matisse was immense. The canvas had been produced by an older artist who was identified by the Paris avant-garde as having forged a new path in contemporary painting: Paul Cézanne. Vollard and Matisse haggled over the price of the work for nearly six months. While the final figure of 1,200 francs stretched Matisse's limited budget, he obtained the painting for a down payment of only 500 francs and cajoled Vollard into adding a plaster bust by Auguste Rodin to the bargain for an additional 200 francs.[1]

Cézanne was at the height of his career in 1899, but Matisse was struggling professionally and financially. He had spent eight years studying in private art academies in Paris, had attended classes at the prestigious École des Beaux-Arts and was trying to negotiate his way through a complicated network of art dealers, collectors and critics. His precarious financial situation had come under strain following his marriage in 1898 to Amélie Parayre. The birth of the couple's first son, Jean, the following year had added to their mounting expenses. The size of the household would further increase following the arrival of Matisse's daughter from an earlier relationship, Marguerite, and the birth of a second son, Pierre, in 1900.

Despite the stresses of keeping his career and finances afloat, Matisse was determined to buy *Three Bathers*. It was an object that symbolized to him the possibilities of art both conceptually and professionally. Matisse recognized that Cézanne had created his own unique idiom while working independently in the South of France. From a position outside the capital, the older artist had conquered the art market and established a reputation on his own terms. Aside from these professional achievements, Matisse felt an affinity with his peer's technical experiments. Cézanne's rejection of realism, compositional adventurousness and bold handling of colour would serve as both an inspiration and a foil to Matisse's own pictorial thinking for decades to come. As Matisse recollected in an interview of 1925:

> If you only knew the moral strength, the encouragement
> that his remarkable example gave me all my life! In moments
> of doubt, when I was still searching for myself, frightened
> sometimes by my discoveries, I thought: 'If Cézanne is right,
> I am right.' Because I knew that Cézanne had made no mistake.[2]

Throughout his career, Matisse embraced the idea that his art extended certain pictorial traditions and he acknowledged the influence of other artists on his own creativity. Although the pair never met, Cézanne served as an exemplar within Matisse's own personal narrative. *Three Bathers* was tangible evidence of the moral courage and aesthetic innovation to which an artist should aspire.

The crafting of such a private mythology came, however, with costs. Recognizing the importance of *Three Bathers* to her husband's creative persona, Amélie allowed a precious ring to be pawned for the purpose of funding the purchase. The jewel was never recovered, but the painting remained in the family household for nearly 37 years. In consequence, Cézanne's canvas became far more than a source of pictorial inspiration. It was also a powerful symbol

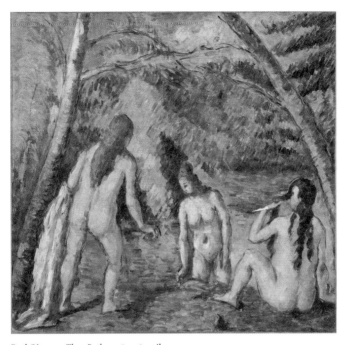

Paul Cézanne, *Three Bathers*, 1879–82, oil on canvas.

of the role that art played within the family and of the sacrifices that Matisse would demand from others for the purpose of sustaining a life of professional creativity.

In November 1936 Matisse and his wife donated *Three Bathers* to the Petit Palais Museum in Paris. This decision to part with the painting came at an important moment in Matisse's life. By 1936, he had long been regarded in Europe and the United States as a leading practitioner of ambitious art. From the perspective of his own creative trajectory, he had worked through the pictorial challenges that Cézanne's painting had posed prior to the turn of the century. More significantly, Matisse's marriage was under strain, and the couple would legally separate in the spring of 1940.

While Amélie had supported the development of her husband's professional career and had helped to fund the acquisition of *Three Bathers*, her departure was also linked to Matisse's separation from that totemic canvas and the memories associated with it.

Matisse noted in a letter of 10 November 1936 to Raymond Escholier, then director of the Museum of the City of Paris at the Petit Palais, that *Three Bathers* had 'sustained me morally in the critical moments of my venture as an artist; I have drawn from it my faith and my perseverance'.[3] If *Three Bathers* had served its principal creative purpose for Matisse by 1936, it had also fulfilled a wider critical function. By the mid-1930s, Matisse's relationship to Cézanne had become established in the minds of art critics. In an article published in the daily newspaper *Le Matin* of 25 July 1937, Edmond Campagnac surveyed Matisse's career and the role that Cézanne had played in its development. He connected his narrative of artistic influence to opportunities afforded by an era of rapid technological development: in the century of the aeroplane and of electricity, art must be in a state of 'constant evolution'.[4] Matisse was presented as a modernist hero whose pictorial innovations had contributed to a cultural refashioning suited to an era of advanced technology.

Recounting Matisse's acquisition and subsequent gift of *Three Bathers* to the Petit Palais, Campagnac suggested that the story symbolized the 'victory' of Cézanne and of Matisse himself. While remaining true to a core component of the artistic tradition that he had acknowledged throughout his career, Matisse had, by the end of the 1930s, supplanted the master in the minds of his critics and had determined the trajectory of his own critical life.

Despite stating that a painter who discusses his own art should have his tongue cut out, Matisse worked hard throughout his career to influence public opinion and to forge a vocabulary for the interpretation of his creative output. The aim of the present volume is to show how Matisse both shaped and responded to

this critical environment. The following chapters will, therefore, position Matisse within a swiftly changing international art world and examine the reception of his works by a diverse range of commentators.

The first half of the twentieth century witnessed a proliferation of art magazines and cultural journalism in Europe, the United Kingdom and the United States. The emergence of new technologies, including radio, cinema and, eventually, television, popularized traditionally 'high' culture. Plane travel facilitated the mobility of artists and their works, and the emergence of a truly international art market brought with it new cadres of collectors, dealers and exhibition opportunities. Matisse swiftly learned how to negotiate these fast-paced exchanges by working with publishers and journalists, giving interviews, posing for photographs and closely managing his connections to important dealers and patrons. This book will show how Matisse manoeuvered paths through critical discussions that took place over the course of his lifetime and will consider how his reputation was developed by family, friends, colleagues and, indeed, by other artists in the years after his death.

The members of Matisse's immediate family were central to the success of this creative and critical life. While Amélie served as a model for her husband and worked as a milliner to provide much needed financial support in the early years of their marriage, she was also a sounding board for ideas and projects. Matisse's daughter, Marguerite, modelled for her father while also serving as his devoted studio assistant and business manager. Her husband, Georges Duthuit, was one of the first writers to offer a sustained analysis of the early twentieth-century art movement with which Matisse was most closely associated, Fauvism. Finally, Matisse's sons often dealt with the logistics of exhibitions and loans of works to museums and galleries. In 1931 Pierre opened a commercial art dealership in the art deco Fuller Building in New York, thereby

helping to develop the market for his father's works in the United States. Against this background, Matisse's art was much more than an expression of individual creativity. It was a family business of which he was the acknowledged leader.

Matisse was aware of the need to manage his public self-image for the purpose of stimulating or maintaining the interest of collectors and dealers. Not all of his critical and business forays were successful and, as in any artistic career, he had to withstand his share of barbed comments in the press. His willingness to enter into these debates demonstrated a keen awareness of prevailing art discourses and the uses to which writing and publishing could be put for the purposes of furthering a career in the arts.

From a twenty-first-century perspective, it is difficult to imagine the importance accorded to artists' essays and critical writing in the first half of the twentieth century. In the wake of debates about Impressionism that had featured regularly in the French popular press during the 1870s and '80s, the power of art to shock, affirm or repudiate standards of beauty and to challenge social convention remained widely debated in newspapers and magazines. When Matisse was described as a 'wild animal' – a 'fauve' – in 1905 or as an artist who 'turned humanity back to its brutish beginnings' following the exhibition of his works at the New York Armory Show in 1913, critics sent a clear signal of art's relationship to broader cultural values.[5]

Critical writing did not, however, simply communicate theoretical analyses of artworks or debate the contribution of creative practices to socio-historical narratives. Instead, writers sought to entertain and to influence the emotional responses of audiences, anticipating – or sometimes fabricating – shock, disgust, humour and awe. By priming audiences' reactions to exhibitions, art criticism could shape reputations, generate markets for artists' works and promote competition between rival art-world factions. Then, as now, it trod a narrow path between dispassionate

reflection and sensationalism. Regardless of the format it took, art writing was also a way in which critics could assert their own cultural authority and, in some cases, write themselves into history.

In a magazine industry devoted to *amateurs d'art*, photography emerged as an exciting new means by which not just artworks, but exhibition spaces and artists' studios could be brought to life on the page. Matisse was photographed at various stages of his career, and these images were an important contribution to the crafting of his public persona. In the early twentieth century, this combination of critical writing and popular culture fuelled the emergence of celebrity artists whose personal lives interested audiences as much as their creative output. When, in 1912, Matisse famously declared to the American painter and writer Clara Taggart MacChesney that he was just 'a normal man', his statement attested to the notoriety that attached to vanguard art production and anticipated a merging of criticism and celebrity culture that has come to dominate the contemporary art world.[6]

In the first half of the twentieth century, poets and writers also contributed to the expansion of critical debates about art beyond traditional circles of connoisseurship. In part, this sprang from a genuine enthusiasm for the visual arts and a drive to explore the relationship between linguistic and visual creativity. But writers also had self-interested motivations when they turned to art criticism. Associating one's name with an established artist or fostering the reputation of a rising star was a means by which a writer could access new audiences and draw attention to his or her own aesthetic preoccupations. Art writing could take the form of a poem; the publication of exhibition reviews was a means by which writers could earn extra income; the interview became a popular format for poets to communicate ideas about their own works as well as those of the painters they discussed; art dealers commissioned essays to support their exhibitions; and collaboration between painters and writers fuelled the production

of innovative bookworks that probed the boundary between verbal and visual expression. Matisse's relationship to writers and publishers of his generation is, therefore, an important piece of the art-critical puzzle that this book will address.

There is a vast body of secondary literature about Matisse, and exhibitions of his works continue to feature regularly in the rosters of museums around the world. Hilary Spurling's two-volume biography of the artist has become a key reference point, while, in their respective projects, Catherine Bock-Weiss and Claudine Grammont have catalogued an array of critical writings about, and key themes in, Matisse's output. In addition, Matisse's own writings and interviews have been edited by Dominique Fourcade and subsequently translated and annotated by Jack Flam.[7] The present volume is indebted to the work of these and other scholars and curators who have dedicated their time to studying Matisse's life, ideas and multifarious creative styles.

The fact that there is such a wealth of critical material about Matisse also reveals features of art history itself. Matisse has been viewed alternatively as a radical experimenter, a conservative, a hedonist, a misogynist, an orientalist, a decorative painter and a quintessentially 'French' artist, among other things. Some of these views have persisted, while others have been challenged and refashioned by new generations of writers who have brought their own assumptions and critical perspectives to the fore. The present volume will debate these historiographical trends and will test narratives that have developed about Matisse as well as the strategies that the artist himself used to endorse or refute them. Against this background, one of the principal contributions of this book is its re-evaluation of Matisse's key sources and motivations, particularly in connection with his paintings of the 1920s.

The following chapters will argue that a significant aspect of Matisse's modernism lay in his acts of audience creation, market making and critical self-assertion. Whether in the form of

interviews, essays and correspondence or, more often, dialogues and friendships with writers, collectors and curators, Matisse understood that art was an enterprise that needed to be managed. This book examines art as a vital contribution to the public sphere of ideas and, hence, as a terrain on which important notions of self and community are debated. The discussion also makes clear that language – and the control of art discourses – plays a crucial role in determining an individual's success or failure in art's institutions and markets. Matisse's lifelong concern with the written word is a measure of his keen awareness of this point. By bringing language into his creative orbit – in the form of drawings, cut-outs, personal testimony, essays and books – Matisse contested his critics on their own terms and set down a challenge for those who continue to write about his art.

1

Seeds

Henri Matisse was not supposed to become an artist. Born on 31 December 1869 in a small town in the north of France, Le Cateau-Cambrésis, he was the eldest son of Émile Hippolyte Henri and Anna Héloïse Matisse and was expected to follow his father's footsteps into the seed merchant trade. The region in which the young Matisse grew up was known for its agricultural industry, but famed for its textile production. Local weavers designed and produced luxury silks destined for Paris fashion houses, and the Matisse family found itself in a robust regional economy during the 1870s and '80s. Émile Matisse ran a grocery store in Bohain-en-Vermandois that gradually developed into a successful agricultural supply business. This furnished him with enough money to provide his son with a good education at the nearby Lycée de Saint-Quentin.

By the mid-1880s, however, it became clear that Henri was unlikely to take over the family concern. Periods of illness disrupted the young man's studies, and it was doubtful whether he would have the physical stamina to oversee a strenuous trade. Instead, he was encouraged to become a copyist for a local lawyer, a job that eventually spurred him to undertake legal studies of his own in Paris in 1887–8. Although he had not accepted his father's mantle, the young Matisse seemed set on a respectable and assured career when, having passed his examinations, he became a law clerk in his old school town of Saint-Quentin. There was, however, an obstacle to his professional success: boredom. While copying

legal documents and doodling absent-mindedly in their margins, Matisse's imagination turned to more interesting possibilities. He enrolled in the local art school – aimed primarily at training local textile designers – and painted in his spare time. It came as both a shock and disappointment to his parents when he announced his intention to abandon his legal job and to embark, instead, on an uncertain career in the art world. This decision represented a triple insult: it was a rejection of the family business, a failure to advance in an established profession and a waste of the precious resources that had been spent on a legal education.

Matisse was 21 when he committed to this new path. After weeks of fierce arguments with his father, he left for Paris in October 1891 with friend and fellow painter Jules Petit, and formulated ambitious career plans from rented rooms on the rue de Maine. Matisse's parents had grudgingly agreed to provide their son with an allowance for one year while he competed for a place at the École des Beaux-Arts, the pre-eminent French art school that had developed from the Royal Academy of Painting and Sculpture founded in 1648. Gaining entrance to this prestigious establishment was not, however, straightforward. Competition for admission was intense, and the failure rate was high.

Matisse's first step was to enrol in preparatory classes at the Académie Julian, a private studio led in the 1890s by the celebrated academic painter William-Adolphe Bouguereau and, subsequently, by the portraitist Gabriel Ferrier. Bouguereau and Ferrier had both studied at the Beaux-Arts, had been recipients of the *Prix de Rome* scholarship and were regular exhibitors at one of the most important annual art exhibitions in Europe, the Paris Salon.

For an outsider attempting to gain a foothold in the Paris art world of the late nineteenth century, the Académie Julian seemed like a good place from which to build a base. Its leaders were esteemed members of the French art establishment, and their style of training was suited to the academic formalities preferred by the

Photograph of Matisse and his mother in Ypres, Belgium, in 1887.

Beaux-Arts. Although the Académie Julian had been established in 1868 as a progressive alternative to its institutional competitor, Matisse found the style of teaching conservative. Copying plaster models, developing the composition of a painting according to a fixed order and reproducing ideals of classical 'perfection' were stifling to an artist who was keen to express his own creative persona. Matisse later recalled that he found himself looking at paintings that were highly accomplished, 'but completely and utterly empty; there was nothing to them: just a method. I couldn't see why I should do it.'[1]

Disappointed with his training, Matisse turned to the past for inspiration. This was a strategy that he would pursue throughout his career. In this instance, his imagination was spurred by paintings that had been produced at the beginning of the nineteenth century by the celebrated Spanish artist Francisco José de Goya y Lucientes. Goya's prints and paintings had made a lasting impression on French nineteenth-century audiences, winning the acclaim of leading writers and painters. The poet and art critic Théophile Gautier had published an influential article in 1842 that popularized Goya's works; in 1857 Charles Baudelaire praised the originality and certainty of means that typified the artist's unique synthesis of the 'real and the fantastic'; and in the late 1880s, the Symbolist writer Joris-Karl Huysmans described one of Goya's paintings as the 'most frantic racket that has ever been thrown onto a canvas, the most intense hurly-burly ever created by a palette'.[2]

Matisse would have been aware of the impact that Goya had made on French artistic circles of the mid to late nineteenth century and, in particular, the indebtedness of Édouard Manet's painting to the palette and compositional experiments of the Spanish artist. In turning to Goya, therefore, Matisse did not just look to history for inspiration; he also positioned himself within an art-critical dialogue that had taken place earlier in the century. More importantly, he identified himself with an artist who had

defied academic convention. In an important biography of Goya published in France in 1867, Charles Yriarte described the rapidity of thought and execution demonstrated by Goya's paintings. These works, he argued, had been produced by a 'spontaneous', 'violent' and 'impatient' character.[3] As scholarship has shown, such characterizations of Goya set his work in opposition to the values of form and finish associated with nineteenth-century academic painting and made him an iconic figure for artists who sought to break with conservative traditions.[4]

The two paintings that made such an impression on Matisse are located in the Palais des Beaux-Arts in Lille, and for much of the nineteenth century they were thought of as a pair: *The Young Women (The Letter)* (c. 1814–19) and *The Old Women* (1808–12). Marvelling at the freedom of Goya's brushwork in *The Young Women*, Matisse declared himself to be simply 'overwhelmed'. Whereas Bouguereau and Ferrier promoted a compositional approach that, according to Matisse, produced 'heavy, muted painting with no vibrancy', Goya's art was an 'open door'.[5]

This was, however, a door that Matisse's father attempted to close in 1892. After a year of training in the capital, Matisse attempted the Beaux-Arts entrance exam – and failed. In the months that followed, he had to cope with not only his own disappointment, but pressure from his father to return to Bohain and embark on a career that offered financial stability. Matisse refused to be swayed by either failure or parental injunctions. Instead, he decided to fashion an alternative professional path for himself by remaining in Paris and taking classes at the École des Arts Décoratifs and, most importantly, in the studio of Gustave Moreau. If he could not gain entry into the Beaux-Arts by conventional means, he would work around the institutional structures of the art world on his own terms.

Matisse's decision to pursue such a path was not unprecedented. Leading members of the previous generation of avant-garde artists

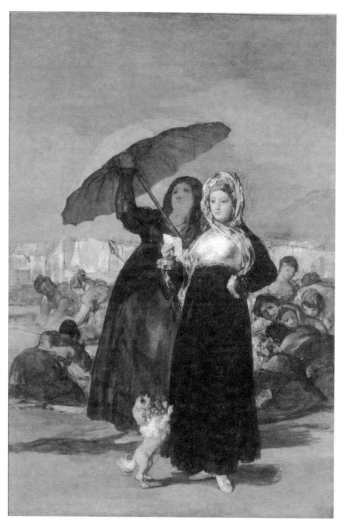

Francisco José de Goya y Lucientes, *The Young Women* (*The Letter*), *c*. 1814–19, oil on canvas.

including Manet, Edgar Degas, Claude Monet, Pierre-Auguste Renoir, Alfred Sisley and Frédéric Bazille had trained in the private studios of academic painters. Many of them had also attended less formal studios, such as the Académie Suisse, an atelier run by Charles Suisse that offered life-drawing sessions.[6] Following the model of his forbears, Matisse constructed his own art education from a bespoke combination of institutional, professional and social networks. Although training at the Beaux-Arts afforded access to an established system of prizes, scholarships and commissions, the informal associational life of the Paris art world offered a creative stimulus and range of opportunities that were no less important.

Gustave Moreau had been made a Chevalier of the Legion of Honour in 1875 and an Officer in 1883. He was elected a member of the Académie des Beaux-Arts in 1888, and a teaching position followed in 1892. Although Matisse had failed the Beaux-Arts entrance exam, Moreau accepted the aspiring artist into his class. In this environment, Matisse found the professional interlocutors whom he had sought since his arrival in Paris. Some of Moreau's students – including Simon Bussy, Charles Camoin, Albert Marquet and Georges Rouault – would become Matisse's lifelong friends. In contrast to the rigid approach to composition practised at the Académie Julian, Moreau took his students to the Louvre and encouraged them to study and copy works by 'the Masters'. This was not a strategy designed to encourage the facile emulation of precedent. Rather, it was a means by which students were taught to engage critically and creatively with unfamiliar techniques and, above all, to respond to them in a personal way. As Matisse put it, Moreau 'didn't show us how to paint; he stimulated our imagination by showing us the life there is in paintings'.[7]

Matisse would never forget the potential of an agonistic encounter with the works of other artists and eventually made this a mainstay of his own critical writing. Looking back to these

early years in an essay of 1935, he emphasized that, despite the radically new expressive styles that emerged under the banner of twentieth-century modernism, there had been no break 'in the continuity of artistic progress'.[8] For Matisse, the history of art could serve as both an inspiration and a means by which to reassure audiences that even the most radical pictorial innovation could be made intelligible by virtue of its placement within an identifiable aesthetic lineage.

Matisse was finally accepted into the École des Beaux-Arts in March 1895. He ranked a modest 42nd out of the eighty candidates accepted into the cohort, but he had broken through at least one professional barrier of the Paris art establishment. It was also in 1895 that Matisse had his first significant encounter with the painting of Paul Cézanne in the showroom of Ambroise Vollard at 39 rue Laffitte in Paris. The exhibition included paintings from the bequest of Gustave Caillebotte that had recently been rejected by the French State, notably the large-scale *Bathers at Rest* of 1877. In what turned out to be a successful attempt to stir up controversy, Vollard used the front window of his gallery to display *Bathers at Rest* – a work featuring naked male swimmers – alongside the mythologically themed *Leda and the Swan* (*c.* 1880) and another nude study. The popular press took the bait and deemed the display an outrage to both art and public morals.[9]

Vollard's show did, however, attract the serious interest of artists, collectors and critics. Matisse recalled his visit to the narrow exhibition space where Cézanne's paintings (some of them unsigned) were crammed from floor to ceiling at odd angles and devoid of frames. This unconventional arrangement did not detract from the impact of the works. Like many viewers, Matisse found Cézanne's art simultaneously extraordinary and shocking. The unconventional shape of objects, presence of singular geometries and striking appearance of unpainted sections of canvas were the antithesis of the Beaux-Arts tradition in which Matisse had been

schooled.[10] Cézanne (who had also failed the Beaux-Arts entrance exam early in his career) had a profound dislike of Bouguereau, dismissed Moreau as little more than a 'distinguished aesthete' and spoke emphatically of the need for artists to distance themselves from formal training.[11] If this philosophy drove the style and composition of his paintings, it was one that also forced Matisse to question many of the artistic precepts to which he had adhered since his arrival in Paris.

The first paintings for which Matisse garnered modest public attention had little to do with the radical pictorial innovations of Cézanne. In 1896 and 1897, Matisse participated in exhibitions at the Salon of the Société Nationale des Beaux-Arts, an exhibition space on the Champ-de-Mars that had developed from the factionalism of the nineteenth-century French art world. Formed in 1890 by Charles Auguste Émile Carolus-Duran, Auguste Rodin, Pierre Puvis de Chavannes and Ernest Meissonier among others, the 'Nationale' was an alternative to the official Salon and was the successor to a similarly named society that had been established by Louis Martinet and Théophile Gautier in 1861.[12] While the costs of running an alternative exhibition venue had proved to be prohibitive for the original venture, the Nationale of the 1890s was a more dynamic, market-oriented enterprise. Opening its doors to the decorative arts and capitalizing on a rejection of academic principles, the Nationale offered itself as a cosmopolitan exhibition environment that welcomed innovation. Although it may not have lived up to all of its promises, the Nationale was described in 1898 as having a 'freer tone' than its State-sponsored counterpart. According to the critic Raymond Boyer, it celebrated the expressive powers of the individual rather than his or her academic pedigree. It was noteworthy, he continued, that the 'intelligent students' of Moreau's studio exhibited there.[13] In terms that would later become part of Matisse's own critical vocabulary, the Nationale was said to be a space that revealed 'personalities, temperaments, natures,

isolated names, artists'.[14] Controversially, the venue was open not only to French artists who had been through Beaux-Arts training, but to those from abroad. For some critics, however, this rival to the Salon compromised the distinctiveness of 'French' art and created an institutional divisiveness that played into the hands of emerging artistic centres in Europe, notably Munich and Berlin.[15]

While concerns about art's relationship to discourses of nationhood would become acute in the turbulent geo-politics of the early twentieth century, the emergence of an international art market suited the development of Matisse's career in the decades immediately following his Beaux-Arts training. Indeed, the patronage of foreign collectors would become his financial mainstay after the turn of the century. For the time being, however, Matisse had to build a reputation by focusing on the local impact of the first official showings of his works.

On the whole, he had reason to be pleased with the results of his exhibitions at the Nationale. Of the five paintings exhibited in the 1895–6 season, his *Woman Reading* was acquired by the French State. The work was a relatively small oil painting on a wooden panel, modelled by Matisse's then lover, Caroline Joblaud (known as Camille), and featured a restricted palette of black, brown and viridian with white highlights. The subject of a female reader had been a recurrent trope throughout the nineteenth century, and Matisse's colour scheme and composition echoed the intimate settings that had been popularized by Camille Corot and Henri Fantin-Latour in the 1860s and '70s. In both its palette and subject-matter, Matisse's painting fell within stylistic and thematic parameters that were unthreatening to conservatively minded audiences.

Indebted to the works he had copied in the Louvre, Matisse also produced naturalistic studies of his immediate studio surroundings in the mid-1890s. The art critic René Maizeroy limply noted the presence of some 'pretty colours' in the still-lifes that Matisse

exhibited at the 1897 Nationale.[16] It was clear that something more ambitious was needed, and Matisse took Moreau's advice to undertake a larger composition. Once again, Matisse turned to an interior scene for inspiration: a maid putting the finishing touches on an elaborate dinner table. Although Moreau encouraged his students to break from Impressionist painting, *The Dinner Table* owed much to domestic scenes such as Monet's luncheon paintings of 1868 and 1873 and Caillebotte's *Luncheon* of 1876.

Despite the familiarity of its subject, Matisse's painting did not find favour with critics. Its naturalism was at odds with the unconventional perspective from which the dinner table was painted, the elaborate surface of which sloped strangely towards the front of the picture plane. Matisse complained that the painting had been poorly hung in the gallery and that, following an outbreak of typhoid fever, audiences purported to see microbes at the base of the decanters he had included in the composition.[17] Ironically, this critique based on hygiene echoed the disapprobation that works by Monet and his colleagues had suffered two decades earlier, when commentators had likened the colours of human flesh in Impressionist painting to that of decomposing corpses in the Paris morgue. Aesthetic judgement continued to find an outlet in metaphors of the body that were specifically designed to provoke feelings of disgust.

Despite having been made an associate member of the Société Nationale des Beaux-Arts in 1896, thereby securing a place in its annual exhibitions, Matisse's reputation and financial position were by no means secure. As the public response to *The Dinner Table* showed, critical success was not guaranteed by an institutional affiliation. In addition to the sale of *Woman Reading*, Matisse had managed to sell a copy he had made of Annibale Carracci's *The Hunt* to the State in 1896. In the same year, he enjoyed private sales of still-lifes to the dairy wholesaler Jules Thénard, and to the textile merchant Jules Saulnier.[18] Together with some copies

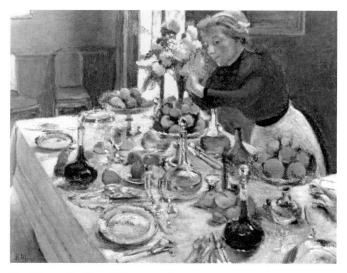

Henri Matisse, *The Dinner Table*, 1896–7, oil on canvas.

of works made for, and bought by, his uncle, Émile Gérard, Matisse witnessed his first glimmerings of commercial success. This was, however, far from the reassurance offered by a stable professional career.

By the end of the exhibition at the Nationale in 1897 Matisse found himself at a crossroads both personally and professionally. In 1894, Camille had given birth to a daughter, Marguerite. Although Matisse formally acknowledged paternity of the child in February 1897, his relationship to Camille was suffering from the stress of financial insecurity and the difficulty of launching an artistic career in a competitive art world. In the summer of 1897, the couple took a holiday to Belle-Île on the coast of Brittany. It was Matisse's third trip to the region, but he arrived with a different set of preoccupations on this occasion.

Before leaving for the coast, Matisse had visited an exhibition at the Paris museum devoted to contemporary art, the Musée

du Luxembourg. The show consisted of a selection of the 67 paintings that Caillebotte had gifted to the State upon his death. This included works by Manet, Cézanne, Monet, Degas, Renoir, Pissarro, Sisley and Caillebotte himself. In what would become a cause célèbre in the history of institutional collecting, the State rejected a portion of Caillebotte's bequest. In part, this was on the grounds of aesthetic disagreement, the legacy of Impressionism still proving controversial within conservative circles in the 1890s. The museum's decision was also driven by the practical difficulty of finding sufficient space to exhibit all of the paintings that made up the bequest.

The exhibition that Matisse saw in 1897 contained 38 works that the State had accepted into the national collection after three years of haggling with Caillebotte's executors. Matisse visited the show with one of the artists whose works were part of the bequest, Camille Pissarro. This was a remarkable opportunity. Through Pissarro, Matisse had a privileged conduit to the social and aesthetic background of the works on display. Pissarro had exhibited his own paintings at each of the eight Impressionist exhibitions that had taken place between 1874 and 1886 and, since the 1880s, had been at the forefront of new experiments in colour and form under the banner of Pointillism (the division of the painted surface into small coloured dots).

Among the paintings that most impressed Matisse in the exhibition were landscapes by Monet, one of which portrayed the coast of Belle-Île (*The Rocks at Belle-Île, The Wild Coast*, 1886). His enthusiasm for the scumbled surfaces and vibrant brushwork of Monet's canvases was reinforced by his discussions with Pissarro and further intensified during an encounter at Belle-Île with another colleague, the Australian painter John Russell.

Trained at the Slade School of Fine Art in London and the Atelier Cormon in Paris, Russell had settled in Belle-Île with his family in 1887. It was there that he befriended Monet and, like his

Impressionist colleague, espoused the virtues of outdoor painting and the expressive possibilities of colour. Matisse had first met Russell on a trip to Brittany with the painter Émile Wéry in 1895, and he developed this connection over the subsequent years. Influenced by Russell's commitment to Impressionist techniques, Matisse slowly changed the palette and style of his own works: 'I couldn't help but admire the luminosity of the impressionist palette, with its mix of prismatic colors. It felt more like a direct rendition, particularly of open-air subjects, a direct contact with nature.'[19] In the wake of his experience of the Caillebotte bequest and his conversations with Russell, Matisse abandoned the muted chromatic schemes that had characterized *Woman Reading* and *The Dinner Table* and embarked on an engagement with colour that he would pursue in different ways for the remainder of his career.

By tracing Matisse's studio training, artistic connections, travels and exhibition visits of the 1890s it is possible to build a picture of his range of interests and sources of inspiration. His enthusiasms changed swiftly during this period as he worked through the ideas of teachers, older painters and contemporaries. They also testify to the sheer breadth of painting styles and exhibition opportunities that placed Paris at the forefront of the European art world. The early professional exchanges in which Matisse engaged contributed to the evolution of his own expressive idiom and stimulated him to fashion a creative persona in response to developments in the history of art. The views of Matisse's interlocutors diverged significantly from each other in the matter of how best to communicate a vision of the world on canvas, but there was more at stake in these debates than just aesthetics. Adopting or rejecting the views of another artist could have a profound impact on personal ties between individuals, and Matisse's enthusiasm for Monet's works brought about a significant rift with Moreau.[20] As the circle of Matisse's professional colleagues widened, so he became less reliant on the guidance and artistic preferences of his teacher.

By the end of the trip to Belle-Île, Matisse's relationship to Camille had reached breaking point, and he returned to Paris alone. A few months later, he met and fell in love with a young woman who was maid of honour at a friend's wedding. The woman was Amélie Parayre, and the couple were married in January 1898. Matisse and his wife spent much of that year travelling: a short honeymoon in London, followed by a six-month stay in Ajaccio, Corsica. If Russell had encouraged Matisse in his experimentation with colour, the landscape of Ajaccio provided the perfect climate and subject-matter to develop this path. Writing to Marquet in February 1898, Matisse described his 'splendid' new surroundings: 'Almond trees in flower in the middle of silvery olive trees and the sea, blue, blue, so incredibly blue that one could eat it.'[21] Matisse heightened the tones of his palette dramatically in response to this landscape, and paintings such as *The Courtyard of the Mill* (1898) and *Small Door of the Old Mill* (1898) evidence a dramatic stylistic shift from the muted interiors he had produced over the previous two years.

Throughout the 1890s, Matisse had systematically worked through ideas associated with the major European art movements of the nineteenth century, experimenting with Naturalism, Impressionism, Post-Impressionism and, by the end of the decade, Divisionism. He continued to work on still-lifes and landscapes in the late 1890s, but heightened the brilliance of his palette and turned increasingly to the use of primary colours. It was during the summer of 1898 that he came across an extended essay 'From Eugène Delacroix to Neo-Impressionism' by the Neo-Impressionist painter Paul Signac.

Signac's essay described the principles of Divisionism, the style in which Signac himself painted and that had been championed by Georges Seurat from the 1880s until his death in 1891. Like Matisse, Signac positioned himself as part of a longer artistic tradition and sought to identify the roots of Divisionist painting in works by the

Henri and Amélie Matisse in Ajaccio in 1898, shortly after their marriage.

celebrated Romantic artist Eugène Delacroix. By so doing, he hoped to show that the division of the painted canvas into a multitude of tiny coloured marks – a method that had once been 'derided' by critics – was, in fact, both 'traditional and normal'.[22] Discussing Eugène Delacroix's *Women of Algiers in their Apartment* (1834), Signac wrote that the different parts of the work

> shiver and vibrate thanks to brushmarks of superimposed
> tones, or of almost identical hues, which the subtle
> master has hammered, stamped, caressed, hatched from
> diverse colours first laid flat on the surface and to which
> he returns via this ingenious labour of erosion.[23]

From the shimmering surfaces of Delacroix's canvases, it was, Signac argued, only a short step to the more radical disintegration of form that typified Neo-Impressionist painting. His essay was a

paean to colour, the express aim of the Divisionist technique being to obtain 'a maximum of colour and light'.[24]

This vocabulary of 'luminosity' and 'harmony' made a profound impression on Matisse and would later prompt him to make contact with the older artist. In 1898, however, Matisse responded creatively to Signac's ideas and to the light of Ajaccio by building up the surface of his paintings from layers of small, choppy brushmarks. This was, however, just one experiment among others that he undertook during the 1890s. Thinking back to the Cézanne exhibition of 1895, he also produced still-lifes that were modelled from broad planes of brilliant, unmodulated colour. Matisse was carrying out his own form of visual research in such canvases, testing different techniques and gauging their expressive power.

Gustave Moreau died in April 1898, leaving Matisse without a mentor. Matisse was reluctant to give up a studio affiliation and wanted to retain the opportunity to draw from a live model. For these reasons, he remained at the Beaux-Arts under the tutelage of a history painter, Fernand Cormon. This was not, however, a situation that could be sustained for long. Cormon's artistic interests were far from the experimental path that Matisse had pursued in recent years and, most importantly, Matisse was now too old to continue training under the auspices of the Beaux-Arts. In 1899, at the age of thirty, he was asked to leave the Academy. That year Matisse exhibited five works in the exhibition of the Nationale: four still-lifes and one drawing. It was his last exhibition at this venue.

During the final year of the century, Matisse also turned his attention to other media: drawing and sculpture. While looking for opportunities beyond the remit of the Beaux-Arts, he spent time in the studio of the Symbolist painter Eugène Carrière. Carrière's sombre palette of brown, black and grey was far from the colouristic experimentation that Matisse had undertaken

in Belle-Île, and perhaps as a consequence of this divergence of interest, Matisse focused intensively on drawing:

> When I was working with Carrière, I would sketch the model in front of me . . . an impression . . . a rhythm . . . The model was food and drink to me, and the sketch was like a moment in the individual's life. Marrying these two things was my goal.[25]

Drawing would come to play a major role in Matisse's career and was a subject that he would address repeatedly in his writing.

For Matisse, drawing was neither a process of mere mark-making nor the prelude to a 'serious' composition. Rather, it evidenced an intimate encounter between hand, eye and page that directly addressed the viewer. As he put it in 1939: 'I have always considered drawing not as an exercise of particular dexterity, but above all as a means of expressing intimate feelings and descriptions of states of being, but a means deliberately simplified so as to give simplicity and spontaneity to the expression.'[26] Throughout his life, Matisse adhered to the idea that drawing was a highly concentrated form of expression that was capable of expressing far more than it showed.

The physical production of a drawing also suggested a connection with sculpture. It was in 1899 that Matisse began copying a sculpture in the Louvre: Antoine-Louis Barye's *Jaguar Devouring a Hare*. It was an interesting choice. Barye's sculpture had first been exhibited at the Paris Salon of 1852, where it had drawn the attention of the writers Jules and Edmond de Goncourt. In their review of the Salon, the Goncourt brothers singled out Barye's sculpture as marking the 'evolution of modern art': depictions of history had given way to landscape in painting and to a new treatment of animal motifs in sculpture. Barye's art was understood to be a unique mixture of 'elasticity and force' that did not aim at beauty, but instead conveyed the dynamic juxtaposition of muscles in tension and repose.[27]

Matisse's approach to studying this work was not to look at it, but to touch it: 'Getting the feel of a form by touching the model, eyes closed, then doing the same for my work and gauging it like that'.[28] The equilibrium that the Goncourt brothers purported to identify in Barye's sculpture was something that, in Matisse's creative universe, needed to be experienced haptically as well as visually and cognitively.

In an interview with Georges Charbonnier in 1950, Matisse described sculpture as a 'complement' to his pictorial studies, a style of making in which he would engage when he needed a change from painting. Crucially, however, he added: 'But I sculpted as a painter. I did not sculpt like a sculptor. Sculpture does not say what painting says.'[29] While Matisse would produce numerous innovative three-dimensional works over the course of his career, he remained attentive to the expressive potential of specific media and to the relationships between them. This often led him to experiment with the same motif in sculpture, painting and drawing.

He did precisely this in a sequence of works produced around the turn of the century. His painting *Male Nude* (*c.* 1900) has a counterpart in the bronze sculpture *The Serf* (1900–1904), just as his female study *Standing Model/Nude Study in Blue* (*c.* 1899–1900) is echoed in the bronze *Madeleine (i)* (*c.* 1901). Treating a single subject on canvas and in sculpture had an important impact on Matisse. By virtue of *not* saying 'what painting says', three-dimensional works stimulated him to investigate ways in which the human body might be rendered 'sculpturally' on a two-dimensional surface. The contours, planes and selectively illuminated facets of the sculpted form encouraged him to craft limbs and muscles from flat, prominent brush strokes and to use dramatic tonal contrasts for the purpose of selectively highlighting parts of the body. These techniques would become increasingly dramatic in his painting over the next five years.

After nearly a decade in the capital, Matisse had worked through a range of stylistic ideas in painting, drawing and sculpture. He had sold a handful of paintings, established a foothold in the Paris art world and developed a network of formal and informal contacts within and beyond the institutional apparatus of the Beaux-Arts. There remained the question of how to generate a sustainable income from these modest successes. In 1941 Matisse pointedly summed up the difficulty of launching an artistic career when he asked: how does one sell something that is 'of no practical use'?[30]

One way artists could overcome this problem was to find a commercial way to monetize their talents while pursuing other projects. Matisse recalled the luck that befell his colleagues Pierre Bonnard and Édouard Vuillard. Through their relationship with the Natanson Brothers – owners of the successful magazine *La Revue blanche* – Bonnard and Vuillard produced designs for the magazine's cover and decorations for page layouts alongside their primary studio work. In addition to providing an income, this foray into graphic design had the advantage of advertising the artists' works and fostering relationships with critics. It was not, however, a path that opened itself to Matisse. Rather, he considered himself to be 'in a trade that offered no hope at all'.[31]

His need for financial security was acute at the close of the century. In 1899, Amélie gave birth to the couple's first child, Jean. The household expanded not long after Jean's birth when Marguerite, Matisse's daughter with Camille, became part of the family. At this point, Amélie was also pregnant with her second child, Pierre. Showing no small degree of determination, Amélie set up a millinery business, and the family moved to living quarters above her shop on the rue de Châteaudun in the fashionable ninth arrondissement. It was a brave venture, but one that was destined to fail in the absence of either sufficient capital or a reliable network of wealthy customers.

At the end of the year, Matisse found a job painting scenery for a model of the Trans-Siberian Railway that was to feature at the World's Fair to be held in Paris from April to November 1900. In a novel and eye-catching installation, scenery set at different levels and moving at variable speeds would give visitors to the train's dining car the impression that they were travelling from Moscow to Beijing. Matisse was not the only former student of Gustave Moreau to undertake this commission. His friend and former Beaux-Arts colleague Albert Marquet also found himself in financial difficulty and was willing to accept the meagre payment of 1.25 francs per hour offered by the well-known theatre-scene painter Marcel Jambon to undertake this labour. The two artists would travel together each day at 7 a.m. by omnibus from the Quai Saint-Michel near Notre-Dame Cathedral to Jambon's studio in the Buttes-Chaumont. It was repetitive, mechanical work that involved painting landscape friezes on long strips of canvas. Workers crouched over their materials for hours at a time and could be fired at the whim of Jambon. As Matisse recalled, the sole 'revenge' of these artist-decorators was to run up debts at the local bistros for lunches that were provided on credit.[32]

The World's Fair of 1900 was visited by nearly 50 million people. Displays occupied spaces in the Grand Palais and Petit Palais on the Champs-Elysées, and pavilions dedicated to specific countries stretched along the right bank of the Seine to the Eiffel Tower and the Champ de Mars. The wonders of modern industry, agriculture and science were showcased alongside distinctive examples of architecture, costumes, military paraphernalia, furnishings, art and design products of different cultures. For those unable to travel, the Exhibition brought the world – or at least a particular version of it – to their doorstep. A moving sidewalk eased some of the pain of exploring the 550 acres of the display. Matisse's creative contribution to this event had taken the form of anonymous labour as a scenery painter. By contrast, the Spanish pavilion featured a

painting titled *Last Moments* by a talented nineteen-year-old from Barcelona who had just arrived in the capital. His name was Pablo Picasso. A younger generation was on the rise, and Matisse now faced the emergence of a new competitive environment.

In 1900 Matisse produced a self-portrait. It was an oil painting only slightly larger than Cézanne's *Three Bathers* that he had acquired from Vollard the year before. Echoing the interest that Matisse had shown in the unpainted sections of that canvas, the

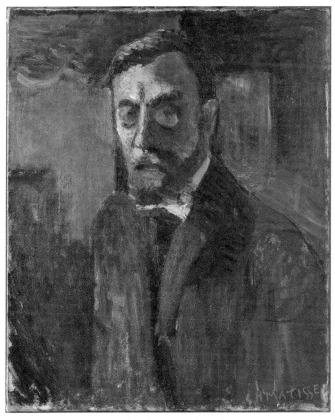

Henri Matisse, *Self-portrait*, 1900, oil on canvas.

scrubby brushmarks of the self-portrait reveal unpainted edges, a visual fraying that extends to the depiction of the painter's jacket. The work is a telling self-image. As would become a typical feature of Matisse's public persona, the work depicts the artist in a suit and tie, the starched whiteness of his collar in this case modelled from a thick impasto beneath his beard. His appearance may be that of a respectable bourgeois, but the gaunt features and hollowed eyes suggest hardship. Even the luminosity of the yellows and greens of the background colour scheme is muted by an overwhelmingly dark palette.

It is a portrait that gives visual form to the difficulties that Matisse had faced over the previous decade. The determination he had shown in defying his parents' wishes and pursuing his own path had culminated in little security and slight success. It had taken considerable courage to pursue this independent path, but Matisse had now turned thirty, had his own family and could no longer convince himself or others to rely on the expectations of the debutant. Financially and professionally, a means had to be found to transform training and studio experience into a viable career. If the *Self-portrait* of 1900 communicated the artist's uncertainties about the possibility of realizing that goal, the situation would be transformed over the following decade.

2

The Wild Man and the Professor

Attending classes at the École des Beaux-Arts and participating in
a network of independent studios were not just steps in an artist's
acquisition of technical knowledge or a means of professional
advancement. They were also activities that fostered the creation of
informal relationships within which artists could exchange ideas,
learn of opportunities and connect with dealers. Then, as now, a
career in the arts depended as much on an individual's ability to
navigate a complex set of social relations as it did on talent and
determination.

Within the shifting alliances of the early twentieth-century
Paris art world, Matisse encountered a man nearly eleven years
his junior who would become an important interlocutor over the
following decade: André Derain. The pair met at Eugène Carrière's
studio in 1899. Five years later, Matisse helped his new friend to
obtain a place at the Académie Julian and brought his works to
the attention of Ambroise Vollard. In return, Derain introduced
Matisse to another young painter, Maurice de Vlaminck, at an
exhibition of Van Gogh's works at the Bernheim-Jeune Gallery in
1901. Throughout the following decade, the output of these three
artists fuelled a polemical debate about the functions of form and
beauty in art that divided audiences on both sides of the Atlantic.

In the early years of the new century, however, Matisse's
professional and financial fortunes were moving in opposite
directions. An important career breakthrough occurred in 1901.

Following his first exhibition at the Salon de la Société des artistes indépendants in 1901, Matisse was elected to its membership. Established in 1884 by Paul Signac and Georges Seurat, among others, the Salon des Indépendants (like the Nationale) mounted exhibitions of contemporary art and shunned official systems of juries and medals. In its manifesto, the Society expressed its ambition of enabling artists 'to present their works freely and directly to public judgement in exhibitions that they themselves have organized and to undertake the necessary matters to arrange sales'.[1] Neither the State nor educational establishments would be the arbiters of taste in this forum created by and for artists. As a member of the Indépendants, and from 1904 a participant in its exhibition committee, Matisse benefitted from a regular public platform and enjoyed an ongoing role in the organization of shows that were more adventurous than those held by the Nationale.

In the 1901 exhibition, Matisse found his works alongside those of Pierre Bonnard, Henri-Edmond Cross, Maurice Denis, James Ensor, Félix Vallotton, Marquet, Signac and Cézanne. He was in good company, but the landscape, still-lifes and drawings he submitted failed to make headlines. A short review of the exhibition in the *Chronique des arts et de la curiosité* glancingly identified Matisse as one of Moreau's 'disciples'.[2] Writing in the newspaper *Gil Blas*, Gustave Coquiot offered a sterner view. Describing Matisse as an 'eccentric deformer' of the human body, he cited as evidence the presence of 'ugliness' and physical 'defects' in some drawings that featured female subjects.[3] It was a harsh judgement by a writer who had been the secretary to Rodin and a supporter of Van Gogh. The accusation that Matisse betrayed standards of beauty in his depiction of women was one that would gain currency over the coming years.

Despite Matisse's increasing commitment to colour following his encounter with the works of Signac and John Russell, the canvases he produced during the early years of the century often featured a sombre palette. Indeed, Alfred H. Barr Jr, the first

director of New York's Museum of Modern Art, would later characterize 1901–4 as Matisse's '"Dark" Period'.[4] While Barr exaggerates for the purposes of highlighting the intense luminosity of the paintings that Matisse produced from 1905 onwards, it is true that colour competes with, and is often overshadowed by, darker tones in works created shortly after the turn of the century.

Developing principles of colour handling that had been familiar since the Renaissance, Matisse used strong shading to build depth and to model contours. *The Studio under the Eaves,* painted during a trip to Bohain-en-Vermandois in 1903, is a case in point. The work depicts the artist's materials – easel, palette, paintbrushes and canvas – isolated within a cavernous studio interior. The scene glimpsed through an open window in the background is one of light and colour, but this does not belong to the world depicted in the painting. A vase of flowers is perched on a table, and the position of the easel indicates that the absent artist has been working on a still-life. With his back turned to the window, the fictional artist's viewpoint is inwards towards the browns and deep greens of the blank wall. It is tempting to impose a psychological interpretation on the work: Matisse creates – and perhaps identifies with – an artist who ignores the pleasures associated with a world of sunlight and is, instead, committed exclusively to his craft. Architectural interiority matches the intense inner life of the artist, complete with its sacrifices.

Matisse continued to exhibit at the Salon des Indépendants throughout the first decade of the century. Increasingly, however, other exhibition venues opened up for him. An important opportunity was created by the private gallerist Berthe Weill. One of the few female art dealers of the period, Weill had set up her gallery in Montmartre in December 1901. Although her business foundered in the late 1930s, she was at the forefront of critical thinking during the early decades of the century and shaped the market for a generation of painters who became leading members

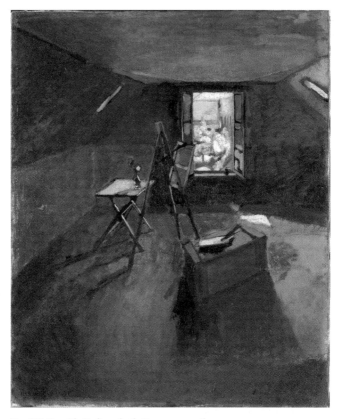

Henri Matisse, *The Studio under the Eaves*, c. 1903, oil on canvas.

of the avant-garde. These included Matisse, Picasso, Marquet, Georges Braque, Raoul Dufy, Marie Laurencin, Amedeo Modigliani and Suzanne Valadon, among others.[5] Throughout the first two decades of the century, Weill was committed to promoting 'les jeunes' – young artists who had not yet established their reputations. Although Matisse was not as young as some of the other artists in Weill's stable, he still ranked as a newcomer who had broken with academic tradition.

In February 1902, Weill staged a group show featuring works by Matisse, Marquet, Jules Flandrin, Elisabeth de Krouglicoff (Elizaveta Kruglikova) and Jacqueline Marval. The show was not a commercial success, but it was an important moment in the creation of a market for this group of artists. In April of that year, Weill secured a buyer for one of Matisse's still-lifes for the sum of 130 francs. This was his first sale on the art market through a professional dealer and gave the implied narrative of hardship in *The Studio under the Eaves* a successful ending. Compared to the 1.25 francs per hour salary that Matisse had earned painting scenery for the World's Fair two years earlier, the sum that he received from the sales proceeds of just one work seemed like a fortune.

Although Matisse was steadily expanding his network of contacts and achieving recognition on the Paris art scene, his personal situation remained precarious following the birth of Pierre in 1900. Despite the financial needs of the growing family, Matisse's father terminated his son's allowance in 1901. By 1903 Amélie's millinery business had folded. The family was, therefore, dependent on the commercial success of Matisse's art. In an attempt to secure a regular income, Matisse had the idea in 1903 of putting together a syndicate of investor art collectors who would purchase a set number of his paintings per year in return for a guaranteed stipend. It was a plan that anticipated strategies common among art dealers later in the twentieth century who ventured their money and reputation in bringing the works of lesser-known artists to the market. Investors were invited to gamble on the possibility that the commercial value of Matisse's art would increase and achieve a profit upon resale in the secondary market. It was a bet they were not prepared to make.

A similar scheme presented itself later that year. This time, however, the project was led by a collector, and the syndicate's money was invested not just in works by Matisse, but in those produced by a range of young artists. André Level, a successful entrepreneur based

in Marseille, gathered together a group of like-minded investors in a scheme he dubbed the 'Peau de l'Ours' (The Bearskin) – a term derived from the French proverb 'Don't sell the skin of the bear until the beast is dead' and an apt metaphor for the time necessary for an artwork to increase in market value. The consortium built up a collection of contemporary art produced by a group of artists that included Matisse, Picasso, Derain, Laurencin, Rouault, Vuillard, Kees van Dongen and Henri Manguin. As the director of the operation, Level proposed works for purchase by the consortium and bought directly from artists' studios or from new gallerists, including Berthe Weill.[6]

Level's plan marked a significant development of the art market: art was recognized and valued not on its intrinsic merits or even in its capacity as a status good. Rather, it was commodified as an asset class to be traded for profit when the relevant artist's reputation was established. The investment strategy of the Peau de l'Ours turned out to be sound, and the eventual sale of the works at the famous Hôtel Drouot auction house in 1914 netted the consortium a substantial profit.[7] Ten works by Matisse were included in the sale, including still-lifes, landscapes that the artist had painted on trips to Corsica, and *The Studio under the Eaves*. At a time when an artist's right to a percentage of the resale profits of his or her work (*droit de suite*) was not yet law, the influx of cash to this consortium of collectors could have been galling to the artists whose works were sold. However, the members of the consortium anticipated this potential quarrel (and the associated bad publicity) and earmarked 20 per cent of their profits for the artists whose works they sold.[8] As Michael C. Fitzgerald notes in his study of the early market for modernist art, the Peau de l'Ours auction conferred a new status on avant-garde painting by signalling a form of public approval that was distinct from critical opinion: this kind of art had achieved an unmistakable financial value.[9]

Concerns over the commercial terms and sales opportunities offered by gallerists kept Matisse permanently on the alert for alternative representation. He exhibited works at Berthe Weill's gallery nearly every year throughout the first decade of the new century, but this was not an exclusive arrangement. As his career progressed, Matisse developed relationships with numerous gallerists and, in 1904, was keenly aware of the pivotal role played by Ambroise Vollard in the Paris market. In addition to his exhibition of works by Cézanne, Vollard had staged a major retrospective of Gauguin in 1903 and, two years earlier, had exhibited the work of a newcomer whose reputation was growing at speed: Picasso. Recognizing that Vollard was a major power broker and taste-maker both in and beyond the capital, Matisse entrusted his first solo show to him in the summer of 1904.

The preface to the catalogue was written by Roger Marx, a critic who had been sympathetic to earlier exhibitions of Matisse's works. Although keen to emphasize Matisse's originality, Marx opened his essay with a familiar epithet: the artist was one of Moreau's students. Expanding upon this artistic lineage, Marx went on to suggest that having absorbed his lessons from Moreau, Matisse had turned to Impressionism and then to Cézanne for inspiration. His work was a 'harmonious synthesis' of pictorial ideas that had been explored by these two artists; his interiors were comparable to the simple beauty of poems by Francis Jammes and aligned with experiments undertaken by another contemporary painter, Édouard Vuillard; the celebration of colour and light in Matisse's landscapes attested to the 'sensitivity' of his vision and to his 'passionate and tender' nature.[10] Although presenting the works in a positive light, Marx domesticated Matisse's art and tamed it within a wealth of literary and art-historical references.

The exhibition comprised a selection of still-lifes, landscapes and interiors, including the work that had vexed critics in 1897, *The Dinner Table*. Although it was not a commercial success, the

show was fairly well received in the press. Louis Vauxcelles found the works to be technically secure and devoid of 'trickery', though in some cases indebted to Cézanne.[11] He went so far as to give his blessing to *The Dinner Table*, a canvas that Vollard later purchased. Charles Saunier commended the 'solidity' of Matisse's approach to painting, singling out the presence of an 'assured' eye that put to good use the most 'audacious samples of tonalities'.[12] While Roger Marx reiterated the theme of artistic lineage in his short review published in the *Chronique des arts et de la curiosité* he made the important point that Matisse had applied himself to developing his 'skills as a colourist'.[13]

Matisse's view of Notre-Dame painted from his studio window on the Quai Saint-Michel (*c.* 1900) was one of several paintings that illustrated Marx's point. Painted in a heavy impasto in which brush strokes of wet paint merge and inflect each other's tonal qualities, the work privileges geometrical form over verisimilitude. The facade of the cathedral is reduced to blocks of pink, umber and crimson, while the shadows and crenellations of the building's colonnade and roof are simplified and rendered in luminous viridian. The Petit Pont and the Seine flowing under it combine brilliant streaks of violet, ultramarine, light green and ochre. Although the brushwork of the painting owed much to the shimmering surfaces of Impressionist canvases, the juxtaposition of vibrantly coloured shapes anticipated the radical compositional experiments that Matisse would undertake towards the middle of the decade. At this stage, however, the direction of Matisse's art remained unclear to many critics, collectors and dealers – including Vollard himself.

Rebecca Rabinow describes Vollard's relationship to Matisse as the dealer's 'most flagrant missed opportunity; he simply failed to anticipate how the artist's style would evolve'.[14] While Vollard purchased works from Matisse sporadically, he did not make a major investment in the artist as he did with other members of the contemporary art scene. Vollard acquired works regularly

from Picasso and, in a bold move, purchased all of Derain's studio stock in 1905.[15] One issue that likely impacted on Vollard's coolness towards Matisse was a perceived instability in the latter's artistic identity. Matisse was a relentless experimenter and tested numerous expressive styles over the course of his career. As he sought to establish his reputation in the first decade of the century, however, his stylistic variability raised serious questions about the characteristics of his creative persona. Vollard obliquely referred to this dilemma in his memoirs when he recollected that Matisse unsettled those 'who wanted an artist to persist in a consistent style'.[16] This issue came to the fore pointedly in critical responses to the artist's painting in the first decade of the century.

Shortly after his exhibition at Vollard's gallery, Matisse headed to Saint-Tropez with his wife and his younger son, Pierre. This opportunity to paint in the brilliant light of southern France coincided with an important meeting with Paul Signac. Having read Signac's essay on Neo-Impressionism, Matisse now had an opportunity to exchange ideas directly with the older painter and to pursue experiments in the Divisionist technique. Fellow painter Henri-Edmond Cross, based in nearby Le Lavandou, also joined the conversation. Among the works that Matisse produced that summer, two would make a major impact on critics when they were exhibited at the Salon des Indépendants in the spring of 1905. The first work, *The Terrace, Saint-Tropez* (1904), was a depiction of the boathouse at Signac's home. Its light-infused surface and planes of blue and aquamarine evidenced the commitment to colour that Matisse had showcased in his exhibition at Vollard's gallery the previous year. The second, larger canvas, *Luxury, Calm and Pleasure* (1904), had a similarly vibrant palette – 'pure rainbow colours', as Matisse put it – but was painted in an entirely different technique that was indebted to Signac's Divisionism.[17]

The latter canvas took its title from the celebrated refrain of Charles Baudelaire's poem 'Invitation to the Voyage' of 1857: 'Là tout

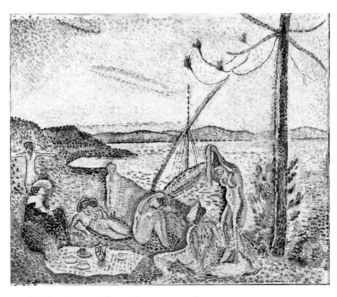

Henri Matisse, *Luxury, Calm and Pleasure*, 1904, oil on canvas.

n'est qu'ordre et beauté / Luxe, calme et volupté' ('There all is order
and beauty / Luxury, calm and pleasure'). In keeping with its title,
the work depicts a seaside idyll: a picnic on the beach with five nude
figures relaxing by the water; another woman stares out to sea;
and a small child, wrapped in a blanket, stands behind the group.
Historians have debated the symbolism of this pastoral. The central
figure of the child (interpreted by John Elderfield as a surrogate
for Matisse himself) suggests innocence, and the non-naturalistic
rendering of the scene an Arcadian quality.[18] Anticipating
Matisse's later experiments with the portrayal of dancers, the five
women in the foreground might represent several individuals or
one woman at different stages of bathing. Of importance is the
rhythm imposed on the viewer's eye by the differently positioned
figures whose limbs create a sinuous line along the base of the
work.

Rather than trying to identify idyllic qualities in the work's narrative, an alternative approach is to link the Arcadian theme to the way in which the subject-matter is depicted. Both the landscape and the human figures are modelled from strong contrasts of colour created by abbreviated brushmarks. As the artist explained: 'Objects are differentiated only by the luminosity given them.'[19] Matisse described Divisionism as a kind of order – though ultimately a 'household that is too well kept'. It was a style of painting that gave primacy to the 'retinal sensation' of colour and to the 'tactile vitality' of the surface.[20] If Baudelaire's poem is an invitation to journey to a world of sensory plenitude, Matisse's painting may be said to enact that very experience by showcasing the visual and tactile stimulation that Divisionist painting could offer the viewer. The experience of 'luxury, calm and pleasure' is not, therefore, located in any story told by the work, but rather in the viewer's bodily engagement with its painted surface.

The major question that troubled critics in 1905 was how to reconcile the different techniques manifested by *The Terrace, Saint-Tropez* and *Luxury, Calm and Pleasure*. As Alastair Wright puts it, critics found in these works an 'uncertainty of the index', namely a difficulty in ascribing a consistent style to the artist.[21] How was it so much as possible to identify a work as a 'Matisse' in the face of such relentless stylistic variability? This was a problem that also had consequences for the marketing and sale of the artist's paintings: buyers wanted to acquire works that were clearly associated with the handwork of a specific individual.

The conundrum was noted in a review of the Salon des Indépendants by Vauxcelles printed on the front page of the literary periodical *Gil Blas* on 23 March 1905. Vauxcelles had written sympathetic reviews of Matisse's works in the preceding years, but in 1905 confessed a mixture of admiration and concern. He singled out *The Terrace, Saint-Tropez* as one of the strongest canvases in the exhibition, but was confounded by *Luxury, Calm and Pleasure*. This

foray into Divisionism was, Vauxcelles suggested, just a mistake on the part of the artist. It was an example of Matisse the theoretician bent on pursuing paths that were hostile to his 'true nature'.[22]

In a gesture that signalled his personal approval of Matisse's Divisionist technique, Signac acquired *Luxury, Calm and Pleasure*. The work represented an extension of the older painter's style and publicly demonstrated the ongoing relevance of his theories to a new generation of creative individuals. This endorsement by an established artist did not, however, persuade Matisse to pursue Divisionism. In a step that further evidenced his creative restlessness and played into the hands of his critics, Matisse abandoned this style over the following twelve months. As he recollected: 'I didn't stay on this course but started painting in planes, seeking the quality of the picture by an accord of all the flat colors. I tried to replace the "vibrato" with a more expressive and more direct harmony.'[23] He discovered this harmony in 1905 during discussions with the artist whom he had introduced to Vollard the previous year: André Derain.

From May to September 1905, Matisse painted in Collioure, a small port in the South of France close to the Spanish border. Derain joined him there from July to August, and together the two artists embarked on a creative path that would have a transformative effect on twentieth-century art. Derain's views on the future of painting and, in particular, on the role of colour overlapped significantly with those of Matisse. Writing to his friend in June 1905, Derain described the need to envisage colour as a 'material' that could be manipulated like marble or wood. Instead of being ancillary to form, colour was a tangible substance that carried meaning in its own right.[24] These ideas would become motivating principles in Matisse's aesthetic. As will be seen in Chapter Six, the statements that Matisse made late in his career about the creation of paper cut-outs as a means of 'sculpting' in colour were the culmination of these early dialogues.

The Salon d'Automne that opened in October 1905 included works by Matisse, Derain and Vlaminck that showcased this new approach to colour handling in painting. Among the works exhibited by Matisse were *Open Window, Collioure* (1905) painted during his recent stay in the South, and *Woman with a Hat* (1905), a portrait of Amélie that Matisse had produced shortly after his return to Paris. Each painting comprised segments of heightened pigment that were dramatically juxtaposed to create form. Looking back on this period, Matisse described his ambitions: 'Construction by colored surfaces. Search for intensity of color, subject matter being unimportant. Reaction against the diffusion of local tone in light. Light is not suppressed, but is expressed by a harmony of intensely colored surfaces.'[25] Among Matisse's submissions

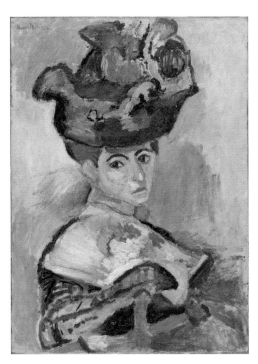

Henri Matisse,
Woman with a Hat,
1905, oil on canvas.

to the exhibition, *Woman with a Hat* caused audiences the most consternation. Here was a work in which a woman's face had been shaped from non-naturalistic, jarring pigments: nose, jaw and forehead were defined by bold stripes of arsenic green; violet had been used to model the cheekbone and chin; striking notes of vermillion, orange and yellow highlighted hair, collar and belt. Crowning the composition was the hat itself, a wild confection of shapes and colours that only made visual sense within the extravagant fiction of the painted surface. Colour had been used to create a recognizable human figure, yet it also drove a wedge between the world of the painting and that of the viewer. In his memoirs, Vollard recalled concerns expressed by the president of the Salon d'Automne, Frantz Jourdain, upon seeing the work. Although he was generally sympathetic to the experimental styles of the new crop of artists, Jourdain feared that Matisse was 'being modern' to excess and that the exhibition of *Woman with a Hat* was likely to damage the artist's career and reputation.[26]

Matisse's works were displayed alongside those of Camoin, Derain, Marquet, Manguin and Vlaminck in Room VII of that year's Salon d'Automne. In an article published on 17 October 1905 in *Gil Blas*, Vauxcelles bestowed what would become a lasting epithet on the painters whose works were shown in that space. Contrasting the paintings with two naturalistic sculptures by Albert Marque displayed in the centre of the room, Vauxcelles described the overall visual effect as akin to seeing the Renaissance artist Donatello among a pack of 'wild beasts' ('Donatello chez les fauves').[27] 'Fauvism' was quickly seized upon as a term of both praise and abuse, and Vauxcelles wrote himself into history.

In an article published in the *Journal de Rouen*, Marcel Nicolle confessed a loss for words when he found himself before works that bore no relation to painting. Fauvist works were 'naive and barbarous games' that a child had played with a paintbox.[28] Three years later, Joséphin Péladan dismissed Fauvism as an assault on

painting, a circus act in which 'the canvas is kicked by colour'.[29] Developing this bodily metaphor, he imagined the Fauves as artists who 'tattooed' the surface of their works instead of painting them. Anyone could be described as an 'artist', he claimed, when exhibitions showcased works that were inferior to the scribblings of a six-year-old – and an untalented one at that.[30]

This adventurous handling of colour and its consequences for the creation of form were, however, only part of the criticism levelled at the works displayed in Room VII of the 1905 Salon d'Automne. The writer André Gide countered the idea that Matisse's painting was either infantile or the product of madness when he purported to identify a different kind of problem. Reiterating Vauxcelles's concerns about Matisse's tendency to theorize painting, Gide argued that the artist's new works were the result of an overly elaborate methodology that had informed each compositional and colouristic decision.[31] On the one hand, Matisse was damned for being naive and 'wild'. On the other, he was at fault for reducing painting to a set of abstract principles. Crowning this critical debate was a dilemma that had more direct consequences for the artist: would anyone buy this kind of art?

As a dealer in vanguard painting, Vollard liked to highlight the difficulty of creating audiences for adventurous expressive styles. He suggested that, in comparison to other European countries, French taste was conservative: 'every innovation born of French genius confronts, on its home turf, indifference bordering on hostility.'[32] The critical dismay caused by the art of Fauvist painters in 1905 bore out his point. Perhaps it was no coincidence, therefore, that the purchaser of *Woman with a Hat* was a consortium of influential American collectors – the Stein family.

Leo Stein and his sister Gertrude moved to Paris in 1902 and 1903, respectively, and soon established themselves as energetic collectors of contemporary art. Backed by inherited wealth from their father's San Francisco cable car business, they acquired their

first paintings by Picasso in 1905 and were described by the artist's then lover, Fernande Olivier, as 'too intelligent to worry about ridicule, too sure of themselves to be concerned about the opinion of others'.[33] This critical self-confidence, coupled with a large budget, made them model art collectors and instant friends of the Paris avant-garde. The apartment shared by the Steins at 27 rue de Fleurus in the sixth arrondissement became both a fashionable meeting place for artists and writers and a showcase for the pair's collection of the newest art. The eldest brother of the family, Michael, and his wife Sarah were also keen collectors and steadily amassed their own sizeable collection of Matisse's works during the years following the 1905 Salon d'Automne.

On the walls of Gertrude and Leo's home, Matisse's *Woman with a Hat* jockeyed for position alongside paintings by Picasso, Bonnard, Vallotton, Manguin and Cézanne. Another portrait of Amélie by Matisse, famous for the dramatic green stripe down the centre of the face (*The Green Line*, 1905) and a landscape (*Olive Trees at Collioure*, c. 1906) were soon added to the collection. The apartment of Michael and Sarah Stein at nearby 58 rue Madame was an even stronger showcase for Matisse's art, with several walls devoted solely to his paintings.

Untroubled by the stylistic variability of Matisse's production during the first decade of the century, Leo Stein acquired a canvas titled *The Joy of Life* (1905–6). Completing the family's investment, Michael and Sarah Stein also acquired a preparatory oil sketch of the work. The painting was a powerful statement of Matisse's new style, and the manner of its introduction to the art world revealed the artist's dramatic flair. It was the only painting that Matisse submitted to the Salon des Indépendants in 1906, but audiences had the opportunity to see a wider range of works at the artist's second solo show that had just opened at the Galerie Druet on the rue du Faubourg Saint-Honoré. Participation in simultaneous exhibitions was a brilliant marketing ploy on Matisse's part and

Michael and Sarah Stein's apartment at 58 rue Madame, Paris, in 1908, showcasing paintings by Matisse.

revealed his keen understanding of how the institutional structures of the art world could be manipulated in advantageous ways.

The Joy of Life continued the Arcadian theme that Matisse had pursued in *Luxury, Calm and Pleasure* two years earlier, but the rendering of this new idyll was different. Divisionist brushmarks gave way to flattened planes of colour, traditional perspective was abandoned and figures were depicted in heavy outline. Viewers were left to wonder how the clashing elements of this strange work cohered. Swift transitions in the paint handling were combined with a fiery landscape of twisted forms and figures that barely seemed to occupy the same space. If colour had been unleashed

by a multitude of abbreviated brush strokes in *Luxury, Calm and Pleasure*, it was now held in check by a radical decorative schema that recalled the thick outlines of *cloisonné* enamels. For Signac this public abandonment of Divisionism was nothing short of a personal betrayal. Matisse had, however, found a new range of supporters.

The endorsement of the Stein family came at a crucial moment in Matisse's career. It not only provided him with much-needed financial backing, but generated a market for his works and extended their critical framework. Matisse had become 'collectable'. It was through the Steins' social network that Matisse was introduced to a range of individuals who would influence his career in different ways. He met Picasso at the rue de Fleurus in 1906. The American writer and critic Walter Pach and the German artist Hans Purrmann were associates of the Steins who later helped to extend Matisse's reputation beyond France. An important relationship was also fostered with another pair of American

Henri Matisse, *The Joy of Life*, 1905–6, oil on canvas.

collectors from the Steins' hometown of Baltimore, Claribel and Etta Cone. Like the Steins, the Cone sisters were prepared to invest in European art that challenged conventional taste and critical opinion. They developed a close relationship with Matisse over the next two decades and established a collection of his works that ranged from the artist's colouristic experiments of the first decade of the century, to books, sculptures and canvases produced up to the 1930s.

One of the works acquired by the Cone sisters was as controversial as *Woman with a Hat*. It was a painting that Matisse showed at the Salon des Indépendants in 1907 and that had originally been acquired by Leo Stein. *Blue Nude, Memory of Biskra* (1907) was derived from a sculpture on which Matisse had been working in early 1907, *Reclining Nude I (Aurora)*. The works on show at the 1907 Indépendants seemed to confirm Vauxcelles' earlier comment that beauty had been banished from ambitious contemporary art. Matisse's *Blue Nude* was widely perceived as an affront to the ideals of art in its failure to conform to classical conceptions of female beauty. In place of smooth curves and just proportions, the body of the woman depicted in the work was twisted and angular. Instead of offering a female form that was flatteringly shaped and positioned so as to invite the gaze, this painting seemed to withhold pleasures typically associated with looking. The sculptural counterpart further accentuated these features as the woman's torso twisted more tightly to the left and the angle of the thigh was made acute. For whom does this figure pose and what kind of visual engagement does it solicit?

The pose of the woman seems to derive from a painting by Jean-Antoine Watteau of 1718–19, *Fêtes vénitiennes*. This pastoral scene, in which elegant men and women socialize and dance, is crowned by a statue of a naked woman in the upper-right corner. The figure's flowing hair and shapely form give the work an erotic undertone, and the pointed finger of the man by the back wall leads the viewer's gaze from the dancing couple in the

Henri Matisse, *Blue Nude* (*Memory of Biskra*), 1907, oil on canvas.

Henri Matisse, *Reclining Nude 1* (*Aurora*), bronze, original model 1907, this cast *c*. 1930.

Jean-Antoine Watteau, *Fêtes vénitiennes*, 1718–19, oil on canvas.

foreground to the suggestively positioned statue. The amorous
theme is unmistakable, and an image of female beauty is at its core.
Matisse's painting and sculpture retained the pose of the figure
in Watteau's painting, but radically altered its proportions and
seductive charm.

Vauxcelles' sympathy for Matisse's art was stretched in his
exhibition review. He admits that he is unable to understand the

Blue Nude: the woman is naked and 'ugly', a nymph who is part-man, part-woman ('hommasse'). The composition is, he continues, rudimentary and the colours 'cruel'; the body itself is 'deformed'.[34] These ideas have persisted in twentieth- and twenty-first-century critical discussions about the work, as commentators have sought to demonstrate and analyse tensions between visual beauty, gender and aesthetic value. Pursuing the idea that *Blue Nude* elides gender difference in potentially confrontational ways, Yve-Alain Bois argues that the woman's left leg is shaped like a phallus, and Arthur Danto suggests that a person who finds the work beautiful is 'talking through his or her hat'.[35]

While discussions of these features of Matisse's art have been debated regularly in art-historical literature, it is worth noting that Vauxcelles' article appeared on the front page of *Gil Blas*. His article fuelled a crisis that the critic Camille Mauclair had identified the previous year: the presence of a 'wilful, barbarous, and howling' drive to ugliness among practitioners of the avant-garde.[36] In the first decade of the twentieth century, questions about how contemporary artists depicted the world and its inhabitants commanded public attention and had the power to unsettle audiences' faith in the stability of prevailing social structures and knowledge frameworks. If the works of Matisse and his contemporaries had relevance beyond rarefied questions of aesthetics, what were they? Answers came dramatically to the fore as Fauvist painting became known beyond France.

In a comedic essay published in 1910, the American poet and critic Gelett Burgess introduced French avant-garde painting to u.s. audiences and thereby crystallized many of the debates that had unfolded in the wake of the 1905 Salon d'Automne. Published in the *Architectural Record*, 'The Wild Men of Paris' posited Matisse as the elder statesman of a provocative tribe of creative individuals whose works defied convention, banished beauty and privileged ugliness. Burgess argued that in the canvases of these artists, women looked

like 'flayed Martians', bodies were stripped of anatomical form and landscapes comprised 'squirming trees, with blobs of virgin color gone wrong'.[37] He stretched the Fauvist label to include works by Braque, Picasso, Béla Czóbel, Othon Friesz, Auguste Herbin and Jean Metzinger. Regardless of their stylistic differences, these individuals were, according to Burgess, artists-cum-artisans leading a revolt against traditional aesthetic values.

In some respects, Burgess's report would not have been surprising to readers. Matisse's works had been exhibited in the United States in 1908 in a small show organized by photographer and gallerist Alfred Stieglitz and the photographer Edward Steichen at Stieglitz's 291 Gallery in Manhattan. Although the works on show were primarily small drawings, lithographs, watercolours and etchings depicting female nudes, they were far from the polished academic drawing that audiences expected. They were, in consequence, deemed 'ugly' and 'indecent' by critics.[38] It was small wonder that Matisse's *Blue Nude* was burned in effigy by students in Chicago when the famous Armory Show exhibition travelled westwards from New York in 1913.

In an influential article of the 1970s, feminist art historian Carol Duncan debated the wider role and ideological significance of avant-garde culture in society. Focusing on the reception of early works by Matisse and his contemporaries, she examined the construction of a 'virile' image of the twentieth-century artist who, above all, epitomized a model of freedom. Crucial to that idea of personal liberty, according to Duncan, was the expression of male heterosexual desire, an investigation of sensuous experience and a working out of power relations between men and women.[39] She argues that portrayals of the female nude by male artists of the 1910s (including Fauvist painters) are characterized by a 'dehumanizing approach' to women who are 'reduced to objects of pure flesh'. Although she considers Matisse to be more 'gallant, more bourgeois' than many of his contemporaries, the exertion of

his virility is nevertheless 'metamorphosed into a demonstration of artistic control'.[40]

The juxtaposition of Burgess's essay with that of Duncan reveals a clash of ideas in the critical reception of Matisse's works. On the one hand, Burgess criticizes Matisse for undermining the relationship between idealized femininity and aesthetic beauty, thus provoking audiences who looked to art for a reinforcement of sexual difference. On the other hand, the disruption of that paradigm through techniques of radical visual distortion is later interpreted by Duncan as evidence of a power structure in which male artists dehumanize women for the purpose of prioritizing their own sexual, imaginative and aesthetic liberty.

Debates about the relationship between European modernist art and gender did, however, develop in arenas that extended beyond theory. In Burgess's essay Matisse and his contemporaries are posited as representatives of a Bohemian myth and are recognized as leaders of a new avant-garde. Their work is 'a wild place fit for dreams', but it is, the essay concludes, 'no place for mother'.[41] By extension, this heroic narrative was no place for female artists. Burgess's vision of modernism singled out the creativity of 'wild men' and, paradoxically, it was their portrayal of women's bodies that determined the stakes of the debate. The challenge to both artistic tradition and gender difference was summed up by Matisse's portrait of his wife, *The Green Line* (1905), that had been bought by the Steins. To model his wife's features from planes of clashing colour and to impose a viridian stripe down the middle of her face was, Burgess asserts, nothing short of cruelty. Yet 'fearful' as this body might be, 'it is alive – awfully alive!'[42] In contrast to the portrayal of 'beautiful', passive women designed to attract and delight the heterosexual male gaze, these 'wild men' of Paris were thought to have transformed the painted canvas into a battleground of sexual desire – including its fulfilment or frustration. From Picasso's *Les Demoiselles d'Avignon* (1907) to Derain's *Bathers* (1907), and Matisse's own *Blue Nude*, the

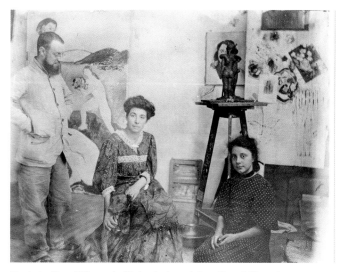

Henri, Amélie and Marguerite Matisse in the artist's studio at Collioure in 1907.

female body was identified at the nexus of that which Danto describes as a 'revolt against beauty' that pushed audiences to question 'what art should be' – and, one might add, how men and women were thought relate to each other in and beyond the art world.[43]

Yet critics were not simply troubled by the rejection of ideals pertaining to female beauty and the implications that this had for definitions of art and social relations. When Burgess described Matisse as an individual who was 'breaking his way through this jungle of art', he also hinted at racialized discussions about the influence of non-Western creativity on this branch of the avant-garde.[44] If artists had tested gender boundaries in their questioning of the role of beauty in art, so too they seemed to have turned their backs on aesthetic tropes and styles that had long epitomized ideals of European refinement and taste.

On his walks to the Steins' apartment on the rue de Fleurus, Matisse would pass a curiosity shop on the rue de Rennes that held

a stock of African sculpture. In 1906 he acquired a carved statuette that had been produced by an unidentified artist working in Vili style from what is now the Democratic Republic of the Congo. Famously, Matisse showed the carving to Picasso and thereby sparked a discussion about African art that would have a lasting impact on the twentieth-century European art world. As Matisse recalled:

> It was a time of new acquisitions. Not knowing ourselves too well yet, we felt no need to protect ourselves from foreign influences, for they could only enrich us, and make us more demanding of our own means of expression.[45]

Pierre Daix points out that beyond their interest in the formal qualities of African arts, modernists including Matisse, Picasso, Derain and Vlaminck seized upon their potential for provoking an 'intellectual rupture' with European traditions. This idea was given further impetus following the posthumous retrospective of Gauguin's works at the Salon d'Automne of 1906 that not only showcased the artist's experiments with colour, but illustrated the profound inspiration of Oceanic arts on his creativity.[46]

Matisse incorporated his Vili statue into a painting of 1907 *Still-life with African Statuette* where, as historians have noted, it features primarily as a decorative object among a range of studio props.[47] There were, however, ways in which African arts impacted more deeply on Matisse's imagination. The circulation of postcards, photographs and magazine pictures of North African peoples were an important inspiration for Matisse's sculpture. To take one example: scholars have traced links between Matisse's bronze sculpture *Two Women* of 1907–8 and photographs of young North African women in the ethnographic magazine *L'Humanité féminine*. In its embrace of African arts, Fauvism represented a significant challenge to the supposed artistic, social and political supremacy of

Henri Matisse, *Two Women*, bronze, original model 1907–8, this cast *c*. 1930.

Western Europe. Yet, as Ellen McBreen has pointed out, Matisse's 'modernist primitivism' – like that of his contemporaries – also developed in a cultural environment that was informed by colonialism and Western imperialism. European interest in African art objects was motivated, she argues, by the desire to conceive of such artefacts as 'sacred alternatives' to European commodities and technological cultures.[48] Paradoxically, Matisse's navigation of European and African cultural influences represented both a threat to the alleged supremacy of European aesthetics and a reinforcement of the colonial gaze manifested in ethnographic and erotic magazines that disseminated a mixture of fact and myth about African peoples and their cultures.

On 15 December 1907, the poet Guillaume Apollinaire published a short essay about Matisse in the literary review *La Phalange*.[49]

Based on an interview with Matisse, the essay was one of the first important public statements about Matisse's art that had the artist's approval. In the aftermath of Matisse's exhibitions over the previous two years, Apollinaire's essay was significant for two reasons. First, it established a counterpoint to the critical view that Matisse's painting was either 'naive' or 'wild'. Instead, Apollinaire presented the image of an artist who was capable of deriving order from chaos. Matisse's 'reasonable art' was the product of reflection and, it was argued, displayed a profound understanding of European artistic traditions. Matisse remained 'above all devoted to the beauty of Europe'. Second, Apollinaire was careful not to constrain Matisse's creativity within a set of pre-existing conventions. In so doing, he put forward an idea that would have a lasting influence on critical discussions of Matisse: his creative practice was driven equally by reflections on the art of the past and by 'instinct'.[50]

Apollinaire's essay was followed by a significant critical intervention by Matisse himself, 'Notes of a Painter' (1908). The essay had been solicited by Georges Desvallières for publication in the prestigious literary journal *La Grande Revue* and offered Matisse an opportunity to counter his critics on their own terrain. The essay developed ideas that had been put forward by Apollinaire the previous year, particularly as concerns the role of instinct in the creative process:

> The expressive aspect of colors imposes itself on me in a purely instinctive way. To paint an autumn landscape I will not try to remember what colors suit this season, I will be inspired only by the sensation that the season arouses in me.[51]

Throughout the essay, Matisse stresses that his art is the product of his own, personal response to his subject-matter. His compositional process consists in working through an initial perception of the

subject for the purpose of stripping it to its 'essential qualities' and thereby revealing a 'harmonious' work devoid of superfluity.

By the end of the first decade of the twentieth century, audiences had been presented with a dual view of Matisse. On the one hand, critical literature had constructed the image of a 'wild man' who was willing to insult beauty, abandon European aesthetic traditions and do violence to the canvas. On the other hand, Matisse's own statements – combined with Apollinaire's essay – presented a thoughtful artist whose works balanced instinct and reflection. Although tensions between these two views would persist into the second decade of the century, by 1908 Matisse had secured a leading position in avant-garde circles. Recognizing that both his art and his critical opinions carried weight, Matisse was emboldened to establish his own art school – the Académie Matisse – on the rue de Sèvres in Paris. Sarah Stein was instrumental in helping Matisse to set up and run the Academy, and her notes of the critical feedback that Matisse gave to students offer the best view of the training that students received.[52] As Jack Flam notes, those expecting to meet a renegade of the contemporary art scene were disappointed, but Matisse did offer important advice on how an individual might develop a unique creative idiom.[53]

The American artist Max Weber attended these classes and recollected that Matisse 'abstained from demonstrating or making corrections on students' work'. However, when Weber was the only one willing to act as the guinea pig for Matisse's comments on an original composition, two weeks of frank criticism were sufficient. Neither Weber nor any other class member brought a sample of work for the third week, and the composition project ended. Life in the classroom was not always so traumatic, however, and Matisse would, on occasion, entertain his students with classical music played on an old pump organ. Weber recalled that at the end of a rendition of Beethoven's Fifth Symphony, Matisse 'would rise slowly, straighten out his shoulders, take a few steps, and convey

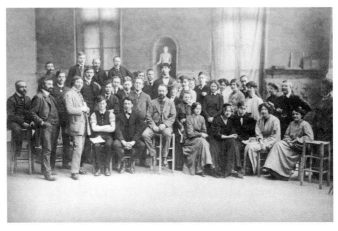

Matisse and his students at the Académie Matisse, Paris, *c.* 1909.

the feeling of great satisfaction'.[54] There was clearly more than one way to impress a class of aspiring artists.

Although it lasted for only three years, the Académie Matisse was evidence of Matisse's burgeoning national and international reputation. Whether known in critical circles as the 'wild man' or the 'professor', Matisse could safely say that by the end of the first decade of the new century his reputation and financial situation were on secure territory.

3

Friends and Rivals

In the early spring of 1910, Matisse held a retrospective of his works at a Paris gallery run by two brothers, Josse and Gaston Bernheim, and directed by the art critic and former anarchist Félix Fénéon. In contrast to Berthe Weill's small establishment in Montmartre, the Bernheim-Jeune gallery was housed in a prestigious location at 25 boulevard de la Madeleine in the heart of fashionable Paris. It had hosted important exhibitions of works by Vincent van Gogh (1901), Pierre Bonnard (1906), Édouard Vuillard (1906) and Georges Seurat (1908). The gallery also held a retrospective of works by Paul Cézanne in 1907, for which Matisse loaned the *Three Bathers* that he had acquired from Ambroise Vollard nearly a decade earlier. According to 23-year-old Marc Chagall, newly arrived in the capital from Russia, the enticing windows of Bernheim-Jeune were always 'lit up as if for a wedding'.[1]

A retrospective was, and remains, an important event in an artist's career. Unlike a regular solo exhibition, it is designed to showcase an individual's stylistic development. It also sends an important message to the market by illuminating the critical framework that has developed around that artist's output. The works that Matisse selected for his exhibition comprised 65 paintings and 26 drawings, the earliest of which had been produced in 1893. Most of the works were contributed from private collections: the Steins loaned a substantial part of their holdings, and the journalist and socialist politician Marcel Sembat

contributed a painting of 1909 titled *Seated Nude*. The exhibition gave audiences the opportunity to see the evolution of Matisse's pictorial thinking for themselves and to consider a lengthy experimentation with colour that peaked in the brilliant tones of the work owned by Sembat.

The year 1910 also marked the first major shift in Matisse's professional relationships as he terminated his arrangements with Berthe Weill and signed a three-year contract with Bernheim-Jeune. The agreement with Weill had worked on a traditional model in which Matisse received the proceeds from sales of his works made through the gallery, less a percentage deducted by Weill. By contrast, the larger-scale operation of Bernheim-Jeune offered an established exhibition platform and a more stable income that involved the gallery's purchase of all new works produced by the artist plus a royalty on sales.[2]

Although the retrospective evidenced a high degree of public and critical interest in Matisse's art, it met with criticism in the press. Some reviews drew on the vocabulary that had developed around Fauvism earlier in the decade. The poet André Salmon described an outbreak of 'anarchy' in the works and alleged an absence of structure in their composition.[3] Although the critic Jacques Rivière admired Matisse's handling of colour, he identified a tendency towards 'plastic speculations' that were unanchored in any clear aesthetic lineage.[4]

A new line of criticism focused on two further developments: the influence of the decorative arts on Matisse's aesthetic and the success of his works outside France. In a short but pointed review, J.-F. Schnerb confessed having to control his indignation in front of canvases that had wilfully abandoned the imitation of nature. Matisse's interest in colour had, Schnerb asserted, confounded painting with tapestry design. He argued that the decorative qualities of Matisse's works disregarded the higher purpose of art, a point that was reflected in the composition of the audiences

to which they appealed: 'Russians, Poles and Americans'.[5] The attractiveness of Matisse's art to foreign collectors was reiterated by Octave Mirbeau in a letter to Claude Monet. The exhibition had been a success, he noted, but primarily because of the enthusiasm of Russian and German museum directors.[6]

Writing in the same year, Apollinaire stated that Matisse was 'one of the most disparaged artists of the moment'. He responded to critics by trying to make sense of the works in relation to key art-historical traditions. Audiences could witness, he argued, a creative style that had freed itself from the yoke of Impressionism. Matisse 'endeavours not to imitate nature, but to express that which he sees and that which he feels through the very materiality of the painting, just as a poet uses the words of a dictionary to express the same nature and the same feelings'.[7] Apollinaire's essay developed the theme of instinctive expression elaborated in Matisse's own 'Notes of a Painter' and tried, once again, to provide an intellectual foundation for Matisse's compositional and colouristic experiments. Emphasis on the materiality of the painted surface was said to reinforce Matisse's approach to the sculptural qualities of colour that had informed some of his earliest exchanges with Derain and that had developed in subsequent years. Apollinaire did, however, also note the strong overseas interest in the artist's most recent work in comparison to the market for them in France.

While members of the Stein family had proven themselves to be strong supporters of Matisse's painting in the wake of the Salon d'Automne exhibition of 1905, significant interest had come more recently from Russia in the form of two businessmen turned collectors: Sergei Shchukin and Ivan Morozov. Shchukin had seen a large-scale work produced by Matisse in 1908 that had been bought by Karl Ernst Osthaus for the Folkwang Museum in Hagen (later moved to Essen), Germany: *Bathers with a Turtle* (1907–8). Of the works by Matisse that the museum acquired in the first decade of the twentieth century, *Bathers with a Turtle* was by far the most

ambitious in scale, measuring over 2 metres in width and just over 180 centimetres in height. Its depiction of three bathers in a semi-abstract setting continued the Arcadian themes that Matisse had explored in *Luxury, Calm and Pleasure* and *The Joy of Life*. Yet the troubled expression of the central figure disturbed the idyllic narrative and created visual and thematic uncertainty.

A preliminary oil sketch (1907) indicates that Matisse took his inspiration from a conventional beach scene featuring three female bathers drying themselves. In the final composition, however, all naturalistic details of the seaside setting, sailing boats and bathing towels have been removed. The background is divided into three horizontal strips of blue and green (perhaps indicating land, sea and sky), while a rock that supported the seated woman on the right has disappeared completely. Compositionally, the work's triangular structure is indebted to Cézanne, while the broad back and

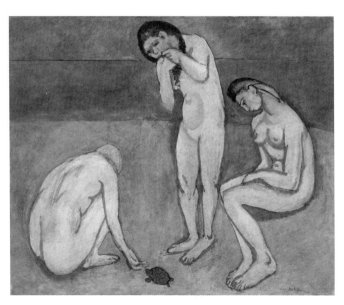

Henri Matisse, *Bathers with a Turtle*, 1907–8, oil on canvas.

outstretched arm of the crouching figure is an even more specific
reference to the older artist's influence.[8]

The dramatic shift from oil sketch to finished work is indicative
of Matisse's pictorial thinking of the period: while remaining
committed to figurative painting and close observation of the world
around him, Matisse was prepared to reduce observed reality to a
series of elemental shapes and colours. In consequence, many of the
works of the first decade of the century verge on the mythological.
Some scholars have argued that the central figure in *Bathers with
a Turtle* refers to the ancient myth of Venus emerging from the
sea; others have interpreted differences in the physical portrayal
of the figures as a representation of the evolution of humankind;
feminist readings of the work suggest its communication of female
submissiveness by identifying the turtle with the Greek myth of the
nymph Chelone, who was cursed by Hermes to carry her house on
her back.[9]

Aside from difficulties of interpretation, one of the most
striking features of the work is the visibility of overpainting.
This is particularly clear around the body of the central figure
(whose position has been shifted to the right during the course of
composition), the head of the seated woman and the placement
of each figure's feet. Rather than taking pains to smooth these
remnants of his earlier ideas, Matisse accentuates them by leaving
ghostly traces visible on the surface. In a further step, a flurry of
abbreviated brushmarks around the upper body of the central
figure highlights the adjacent outline of the woman's body that
bisects the composition. *Bathers with a Turtle* showcases a process of
pictorial thinking and invites the viewer to look through its painted
surface to other potential realizations of its subject-matter.

Shchukin was impressed by both the palette and enigmatic
subject-matter of the canvas and began acquiring and
commissioning works by Matisse. Among the 36 paintings that
he had bought by 1913 were two stylistically similar works that

continued the compositional thinking of *Bathers with a Turtle*: *Game of Bowls* (1908) and *Nymph and Satyr* (1909). It was, however, a series of large-scale works that cemented a connection between Matisse and this daring collector. Lending credence to the charge that his painting had acquired a decorative impulse, Matisse's *The Dance* (1909–10), *Music* (1910) and *Bathers by a River* (1909–16) were specifically commissioned by Shchukin to decorate a staircase in his home, the Trubetskoy Palace in Moscow, though only the first two panels were delivered and installed.[10]

The Dance and *Music* were two of the most important paintings that Matisse produced in the opening decade of the century. Together, they might be thought of as his manifesto of the period as they articulated key metaphors that underpinned his creative process: the rhythm of artistic gesture and musical harmony. Throughout his career, Matisse was alert to the physical performance involved in creating visual art and drew attention to acts of bodily co-ordination that were needed to produce a graphic line (or 'arabesque'). The balletic qualities of applying a brush stroke or pencil mark lay the foundation for an interest in stage design and the portrayal of movement. Over the next twenty years, Matisse would undertake a detailed interrogation of ways in which the rhythms of a dancer's body could be communicated in visual form and how the creation of art itself was an act that engaged audiences both physically and imaginatively.

Closely linked to these ideas about making art were the musical analogies that Matisse used to describe his works. A violinist himself, Matisse spoke of ways in which colours could 'sing' and 'harmonize' with each other. He described text and imagery combining to form a 'harmonious whole', insisted that pigments could produce sounds when placed in different relations to each other and identified the graphic line as a phrase that arranged itself 'like music'.[11] A pair of canvases thematizing dance and music was, therefore, an apt convergence of two of Matisse's central

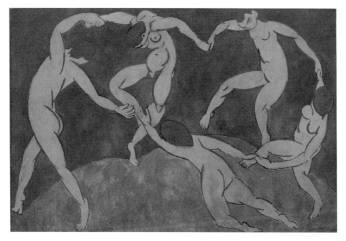

Henri Matisse, *The Dance*, 1909–10, oil on canvas.

preoccupations. Created in a similar palette, *Dance* and *Music* were
exhibited in the Salon d'Automne in October–November 1910. They
fared no better with critics than Matisse's other recent efforts and,
once again, it was Apollinaire who came to the artist's defence.[12]
Even Shchukin was troubled by the critical response to the works,
first rejecting and later accepting them on his return to Russia.

The term 'decorative' was often used pejoratively when applied
to Matisse's art. Not only did this description distinguish museum
'art' from 'craft', but it also carried connotations of commercialism:
Matisse was thought to be producing decorative commissions
for wealthy patrons. Even more damningly, critical literature
had long associated the decorative arts with negative stereotypes
of female creativity. It was not, therefore, thought to occupy the
realm of intellectual or 'high' art. André Salmon's 1912 discussion
of Matisse's output summed up the point: 'His real gifts are skills
– of suppleness, of quick assimilation, of meagre, but quickly
acquired, science, feminine skills.'[13] Matisse's interest in decoration
was sincere, however, and would become a mainstay of his later

creativity when he turned with intensity to the production of large-scale murals and cut-outs. In the years immediately preceding the First World War, however, much of Matisse's interest in decoration was expressed by a focus on pattern design and textiles.

In 1909 Matisse moved to a large house in the Paris suburb of Issy-les-Moulineaux. With an ample garden and a detached studio, the house afforded Matisse a dedicated space in which to work and provided his family with more comfortable living quarters. The new home was not without its drawbacks. It stretched the family's finances and imposed detachment from life in the centre of the capital. Many of the paintings that Matisse produced in the years immediately following the move have an introspective air with a focus on the contents of the artist's studio and the life of his family.

The Pink Studio of 1911, for example, reads like a personal diary. The viewer is offered a glimpse of the artist's studio, complete with a range of works produced to date. Among the pieces depicted in the background are the first version of *The Dance* (1909), *The Young Sailor* (1906), *Luxury II* (1907–8), *Nude with a White Scarf* (1909), a bronze sculpture of 1908 titled *Decorative Figure*, and a study for the monumental sculpture *The Back* (1908–9). Taking centre stage, however, are two textiles, one draped over a screen, the other a yellow carpet on the pink floor. A jug perched on a small wooden stool is placed in the centre of the canvas, and this (together with the surrounding textiles) is incongruously positioned as the principal subject of the work.

The presence of textiles in Matisse's paintings recollected his family background in northern France. In interviews, Matisse was fond of reminding audiences that his earliest training as an artist had taken place in Saint-Quentin at a school for those seeking jobs in fabric design.[14] This interest in textiles developed further when Matisse and his friend Albert Marquet travelled to Munich in 1910 to see an exhibition of Islamic art. Historians have noted the cultural significance of this exhibition in terms of both its scale and

the way in which the works were presented to the public. Andrea Lermer and Avinoam Shalem point out that the exhibition broke significantly with Orientalist stereotypes and took seriously the aesthetic values and wider cultural significance of Islamic art.[15] At the exhibition, Matisse had the opportunity to study at first hand textiles, rugs, bronzes and Persian miniatures, all of which impacted on his pictorial thinking over the following years.

The Painter's Family of 1911 – another work acquired by Shchukin – illustrates the combined influence of textiles and Islamic art on Matisse's imagination. Taking as its subject an ordinary domestic scene featuring Matisse's wife, his daughter and two teenage sons, the work gives equal importance to the human figures and the contrasting patterns of the background wall, sofa, fireplace and rug. Echoing the structure of a compartmentalized Persian miniature, the work abandons European Renaissance perspective. Instead, decorative segments are juxtaposed to create a flattened, elaborately patterned surface.

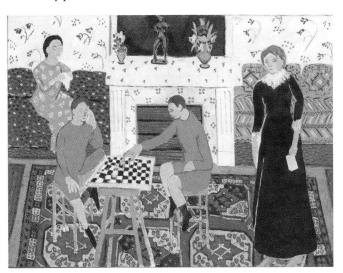

Henri Matisse, *The Painter's Family*, 1911, oil on canvas.

This radical equalizing of each section of the canvas extended to Matisse's still-lifes. His *Interior with Aubergines,* painted on a trip to Collioure in 1911, is a more dramatic experiment with this technique. Developing the ideas described above, the entire work is an exercise in detailed pattern-making, with each object contributing to an overall decorative scheme. Screen, table, wallpaper, carpet and textiles form a pseudo-collage comprising layered segments. Matisse adds a range of optical features to the work that extend these various patterns: a mirror on the left reflects part of the table and screen; an open window in the upper-right corner offers a glimpse of a landscape; and further frames (including that of a fireplace) generate interlocking shapes between wall, floor and furnishings. In consequence, the space behind the (unpictured) artist and the scene through the open window are brought on to the same plane as the interior of the room in a single, unified design. The work is one of the 'Symphonic Interiors' – alongside the *Pink Studio, The Painter's Family* and the *Red Studio* – that marked the pinnacle of the artist's creative output of 1911.

In 1911 Matisse submitted two paintings to the Salon d'Automne that he had painted at Collioure during the summer of that year: *View of Collioure* and a preliminary oil sketch for *Interior with Aubergines.* In contrast to the heavily worked surfaces of the paintings discussed above, these canvases were lightly painted, their brushmarks foregrounded with sections of empty background left visible through the pigment. For Louis Vauxcelles, this was nothing short of an insult to the audience:

> Two Matisses: let's be frank, there is hardly anything there. These are oil sketches, outlined in a quarter of an hour. Someone with the name Matisse should not produce this lamentable example. If this continues, Matisse will soon give us a blank canvas.[16]

Matisse did not offer his audiences blankness, but he did the next best thing by creating a monochromatic work. For *The Red Studio*

Henri Matisse, *Interior with Aubergines*, 1911, oil on canvas.

produced at Issy-les-Moulineaux in the autumn of 1911, Matisse
created a background drenched in vibrant vermillion (although the
work was originally conceived in a blue colour scheme). The outlines
of furniture are scratched from a uniform background, while floor
and walls are differentiated primarily by the placement of art
objects. In keeping with Matisse's preoccupations of the period, the
work showcases a range of the artist's own paintings, sculptures
and ceramics, yet these are pushed to the periphery of the painting.
As Jack Flam notes, this is a work that eschews a single focal point.
Here, as in so many of Matisse's decorative paintings of the period,
'one thing always acts as a foil for something else'.[17]

In 1911 the Danish art historian Ernst Goldschmidt interviewed
Matisse and described the curious effect of seeing *The Red Studio*.
Despite the work's uniform surface, 'the colors of the things in one

inexplicable way or another made the wall come alive' and imbued the objects with 'a curious visionary strength'.[18] His comments capture the paradox of naturalism in the work: real objects are depicted in an unreal space. By portraying the closed room in a single colour, Matisse undermines its architectural parameters and suggests its potentially infinite expansion. Developing Flam's argument, it is not merely the case that objects act as visual foils for each other. Rather, they bring each other into being. The barely articulated walls of *The Red Studio* are integral to the room's content, and the only things capable of asserting themselves independently are artworks and the artist's materials depicted in their own tonal registers.

In 1912 and 1913 Matisse deepened his interest in Islamic art and culture during two trips to Morocco. In each case he painted primarily in the medieval walled city of Tangier and, on his second journey, worked on a series of landscapes, still-lifes and figure paintings for both Shchukin and Morozov. His stays at the Grand Hotel Villa de France lasted for several months, and Madame Matisse accompanied her husband on both occasions. During the second stay in Tangier, Matisse was also joined by his friend and former Fauvist associate Charles Camoin. Matisse enjoyed the sociability of like-minded artists, and his correspondence with contemporaries including Bonnard, Camoin, Derain, Marquet and Rouault attests to his interest in sharing ideas and navigating the art world in a collaborative way. Camoin had fond memories of painting in Morocco alongside Matisse, writing to his friend in August 1913 that he thought of 'this Winter in Tangier as a rare period of health . . . and of happy work'.[19]

During his stay in Morocco, Matisse worked with local models and produced studies of individual figures that were painted in the loosely worked style that had so annoyed Vauxcelles in 1911. *The Standing Riffian* (1913), later purchased by Shchukin, is a good example. It is a monumental portrait of a man belonging to the

Henri and Amélie Matisse at the Hotel de France in Tangier, 1913.

Berber peoples from the Rif region in northern Morocco. The work is arresting in its simplified composition, the divided background colours of blue and green leading the viewer's eye along the vertical shading of the face and towards the decorative pattern of the model's green djellaba (tunic).[20] The static frontal pose offsets the dynamism of the brushwork.

Matisse was inspired by the architecture of Tangier, and his paintings and drawings include depictions of famous landmarks (the Bab el-Assa gate), views of minarets, tombs of Muslim religious leaders (marabouts), dwellings and cafés. In September 1912 Matisse renewed his contract with Bernheim-Jeune for another three-year period. The occasion was marked by an exhibition in 1913 of his Moroccan paintings, including an important triptych produced for Morozov between 1912 and 1913 that takes the viewer from Matisse's hotel room in Tangier to the interior of the Casbah: *Landscape Viewed from a Window, On the Terrace* and *The Casbah Gate*. The exhibition also included a range of sculptures from the

early stages of the artist's career to the present. As with Matisse's previous exhibition at Bernheim-Jeune, the majority of the works on show had already been sold prior to opening. Evidence indicates, however, that Matisse was involved in the installation of the works, a point that is borne out by the visual connections made between some of the sculptures and their adjacent paintings.[21] The limbs of the pale figures depicted in *Moroccan Café* (1913), for example, led the viewer's eye to the elongated, sinuous shapes of *La Serpentine*, a bronze that Matisse had produced in 1909.

Reviews of the exhibition were generally positive. René Jean noted the finesse and subtlety of Matisse's colour handling, taking up the artist's own musical metaphors in his description of 'a sort of brightly colored music that attains the extreme limits of the pictorial domain'.[22] Apollinaire's short review developed ideas about Matisse that he had expressed in earlier writings. The works on display showcased, he asserted, Matisse's strengths as a colourist and demonstrated a strength in drawing that derived from instinct.[23] For Vauxcelles, however, the drawings were little more than amusing sketches, while the paintings themselves were under-developed patchworks.[24]

Matisse occupied a difficult position within avant-garde circles at the time of this exhibition. He may have been classed among Berthe Weill's 'young' painters earlier in the century, but he was of a different generation from many of his key competitors (Georges Braque, Juan Gris, Robert Delaunay, Marie Laurencin, Amedeo Modigliani and Pablo Picasso) and key writers with whom they were associated (Apollinaire, Salmon and Max Jacob). Despite the uproar that had been generated by Fauvism, Matisse appeared to some members of the literary avant-garde as bourgeois and old-fashioned, too closely linked with the world of Gustave Moreau and outmoded institutions. In his memoirs, Salmon recollects throwing soft-edged darts at Matisse's portrait of his daughter Marguerite (a painting that Picasso had acquired from Matisse in

Edward Steichen, photogravure of Henri Matisse working on *La Serpentine* in 1909, published in *Camera Work*, no. 42/43 (April/July 1913).

an exchange of works), and even Apollinaire had joined in the game of dreaming up public health warnings against Matisse's art that he and other members of 'Picasso's band' scrawled on walls around Montmartre.[25] For some critics Matisse counted among the 'young'; but for others, he was not young enough.

Regardless of factionalism within the Paris art world, Matisse was an international celebrity by the time of his second Bernheim-Jeune exhibition. In addition to private sales to the Steins, the Cone sisters, Shchukin and Morozov, his work could be seen regularly in Germany, Switzerland, Denmark, Austria, the United Kingdom, Russia, Italy and (what was then) Czechoslovakia. In 1911, he had been feted in Moscow during a trip he had made with Shchukin to see his works installed in the Trubetskoy Palace. Reviews and essays for exhibition catalogues kept his name at the forefront of the international art scene. The reception of his works was, however, shaped by journalists, curators and other artists, each of whom had different preoccupations and wrote about Matisse in ways that appealed to their own national traditions and art-historical heritage. The contrasting reception of Matisse's work in Britain and the United States in 1912–13 illustrates the point.

The artist and critic Roger Fry played an important role in introducing Matisse's art to British audiences and identified ways in which his works contributed to a narrative of transnational modern art. The Second Post-Impressionist Exhibition at the Grafton Galleries in London in 1912 included nineteen paintings, eight sculptures and a collection of drawings and prints by Matisse. In addition to showcasing these and works by Picasso, Braque and Cézanne, the exhibition introduced audiences to avant-garde British painters including Eric Gill, Duncan Grant, Wyndham Lewis and Fry himself. The painter Vanessa Bell had been involved in the organization of the show and produced a painting that signalled her own response to the works on display. Taking inspiration from Matisse's *Red Studio*, her painting titled *A Room in the Second Post-Impressionist Exhibition (The Matisse Room)* of 1912 highlighted Matisse's commitment to colour not only by portraying a selection of his works, but by heightening the tonalities of the room itself. Pigments from the paintings on the walls were echoed in the architecture and furnishings to create a shimmering lightbox.

Rather than simply depicting an exhibition space within which paintings were hung, Bell showcased the pictorial logic of *The Red Studio* by allowing the paintings on the wall to structure their environment.

For Roger Fry, Matisse's art contributed to a narrative of modernist painting that culminated in the expressive energy of *The Dance,* the first version of which was exhibited at the exhibition. It had taken Fry a while to understand Matisse. In 1909, after a studio visit, Fry had drawn an analogy between the latter's work and pictures produced by his own seven-year-old daughter. By the time of the 1912 exhibition, however, he committed himself to Matisse's simplified forms, pigments and expressive lines. As Frances Spalding notes in her analysis of the exhibition, Fry worked hard to communicate ideas about the works on show in both his essays and his discussions with visitors. Although many of the works (including those by Picasso) generated as much confusion as they did excitement on the part of audiences, the exhibition was a financial success in terms of its sales and entrance fees.[26]

Key to Fry's discussion of works by both Matisse and Picasso was a contrast between imitation and design. It was, Fry argued, a commonplace that European artists had gradually abandoned the idea of faithfully rendering the world in their works. Instead of imitation, avant-garde artists sought to achieve an 'organic unity' that applied 'the strict laws of design'.[27] In other words, an abandonment of naturalism did not result in compositional anarchy, but rather in the imposition of an unexpected but heightened sense of order. Fry offered an example of Matisse's sculpture to illustrate the point: a series of bronze portrait busts titled *Jeannette* that Matisse had produced of Jeanne Vaderin, the first four of which were created between 1910 and 1911. Fry commented on successive states of the work, noting how Matisse increasingly emphasized form over naturalism, working towards a singular 'plastic unity'. This was key to understanding the so-called

'ugliness' of Matisse's work. While the final state of the bust may have been 'monstrous and repellent', according to Fry, its unified design gave it 'an intensity, a compactness, an inevitability which gives it the same kind of reality as life itself'.[28]

If the exhibitions at the Grafton Galleries challenged audiences, the International Exhibition of Modern Art held at the 69th Regiment Armory in New York in 1913 provoked nothing less than outright hostility, with questions of beauty coming once again to the fore. Arthur B. Davies, president of the Association of American Painters and Sculptors, explained that the ambition of the exhibition was to provide local audiences with an opportunity to see 'new influences' at work in artistic centres beyond the United States: the works would be put on show and 'the intelligent may judge for themselves by themselves'.[29]

Judgements abounded in the weeks that followed the show's opening. As discussed in the previous chapter, Matisse's depiction of the female nude provoked the ire of many critics. Linked to this was the supposedly 'barbarous' nature of the way in which he portrayed the human body more generally. Far from signalling a step forwards, Matisse's 'ugly' and 'coarse' works were said to represent a regression that undermined artistic refinement and

Henri Matisse, *Jeannette I–V*, 1910–16, bronze.

good taste. One potent line of criticism focused specifically on the financial success that many of the artists had enjoyed. The American artist Kenyon Cox singled out Matisse as the 'nasty boy' of modern art: he and his compatriots had 'seized upon the modern engine of publicity' and were 'making insanity pay'. As he pithily put it: 'Matisse has his tongue in his cheek and his eye on his pocket.'[30]

In an interview with Clara Taggart MacChesney that was given in 1912 and published in 1913, Matisse made a statement that anticipated some of the criticisms that would be levelled against him during the Armory Show: 'Oh, do tell the American people that I am a normal man, that I am a devoted husband and father, that I have three fine children, that I go to the theatre, ride horseback, have a comfortable home, a fine garden that I love, flowers, etc., just like any man.'[31] While MacChesney reassuringly described her visit to the artist's studio as an encounter with a 'perfectly normal gentleman', even she could not resist hinting at Matisse's commercial success: 'M. Matisse sells his canvases as fast as he can paint them, but, if the report is true, speculators buy the majority.'[32] While this was not true, the rumour gained credibility when the sale of the works by the Peau de l'Ours consortium took place in March 1914. It was a propitious moment, for Matisse's financial fortunes – like those of many of his contemporaries – were about to take a significant turn for the worse.

The controversies of the Armory Show developed as the exhibition transferred to Chicago and Boston, but a far graver conflict loomed in the later part of the year and culminated in the outbreak of war in 1914. On grounds of age and health, Matisse did not serve in the First World War, and this was a fact that imposed a lasting psychological separation between him and many members of his avant-garde circle. By contrast, Apollinaire, Braque, Camoin, Derain and Jean Puy were among those who enlisted or were drafted into service. Finances were frozen in many quarters.

Shchukin was unable to wire monies from Russia, the European art market was dramatically reduced and Bernheim-Jeune ceased advancing funds.[33]

Added to this was the strain of limited communication with friends and family. The north of France – including Matisse's hometown of Bohain-en-Vermandois – was heavily shelled and household supplies seized by the advancing German army. Matisse had little to no news of his mother or other close relatives. His letters to Camoin, who served for the duration of the conflict, reveal a mixture of anxiety, admiration and guilt at not being able to contribute to the defence of France and its allies. Having recently spent time in Morocco, Matisse was also concerned about the fate of North African troops who had been called up to serve on behalf of their colonial occupier. In addition to providing support to his friends at the front in the form of letters and supplies, Matisse used his art to raise money for those in need at home. Between December 1914 and October 1915, he produced a series of prints *For the Civil Prisoners of Bohain-en-Vermandois* – a group that counted Matisse's brother among its number – and used the proceeds to send food and other supplies to his hometown. Although full details of the purchasers of these works are unknown, it is documented that the celebrated collector and couturier Jacques Doucet invested in a series of the prints.[34]

While Camoin was painting strips of camouflage for the French troops, Matisse was working on one of his own most ambitious works to come out of his trip to Morocco, a large-scale canvas that would ultimately bear the simple title: *The Moroccans* (1915–16). In a letter to Camoin of 22 November 1915, Matisse described the work and provided a small sketch of his ideas. The work would depict a café terrace, men reclining in the afternoon sun and a domed shrine in the distance. The painting that Matisse finally produced was, however, significantly different in structure from his initial sketch. Matisse often described his compositional practice as a

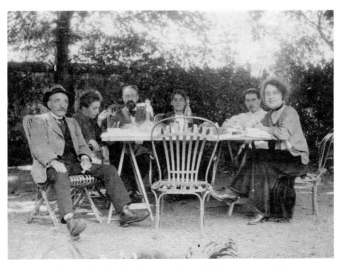

The Matisse family at Issy-les-Moulineaux with Amélie's father, Armand Parayre, c. 1915.

process of stripping visual ideas down to their 'essential lines'. In keeping with this, the final version of *The Moroccans* is devoid of narrative content and comprises four sections containing shapes that echo each other. Green melons in the lower-left part of the painting are reflected by circular tables and turbans on the right. The white dome is brought on to the same pictorial plane as the melons beneath it, just as the seated individual in the upper-right corner occupies the same colouristic space as the men below.

John Elderfield and Stephanie d'Alessandro have studied the technical components of this complex work through X-radiography. They point out the scratching and scraping made to the surface, the multiple revisions that Matisse undertook and the dramatic use of black to define and control the interplay between the different segments.[35] The work was one of Matisse's most daringly composed paintings to date. It marked a change from the grand planes of brilliant colour that had characterized his work of the

previous years and contributed to the emergence of a more austere and abstract style of composition dominated by geometrical patterns. This was a feature of his work that had been expressed most strikingly in 1914 in his *French Window at Collioure* that was comprised solely of blue, grey, green and black rectangles.

This commitment to geometry also impacted significantly on Matisse's portraiture of the period. His *Head, White and Rose* of 1914–15 comprises a series of interlocking triangles and rectangles, each one offsetting the other in complementary colours and generating nested shapes and sub-structures. A daring *Portrait of Yvonne Landsberg* (1914) – ultimately rejected by the sitter's family – expanded the contours of the body with a series of scratched lines that refused to settle into a stable shape. This interest in the ways in which form could be broken down into geometrical components betrayed Matisse's troubled, but long-standing, interest in Cubism. In 1908 Matisse had seen Braque's painting *Houses at L'Estaque* and famously described it as a landscape comprised of little cubes. His comment was not intended to be flattering.

Throughout the following decade, the experiments of Cubist painting seemed far from Matisse's pictorial ambitions. In contrast to the heightened colours of Fauvism, paintings by Picasso and Braque had a dramatically reduced palette. While Cubism broke down the depicted object into distinct elements and presented it from multiple points of view, Matisse remained committed to the integrity of the figure and used architectonic planes of colour to subvert traditional perspective. Matisse's association with decoration also set him apart from his Cubist contemporaries. André Salmon recalled a comment by Picasso when confronted by one of Matisse's canvases: 'And we [Cubists] who took so many pains to ensure that nothing should ever be decorative!'[36]

These contrasts did not, however, mean that Matisse was immune to the experiments of his contemporaries. His *Still-life after Jan Davidz. de Heem's 'La Desserte'* of 1915 is not just a witty

response to an earlier work of art. Rather, its composition of interlocking planes and angled sections are in dialogue with Cubist still-lifes and anticipate some of the experiments undertaken by Juan Gris in the 1920s. As was typical for Matisse, however, a range of stylistic experiments could sit alongside each other, and it is worth drawing out the contrast between the monumental painting on which he worked from 1909 to 1916, *Bathers by a River*, and the *Three Sisters* triptych he produced in 1917.

As with other of Matisse's works, *Bathers by a River* began as a naturalistic sketch depicting a group of women bathing by a waterfall. As the composition evolved, however, the background was stripped away in favour of a series of blue, grey, black and green panels. Four faceless women stand or sit, while the river and waterfall are reduced to a series of curved lines and a band of colour. As Elderfield and d'Alessandro show, the work went through numerous revisions, some of which are demonstrated in photographs of different states of the work, others that are only visible in X-radiographs. They note the sheer effort it would have

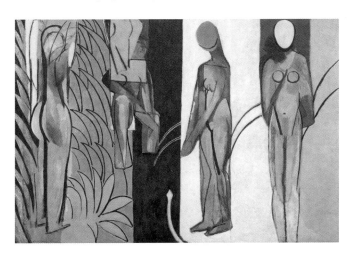

Henri Matisse, *Bathers by a River*, 1909–16, oil on canvas.

taken to reconceptualize and execute the numerous changes to the structure and composition of the work and point to Matisse's 'great desire to challenge himself at the height of the war'.[37] Camoin wrote to Matisse in July 1916, noting that the work (in its then state) had left him 'a little bit stunned'.[38]

In contrast to the challenging symmetries of *The Bathers*, the *Three Sisters* triptych (1917) was more comprehensible with its identifiable domestic setting. The work featured a model whom Matisse had met in 1916, an Italian woman called Laurette. As Spurling notes, this was the first professional model with whom Matisse worked on a regular basis, and he had produced nearly fifty works featuring her by 1917.[39] These paintings marked a transition to a naturalistic style that contrasted with the geometrical abstraction which Matisse had practised in the immediately preceding years. It was a style that would come to dominate Matisse's post-war art production, but it is not one that should be dismissed as retrograde. The *Three Sisters* triptych marked the beginning of Matisse's interest in groups and seriality and showcased his interest in developing graphic rhythms and colour schemes across canvases. The paintings also demonstrated Matisse's increasing interest in theatricality, and Laurette in particular was a model who donned different costumes for the roles she played in his works.

What might have been a straightforward portrayal of women at home becomes, by virtue of the different costumes and the positioning of the figures, a more complicated engagement with the world of three individuals willing to assume different identities. Visual energy accumulates from left to right as the gazes of the protagonists gather force. No clues are given as to the Turkish dress or turbans that appear in two of the works. The viewer may be presented with the world of three fictional sisters, but the turned back of the woman on the left and the chair back in the right-hand panel suggest that the sequence is concerned as much

with excluding the viewer as it is with providing information about the scenes. The American entrepreneur and collector Dr Albert C. Barnes acquired the two outer panels from the Paris dealer Paul Guillaume in 1922 and 1923, and in 1930 Matisse urged Barnes to complete the set by acquiring the central panel from the New York-based gallerist Valentine Dudensing.[40]

Matisse's attraction to decoration and naturalism has been used to place his art in relation to Picasso. Art history has enjoyed pitting Matisse and Picasso alternatively as friends and enemies, thereby fuelling an agonistic narrative of modernist ambition that persists into the present. The myth was popularized by Gertrude Stein who, in her role as patron to both artists, purported to offer audiences privileged insight into the personalities of those who frequented her salon. André Salmon put the point succinctly: 'Whom to follow: Matisse or Picasso? Oh, heroic days!'[41]

In August 1912, Stein had made a foray into critical writing by placing Matisse and Picasso in head-to-head competition. Her two essays were published in *Camera Work*, a quarterly review edited by Alfred Stieglitz. In his editorial to the volume, Stieglitz made clear that the two essays related to Matisse and Picasso, for one of Stein's conceits was to omit the name of each artist from her essays. In her innovative use of language, Stein forged an idiom that asserted her own creative personality. Stieglitz tried to prepare the readers for this unusual critical exercise by drawing an analogy between Stein's language and the art she set out to critique. So close was this analogy, Steiglitz suggested, that readers may find the essays 'no less absurd, unintelligible, radical or revolutionary than the so-called vagaries of the painters whom they seek to interpret'.[42]

While Stein's writing style bordered on the opaque, its ultimate message was clear: Matisse was an artist who struggled, suffered and endlessly complained about the difficulties he had faced over the course of his career:

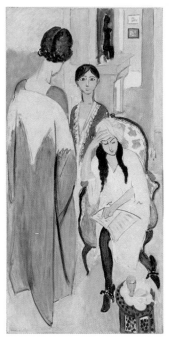 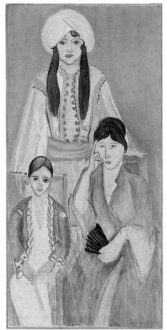

This one was knowing some who were listening to him and he was telling very often about being one suffering and this was not a dreary thing to any one hearing that then, it was not a saddening thing to any one hearing it again and again, to some it was quite an interesting thing hearing it again and again.[43]

Picasso, on the other hand, was portrayed as a relentless worker, an artist dedicated to the production of complex meaning:

This one was working. This one always had been working. This one was always having something that was coming out of this one that was a solid thing, a charming thing, a lovely thing, a perplexing thing, a disconcerting thing, a simple

Henri Matisse, *Three Sisters with an African Sculpture, Three Sisters with a Grey Background, Three Sisters and 'The Rose Marble Table'*, 1917, oil on canvas.

thing, a clear thing, a complicated thing, an interesting thing, a disturbing thing, a repellant [*sic*] thing, a very pretty thing.[44]

As scholars have noted, Stein's essays evidenced her own personal interests and creative self-expression rather than constituting objective art criticism. The public demonstration of her allegiance to Picasso also signalled a growing distance between her and her immediate family members (Leo, Michael and Sarah) who remained faithful to Matisse. She strategically ascribed a greater value to Picasso's work, thereby reinforcing the importance of her own collection that was dominated by Picasso's paintings.[45] The essays were examples of how critical writing could be used to support specific personal and economic ends.

The narrative of competition between Matisse and Picasso was given further impetus in 1918 when Paul Guillaume held an exhibition at his gallery in Paris that featured the two artists. Audiences would now have the chance to make a direct comparison of works by each artist. Apollinaire, recently returned from the Front, wrote the preface to the catalogue and, once again, personal loyalties came into play. Like Stein, Apollinaire chose the form of a diptych that juxtaposed the two artists. In his pithy description of Matisse's work, Apollinaire recapitulated some of the themes that had appeared in his earlier essays and reviews: Matisse was motivated by instinct, his painting was the 'fruit of brilliant light', comparable to the brightness of an orange. Picasso, by contrast, was a lyrical painter, an individual whose talent developed through acts of will and who had enlarged the domain of art 'in wholly unexpected ways'.[46] As in Stein's commentary, Picasso emerges as the dominant creative force of the twentieth century.

The exhibition received considerable coverage in the press, with each artist heralded as the head of a contrasting branch of the avant-garde. Paul Guillaume mounted a major publicity campaign for the exhibition and reprinted highlights of the press coverage in his own journal *Les Arts à Paris* after the exhibition closed.[47] The show was, he claimed, nothing short of a sensation, and newspaper reviews bore out his assertion. *Paris-Midi* and *L'Opinion* declared Matisse and Picasso to be the undisputed leaders of modern art, and even Vauxcelles admitted that neither painter had ever been able to leave his audience indifferent.[48] Illustrating the point that critical writing aims to influence audiences' emotional responses to artworks, the critic for *La Revue* mentioned that any passer-by who wandered into the exhibition unprepared would most certainly be completely dumbfounded.[49] Matisse, however, found the combined publicity and press coverage overwhelming. It left him, he told his friend the poet André Rouveyre, 'filled with disgust'.[50]

Matisse worked hard throughout the First World War, the conflict serving as a spur to focus more intensely on his work. He was shocked when, acting against family wishes, his older son Jean volunteered to join the army as an aviation mechanic in 1917. As is typical for Matisse's correspondence with other artists, news of this family difficulty jostles with discussions of art. A letter to Camoin written during the summer of 1917 mentions Jean's departure and the young man's disillusionment with his situation a mere two weeks later. In a swift transition of topics, Matisse also describes purchasing a car that conveniently doubled as a mobile studio. His painting *The Windshield, On the Road to Villacoublay* (1917) showcased his enthusiasm for this new status symbol.

In December 1917 Matisse travelled to the South of France. He had finished his series of paintings featuring Laurette and was looking for new sources of inspiration. He began working from a room in the Hotel Beau-Rivage that overlooked the sea and decided to make Nice his base. Although he would return periodically to Issy-les-Moulineaux, to his Paris studio on the Quai Saint-Michel and, later, to a family apartment in Montparnasse, it was the light of the South that now held his interest. At a time when Paris was not only the epicentre of an international art market, but a cosmopolitan cultural arena that attracted artists and writers from around the world, Matisse turned his back on the capital and its social networks. His *Self-portrait* painted in a hotel room of the Beau-Rivage in early 1918 is an assertive vision of his new self.

Towards the end of the First World War the Spanish flu pandemic is estimated to have claimed the lives of around 50 million people worldwide.[51] The second wave of the virus's spread from October to December 1918 was the most lethal period, and it was on 9 November 1918 that the war-weakened Apollinaire died of the infection in his apartment on the Boulevard Saint-Germain-des-Prés in Paris. The poet's death marked the end of a critical period for Matisse. Art history rightly associates

Apollinaire with Picasso on the basis of their friendship and close creative exchanges. Yet Apollinaire contributed crucially to the development of Matisse's career by establishing an early critical framework for some of the artist's most challenging paintings and by providing a counterweight to negative critiques that ensued in the wake of the Fauvist enterprise. It was not until 1952 that Matisse would publicly acknowledge his debt to the poet in an artist's book dedicated to his memory.

By 1918 Matisse's relationship to his Russian patrons had also shifted dramatically. In the aftermath of the October Revolution of 1917, the collections of both Shchukin and Morozov were seized by the Russian State and the two collectors fled the country with their families. While Shchukin's mansion was converted into the State Museum of New Western Art, the ensuing cultural politics meant that many of Matisse's works in Russia were not seen again until the 1960s.

Matisse's move to Nice came at the end of a period of radical social and political upheaval throughout Europe. On a personal level, it also marked the culmination of a decade of intense creativity, stylistic change and financial success. Relocation to the South of France offered Matisse fresh stimuli for his art and signalled the emergence of a new set of critical responses to his works.

4

Hedonism

Matisse's relocation to Nice had important personal and professional consequences. It removed him from daily life with his family, his studio in Issy-les-Moulineaux and the network of dealers and critics he had worked so hard to establish in Paris. Yet it also gave him a new social environment to explore and a different range of models with whom to work. In the 1920s Nice was a glamorous, cosmopolitan tourist resort. With its sunny climate, casino and burgeoning film industry, it attracted wealthy visitors, aspiring actors and actresses, and workers looking for a dynamic city in which to earn a living. Although Matisse sometimes admitted the artifice and spectacle that characterized life in his new surroundings, he was entranced by the city's vistas on to the sea and, above all, by its 'tender and mellow light'.[1]

Matisse had left his habitual working environment, but he was by no means isolated in the South of France. His wife and children spent time with him throughout the 1920s and '30s, Pierre Bonnard came to live at the Villa du Bosquet in nearby Le Cannet in 1926, and Matisse maintained contact with friends and colleagues both in person and via an extensive correspondence. One of the first artists he visited in the South was the 76-year-old Impressionist painter Pierre-Auguste Renoir. Renoir had moved to a villa on the outskirts of Nice, Cagnes-sur-Mer, in 1908 and painted there until his death in 1919. At Renoir's home, Les Collettes, Matisse had an opportunity to present his work to an artist who was connected to

one of the major avant-garde art movements of the late nineteenth century.

Matisse's interest in Renoir and his desire for the older artist's feedback attested to an ongoing need for participation in an artistic community. Throughout his life, Matisse exchanged ideas about art with friends, family members and colleagues, and peppered his correspondence with sketches of works in progress, discussions of technical matters and observations about other artists. In the company of Renoir, Matisse debated approaches to painting and took inspiration from Impressionist portrayals of domesticity. The criticisms that he received from his peer were frank, but sincere. Picasso's then lover, the artist Françoise Gilot, recollected Matisse's description of these visits to Renoir. The latter was troubled by Matisse's use of black in his paintings. This was a colour, Renoir explained, that he had banished from his own palette on the grounds that it 'made a hole' in the surface of the canvas. He was prepared to admit, however, that the selective introduction of black into Matisse's works fulfilled an important structural function:

> you speak the language of colour. Yet you put on black and
> you make it stick. So even though I don't like at all what
> you do, and my inclination would be to tell you you're
> a bad painter, I suppose you are a painter, after all.[2]

These comments resonated strongly with Matisse. As he explained in an interview with the Swedish art historian Ragnar Hoppe in 1919, his move to Nice coincided with a search for 'a new synthesis' in painting.[3] He referred to his painting of 1918, *Interior with a Violin*, which contained an interplay of white, Prussian blue and burnt umber against a black internal architecture. Depicted from an unnaturally elevated perspective, the work comprises a succession of motifs that open and close (violin case, curtains, windows, shutters), each of which creates a different visual effect and selective

Detail of photograph of Renoir by Dornac (Paul Cardon), *c.* 1904, reproduced in *Nos contemporains chez eux*.

source of luminosity when offset against the black background. Still reflecting on the compositional importance of black in 1946, Matisse commented that it played 'an important part in color orchestration, comparable to that of the double-bass as a solo instrument'.[4]

Over the course of around sixteen visits to Renoir's home, Matisse did not concern himself solely with questions about the structural qualities of pigment. He also found much of interest in the older artist's portrayals of women and, in particular, the sensual qualities of his female nudes.[5] In homage to his friend, Matisse produced two paintings of the garden at Les Collettes featuring a plaster statue of Renoir's large-scale sculpture *Venus Victrix* (1914–16) rising majestically from the foliage. Although Matisse had experimented with – and abandoned – Impressionist techniques much earlier in his career, he was intrigued by Renoir's depictions of the human figure and of intimate female life.

While Renoir's depictions of female bathers have sparked criticism on the grounds that they eroticize passive subjects, these late paintings also celebrate the fact that Renoir lived among women, was cared for by them and was a participant in their sociability.[6] Instead of interpreting the presence of a voyeuristic gaze in Renoir's depictions of this female environment, these late works may be understood, in part, as an affirmation of private female leisure and physical abandon. Renoir's painting set the tone for much of Matisse's work of the 1920s and, as will become clear, the critical response to it. If Matisse had pursued a rigorous, geometrical compositional style prior to the end of the First World War, his move to the South of France coincided with an interest in the painterly possibilities offered by female life, fashion and 'exoticism'.

Many exhibitions have focused on Matisse's transformation of hotel rooms and apartments into stage sets where he crafted still-lifes and depicted women in a variety of dress styles.[7] The resulting works ranged from quiet interiors to lavish Orientalist scenes that drew on props which Matisse had collected over the previous decades. The poet Louis Aragon described the abundance of curios, textiles, ceramics and furniture in Matisse's studio as a 'palette' – or better still – 'a vocabulary' of objects that the artist took up and transformed, just as a writer might select words to craft a poetic phrase.[8] The importance that Matisse attached to choosing the subjects of his still-lifes was not lost on Picasso. While the latter preferred to incorporate mundane things into his paintings and collages, he noted the extraordinary visual qualities of props that received 'the honour of becoming an object in a painting by Matisse'.[9]

Matisse lived in numerous hotel rooms and apartments during his years in Nice. As restless in his day-to-day life as he was in his art, he worked in the Hôtel Beau Rivage, the Hôtel Méditerranée, the Villa des Alliés, two apartments at the Place Charles-Félix and,

later in his career, the Hôtel Regina and a villa in Vence. Separate studio spaces (ranging from hotel suites to garages) were rented for the execution of large-scale works. In the early years of the decade, however, the confined spaces of hotel rooms offered Matisse the starting point he needed to embark on imaginary journeys and to transform impersonal lodgings into fantastical settings. The recycling of props within these spaces established continuity between works and imposed psychological coherence on them. More importantly, Matisse devised a way of interrogating the possibilities of the real by subjecting a repertoire of tangible things to endless visual variation.

Although Matisse's paintings of the 1920s evidenced new thematic and compositional ideas, they divided critical opinion. Much of this debate revolved around a supposed commitment to beauty in the works. How was it possible, critics asked, for an artist to have worked on large-scale, complex paintings such as *Bathers with a Turtle* or *The Moroccans* and then turn suddenly to naturalistic depictions of women in hotel interiors? The contrast between Matisse's painting prior to the First World War and a work such as *The Venetian Blinds* (1919) confounded audiences. When Matisse exhibited the paintings that he had produced during the first year of his stay in the South, the writer Georges Ribemont-Dessaignes publicly declared that the artist had gone senile. Jean Cocteau took a similar view when he suggested that the intimist works on show at Bernheim-Jeune's gallery proved that the 'wild beast' had turned into a pussycat.[10] Continuing this critical vein, Cocteau introduced the further damning idea that Matisse was simply capitalizing on his reputation by turning out small-scale canvases of 'safe' subjects that suited the tastes of bourgeois collectors. This blatantly commercial strategy was, he argued, nothing short of a 'professional deformation' that betrayed the ideals of the avant-garde. If Matisse had once been criticized for being too 'wild' in his approach to art, he was now too tame.

Henri Matisse, *The Venetian Blinds*, 1919, oil on canvas.

While Matisse's contemporaries struggled with this change in the artist's aesthetic, more recent writers have tried to explain how personal and creative ideals might align in these works. In 1946 the American art critic Clement Greenberg defended Matisse's turn to 'hedonism' in the 1920s and linked the enjoyment of sensory pleasure to material features of the paintings themselves. He argued that the works of this period were characterized by 'luscious color, rich surfaces, decoratively inflected design' that placed the physical on a par with the spiritual.[11] Typically for Greenberg, whose criticism focused on the formal aspects of artworks, the content of Matisse's paintings came second to their qualities as objects.[12]

In 2004 Arthur Danto took a different approach when he proposed that the paintings' visual content (as opposed to just their style or material features) could generate pleasure for both artist *and* viewer.[13] In his account, Matisse's Nice-period works offer more than the sensory pleasure described by Greenberg. Instead, they rehabilitate the role of beauty in European modernism. Whereas Gelett Burgess had asserted in 1910 that the modernist credentials of art by Matisse and his contemporaries lay in their manifestation of 'ugliness', Matisse now challenged audiences to accept that a work could be both avant-garde and beautiful. As Danto concludes, by the 1920s beauty had become internal to the meaning of Matisse's paintings and, by extension, to the way in which they contributed to a history of twentieth-century European creativity.[14]

David Carrier completes this line of thinking by introducing a stronger biographical element.[15] It is known that Matisse and his wife had experienced difficulties in their marriage prior to the artist's departure for Nice. Matisse had had an affair with one of his students, Olga Merson, in 1911. The confrontation between a man and a woman in the large-scale painting that he created for Shchukin around this time, *The Conversation* (1908–12), has often been interpreted as a biographical work that signalled the existence of marital tensions.[16] While ongoing familial problems may or may

not have influenced Matisse's relocation to the South, it is certainly the case that a significant change occurred in the artist's self-depiction after the move. The works painted in the South convey, Carrier argues, the sensual pleasure of a heterosexual man as he paints a beautiful woman. In this account, experience of the erotic power of the model is understood as key to Matisse's art of the 1920s and the means by which ordinary perception is transfigured into aesthetic experience.[17]

If Matisse's transition to an apparently self-indulgent enjoyment of feminine beauty posed problems for critics and historians, his depictions of women in pseudo-Orientalist interiors added an extra layer of difficulty. Extending his interest in textiles and the decorative potential of intricately patterned screens and carpets, Matisse explored the theme of the female nude in highly stylized settings. The paintings have become known as Matisse's *Odalisques*, a term that (in French) denotes courtesans in Turkish harems.

The structure of these works developed experiments with pictorial space that Matisse had conducted over the previous decade. In *Odalisque with Green Sash*, for example, fabrics, carpets and screens combine to create a lavish decorative setting for the woman whose outstretched body occupies the lower half of the canvas. A bold panel of vertical pink and white stripes contrasts with curved table legs that are reminiscent of the studio interiors that Matisse had painted in Paris around eight years earlier. Naked from the hips up and gazing towards an unseen point, the reclining figure can easily appear to be sexually available and positioned so as to attract the kind of visual enjoyment described by Carrier. Yet the woman is only one element in a wider decorative scheme. The real pictorial drama unfolds around her in the dynamic interplay of different coloured stripes, swirls and geometrical patterns.[18]

As late as 1931, Alfred H. Barr Jr was reluctant to endorse Matisse's depictions of women relaxing in these highly decorative interiors, preferring instead the more austere aesthetic that had

Henri Matisse, *Odalisque with Green Sash*, 1926, oil on canvas.

dominated the artist's earlier work. By dismissing the *Odalisques* as portrayals of 'indolent creatures', Barr moralized the pleasures enjoyed by the depicted women and extended this to the artist's own aesthetic.[19] In contrast to the virility of the earlier works, Matisse's Nice-period paintings came to represent a 'feminine' aesthetic that reminded viewers of intimist works by Bonnard and Vuillard.[20] Barr went even further, however, when he sought to excuse Matisse's production of this period. These were paintings that displayed a 'carelessness which sometimes attends complete mastery of a problem', he suggested apologetically.[21] If Matisse was painting 'indolent creatures' in Nice, some of that languor was thought to have permeated the artist's own work ethic.

Exacerbating this problem, Matisse included various North African cultural artefacts in his *Odalisque* paintings. These ranged from veils and culottes to ceramics, *haiti* (Moroccan wall hangings), brass teapots and incense burners. This has led Marilynn Lincoln

Board to argue that the works not only depict passive female subjects, but communicate France's imperialist perspective on its colonies and overseas protectorates in North Africa during the 1920s.[22]

These views position Matisse, at best, as a man who used the erotic stimulation of female subjects to create art and, at worst, as a sexist and colonialist exploiter of those subjects in a European art world that privileged the creativity of men. Is there another way of understanding Matisse's depictions of women and the relationship between the artist and his models during this period? In order to answer that question, it is necessary to probe further Matisse's own conception of these works and to locate them within a broader range of influences.

In an interview with the publisher Efstratios Eleftheriades (Tériade) of 1929, Matisse claimed that he painted *Odalisques* 'in order to do nudes'. But he followed that statement with an important question: 'how does one do the nude without it being artificial?'[23] This statement has important implications for understanding the *Odalisque* paintings. First, they need not be considered as a separate category within Matisse's output, but rather as a logical extension of his earlier interrogation of the female nude in art. Second, and more importantly, Matisse was aware of the artificiality of the scenes he generated in his studio and considered this an integral aspect of the resulting works. Developing this point, Matisse's models can be understood as actors in these scenarios rather than as passive victims of a voyeuristic gaze: the artificiality of 'the nude' is on a par with the theatricality of the *odalisque*. Rather than viewing either Matisse or his models as unwitting participants in an exploitative practice, both artist and model are practitioners who understand – and often disrupt – the conventions that structure relationships within and outside the studio.

While discussions of Matisse's art of the 1920s have opened important debates about gender, power and empire in Western art,

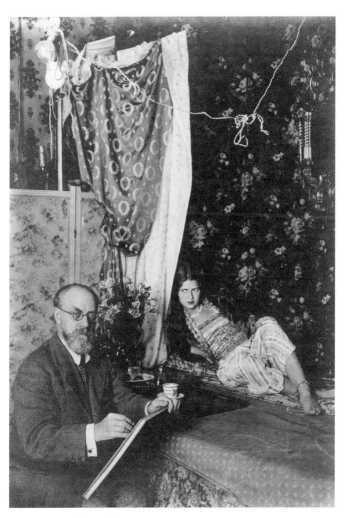

Matisse and one of his models, Zita, Nice, 1928.

little consideration has been given to their portrayal of female agency. By focusing on the pleasures that Matisse may have found in creating these works, historians have underestimated the depicted subjects' enjoyment of fabrics and colours, of their own bodies, of relaxation and – in some cases – of each other's company. Far from effacing female subjectivity, Matisse's decorative interiors can be understood as a vital part of their *protagonists'* world of sensory pleasure. There is a critically underestimated set of influences from popular culture that impacted on this aspect of Matisse's creativity: female fashion and film.

When Matisse moved to the South of France, the French film industry was flourishing. The Irish-American director and producer Rex Ingram moved to Nice from Hollywood and opened what would become the most important film studio in France – La Victorine. Constructed in 1921, the operation had been conceived as a rival to California's film production, but was struggling financially by 1935.[24] In the 1920s, however, the Victorine studios were full of promise in an environment that could rival the western coast of the United States for its sunny climate and open spaces.

Matisse knew Ingram and often spent time on set, sketching film shoots and scouting for models among the extras. Matisse was as fascinated by the composition of the sets as he was by technologies of the moving image. Film appealed to his interest in seriality, and, later in his career, he would speak of his drive to repeat subjects as the 'cinematography' of his imagination.[25] In addition to this interest in the industrial and creative aspects of the film industry, Matisse was also keenly aware of the movies that were being produced and screened throughout the 1920s, including those imported from Hollywood. Orientalist romances were popular in silent films of the period, and audiences were thrilled by the charisma of Rudolph Valentino in Paramount's *The Sheik* (1921) and *The Son of the Sheik* (1926), by Pola Negri's performance in Ernst Lubitsch's *Sumurun* (1920), and by the

overlap of Orientalist fashion and science fiction in Stacia
Napierkowska's performance as the heroine in *The Mistress of
Atlantis* (1921). Many of these escapist fantasies were aimed at
women both in terms of their romantic plots and the leading roles
they gave to glamorous female stars.

In her analysis of the strategies that Orientalist films and fan
magazines employed to appeal to female viewers of the 1920s,
Gaylyn Studlar argues that women's fascination with the 'Orient'
was part of a search for 'intensified experience' expressed in a
combination of physical and sexual freedom.[26] In the wake of
the First World War, many French women looked to a fantastical
conception of the 'Orient' and to the possibilities of solitary travel
to the nation's North African colonies as a means of satisfying a
desire for independent self-expression. Describing the itinerary of
a journey to Morocco in 1920 by train and car, one journalist for
French *Vogue* wrote that: 'After the sorrows of these past years, it
seems that an immense need to travel, to forget a little the places of
suffering, draws us to countries of light, of dreams in order to allow
us to rest our weary nerves.'[27]

Matisse's art of the 1920s needs to be read against this
background of female fantasy and self-realization. Without
diminishing the art-historical reference points of Matisse's
Odalisques – namely, paintings by Jean-Auguste-Dominique Ingres
and Eugène Delacroix – the ways in which these works drew upon
popular film and magazine culture aimed at women offers an
important perspective on the depiction of their female subjects.
Examining the overlap between these works and the appeal of
popular cinematic culture to women's own fantasies, it becomes
clear that Matisse's Orientalist scenarios interrogated and appealed
to a conception of women's interests as mediated by popular
culture of the period. Whereas Renoir's late works depicted women
in idyllic closed settings, Matisse's portrayal of female life was
embedded in a dynamic interplay between classical tradition and

popular culture, at the heart of which lay new demands by women for independent experience.

This aspect of Matisse's work also extended to an interest in female fashion. Building on his interest in textiles, Matisse repeatedly turned his attention to the visual possibilities offered by haute couture dresses and hats. *The White Plumes*, painted at the Hôtel Méditerranée in 1919, featured a model with whom Matisse worked from that year to 1921, Antoinette Arnoud. The extravagant hat that she wears in the painting recalls *Woman with a Hat* of 1905, but the dynamic brushwork of the former gives way to flat planes of colour. The painting went through an extensive preparatory phase, including drawings that depicted more of the model's body as she sits in an armchair. These sketches show how Matisse worked through the detail of the ribbons and feathers of the hat, exploring different graphic marks to investigate density and texture.

In the final painting, much detail is removed, and the boundaries between flesh and fabric, hair and ribbons become porous. Far from a portrait or even a naturalistic depiction of a woman in an everyday setting, the work takes the hat itself as its subject-matter, offsetting it against a background of vivid crimson. As Matisse noted in his interview with Ragnar Hoppe: 'The feather is put there as an ornament, decorative, but it also has a physical presence; you sort of feel its lightness. The soft, airy down, which moves like a breath of air.'[28] In support of Greenberg's analysis of the early Nice-period paintings, Matisse reworked the surface of the work in such a way as to trigger a physical response from the viewer. Yet the expression of the sitter is unsettling. Her constrained posture, distracted gaze and glum expression undercut the idea that this is a woman who enjoys dressing up in order to be seen by others.

Matisse did, however, experiment with other ways in which women engaged with contemporary fashion. He collected samples of fabrics throughout his career and, by the 1930s, had gathered an extensive range of clothes that he stored in studio cupboards

Henri Matisse, *The White Plumes*, 1919, oil on canvas.

like an array of props to be used in different settings.[29] It would be easy to collapse Matisse's interest in fashion into the rhetoric of objectification that has been imposed on his *Odalisque* images. While Matisse was capable of imposing a troubling inflection on the connection between looking and female beauty as suggested by *The White Plumes*, it is also the case that he explored the possibility of women using fashion as a means of constructing identity and communicating their own agency. As Sharon Marcus has argued in her examination of Victorian literature, nineteenth-century dolls and fashion plates have typically been interpreted as 'mere tools for teaching women to become objects for men'. Such an approach overlooks, she argues, the extent to which such artefacts and images can create bonds between women and appeal to their own pleasure in projecting an image of the self.[30] Matisse's portrayals of fashionably dressed women relaxing in shared spaces or watching life on the busy streets of Nice also attest to such female bonding. That many of Matisse's paintings of women during the Nice period appealed to just such an active sensibility and sense of shared interest between women is illustrated by the acquisition of *Odalisque with Magnolia* (1924) by the Hollywood actress Miriam Hopkins in the 1930s. She had planned, it is said, to devote an entire room to the painting in her Hollywood mansion.[31]

Another manifestation of female agency can be found in Matisse's portrayals of female creativity. Matisse worked with women throughout his career and was familiar with their work as artists (Henriette Darricarrère, Jacqueline Marval, Olga Merson); as writers (Dorothy Bussy, Colette, Elsa Triolet); as collectors (Gertrude and Sarah Stein, the Cone sisters); as gallerists and bookshop owners (Berthe Weill, Marie Harriman, Sylvia Beach, Adrienne Monnier); and as production managers in the Parisian printmaking business (Marthe Fequet, Angèle Lamotte). That Matisse should produce paintings that depict women actively engaged in the production of art is not, therefore, surprising.

Two works of 1924 feature Henriette Darricarrère painting at an easel: *The Morning Session* and *The Three O'Clock Sitting*. Reversing the typical roles of model and artist, these works give precedence to the gaze of the female artist. While the subject of Darricarrère's canvas is hidden in the first work, the second shows her painting a female nude. Alternatively, she may be painting Matisse as he depicts both her and the model. Matisse's own engagement with the naked subject parallels that of the female artist, and the work calls into question the conventional power structures described above. In this case, a woman gazes upon both the artist and the body of another woman in the exercise of her own creativity.[32]

Matisse's own gaze on the female nude is expressed through another work placed conspicuously in the composition. Matisse's small sculpture *Reclining Nude 1 (Aurora)* from 1907 is visible above the wardrobe in the background, directly above Darricarrère's easel. In Chapter Two, I mentioned that the sculpture recalls the shape of the statue in Watteau's *Fêtes vénitiennes*. In *The Three O'Clock Sitting*, the parallel with Watteau's painting is even more obvious. Restaged in the interior of Matisse's hotel room, the dance between the male and female protagonists in Watteau's painting becomes a drama of looking between male and female artists positioned opposite each other. Echoing the placement of the sculpture in Watteau's painting, Matisse's *Reclining Nude* presides over a scene of creative exchange. Yet the figurine plays a different role in Matisse's painting. Instead of signalling the possibility of amorous adventure, the sculpture reinforces the gaze of the women *in* the work, both of whom look towards the unpictured artist. The result is that women inhabit each stage of creative production: as artist, model and artwork. By comprehending himself as the object of a female artist's gaze, Matisse wittily undermines gendered hierarchies of looking that have been associated with his works.

If Matisse enjoyed turning his studio into a stage set for his paintings, he had a more direct opportunity to develop this

Henri Matisse, *The Three O'Clock Sitting*, 1924, oil on canvas.

theatrical approach to art production in a commission he received in 1919. The invitation was from Igor Stravinsky and Sergei Diaghilev and it concerned the design of costumes and sets for a symphonic poem to be staged by the Ballets Russes, *The Song of the Nightingale*. The commission enabled Matisse to put his ideas about colour and movement into practice by working with dancers' bodies. It also allowed him to experiment further with textile design. The plot of the ballet, adapted from a fairy tale by Hans Christian Andersen, was set in the court of a Chinese emperor and pitted the song of a real nightingale against that of a mechanical bird. Matisse's sets for the ballet were simple and luminous based on a palette of white, gold and yellow.

If some critics had questioned the development of Matisse's aesthetic in his painting of the 1920s, the response to his theatrical debut was positive. In an article on the front page of the major arts newspaper *Comœdia*, Louis Laloy noted the 'refined simplicity' and 'brilliant harmony' of Matisse's designs.[33] The commission also ushered in a new working style for Matisse as he turned to cut-outs for the purpose of thinking through the visual impact of costumes and decor. Rather than simply sketching his designs, Matisse used scissors to cut out shapes that he then placed, rearranged and pinned to test the look of different patterns. Over the course of the following decades, this would become one of the most important ways in which he thought about composition, culminating in his use of cut-outs as an independent medium in the 1940s and '50s.

Although Matisse had removed himself from the Paris art world, he was by no means isolated in the South of France. His contract with Bernheim-Jeune afforded him an annual exhibition, his works continued to be shown at the Salon d'Automne and at other private galleries in the capital, and numerous invitations came from abroad. In addition to featuring in exhibitions in Oslo, Barcelona, Venice, Copenhagen, Kurashiki, Philadelphia and New York, Matisse continued to build a reputation in London. Organized

by the aristocratic brothers Osbert and Sacheverell Sitwell, 'The Exhibition of French Art 1914–1919' at the Mansard Gallery in Heal's furniture store on Tottenham Court Road in 1919 was an important successor to Roger Fry's 'Second Post-Impressionist Exhibition' of 1912. It featured works by contemporary modernists including Matisse, Picasso, Derain, Modigliani, Valadon and Vlaminck, and the catalogue was written by the novelist and playwright Arnold Bennett. The British artist Paul Nash reviewed the exhibition, noting the 'profound and simple beauty' of the works in 'one of the most interesting exhibitions of pictures seen in London for many years'.[34] Nash stressed, however, the danger of inviting novelists and poets to write about art on the grounds that they tended 'to utter curiously irrelevant remarks'. There were, he admitted, 'poets and poets, but the latter are quite rare'.[35]

One of those rare poets was the Surrealist writer Pierre Reverdy. In 1918 Matisse collaborated with Reverdy on the publication of a small volume of verse titled *The Camouflaged Jockeys* in which four poems were paired with five drawings by Matisse. The drawings were not created in response to the poems, but were selected from Matisse's existing repertoire. Matisse's decision to ally his name with that of Reverdy in 1918 was a bold statement. The coupling of Reverdy's daring poetry with a set of naturalistic drawings by Matisse seemed to some critics an incongruous combination. Matisse showcased four studies of the female nude and a view from a window made during one of his trips to Morocco in 1912. Matisse did not supervise the physical production of the book, yet it was an exercise that introduced him to the idea of working creatively with a poet and that also encouraged him to disseminate his ideas through literary networks.

Increasingly, writers within and beyond Matisse's immediate circle responded to his work in their own idiom, often using his painting as a stimulus to create new kinds of poetry and fiction. In 1921 the U.S. poet William Carlos Williams published a prose poem

about *Blue Nude* (1907) when the painting was on show at a New York gallery run by the Mexican artist and dealer Marius de Zayas. In his memoirs, de Zayas recalled the antagonism that Matisse's works had sparked at the Armory Show of 1913. The artist had been declared 'the source of evil' who had pitted 'the contagious bacilli of modernism' against 'the sacred canons of academism'.[36] While *Blue Nude* had fuelled this confrontation, an altogether different atmosphere reigned in Williams's lyrical poem written when the work was exhibited eight years after the Armory Show. The opening line makes clear that this canvas portrays a foreign subject: 'On the french grass, in that room on Fifth Ave., lay that woman who had never seen my own poor land.'[37] Williams stresses the simplicity of the depicted scene and of the vision that had underpinned its production. This is no Aphrodite or Diana, but an ordinary woman resting in the sunshine and allowing herself to be painted by the artist. Devoid of history, symbolism and mythology, the work represents nothing more that the experience of the painter in front of the woman: 'Bare as was his mind of interest in anything save the fullness of his knowledge, into which her simple body entered as into the eye of the sun himself, so he painted her. So she came to America.'[38] Throughout the poem, motifs of light and sun are associated with the gaze of the artist and the production of the painting. As the woman in the painting becomes the painting itself, Williams celebrates the unique visual experience prompted by the work. In contrast to this, he asserts: 'No woman in my country is naked except at night.'[39] It was a reminder that in the early 1920s, Europe was still viewed as the engine room of the avant-garde.

Williams's poem suggests the existence of conflicting tastes in Europe and the United States, but this was ultimately not borne out by the social biography of *Blue Nude* itself. After its exhibition in de Zayas's gallery, the painting was bought by the wealthy New York lawyer and collector John Quinn. Following the sale of his estate at auctions in the mid-1920s, the work was then acquired

by two of Matisse's most important collectors mentioned in the previous chapter, Claribel and Etta Cone. As determined by the bequest of the Cone sisters, the painting finally made its way into the permanent collection of the Baltimore Museum of Art, where it remains on display. 'So she came to America,' wrote Williams of the 'french girl' in *Blue Nude*. And so she stayed in that country by virtue of dramatic changes in the taste of American collectors who rose to prominence during the 1920s.

Throughout his career, Matisse sought to be understood by his audiences and this led him to communicate his ideas in essays, interviews and, ultimately, film. In 1920 his interest in the publishing industry led him to produce a small volume that would showcase the development of his drawing. Published by Bernheim-Jeune, but financed by the artist himself, *Fifty Drawings by Henri-Matisse* featured an introduction by the critic and playwright Charles Vildrac. This essay explained how Matisse's naturalism combined with broader tendencies to abstraction that had characterized avant-garde art since the first decade of the century. In the 'epoch of research and reconstruction' of the 1920s, Matisse's drawing was capable of penetrating the personality and 'moral character' of his subjects.[40] Developing lessons learned from Leonardo da Vinci, Matisse is said to have stripped away extraneous details in order to arrive at the 'truth' about his model and about the best means by which to convey the expression of that model.

Vildrac's short essay captured ideas about Matisse's attitude to drawing and his relationship to the model that would be reiterated by the artist in later interviews and essays. Matisse was keen to emphasize his reliance on perceptual experience, claiming in 1939 that his models were 'never just "extras" in an interior' and that he determined the model's pose on the basis of what 'best suits *her nature*'.[41] In keeping with Matisse's interest in mediating ideas about his creative practice, *Fifty Drawings by Henri-Matisse*

can be understood as a graphic essay that demonstrated the importance of drawing to the artist's thought processes. It also came at an important time in Matisse's career. While the Dada poet Tristan Tzara had criticized the drawings that Matisse paired with Reverdy's poems in 1918 as being too conventional, British audiences found the lack of finish in Matisse's drawings to be evidence of incompetence.[42] Roger Fry came to the artist's defence in an essay of 1918 published in the *Burlington Magazine* in which he described Matisse's drawing as being 'so hypersensitive, so discreet, so contrary to all bravura or display' that audiences misunderstood its simplicity.[43] He captured a theme that would gather force in critical literature about Matisse in the 1930s, namely the artist's ability to reduce compositions to their 'essential forms'.

The 1920s witnessed a dramatic extension in the critical literature about Matisse. In 1920, Marcel Sembat wrote a monograph about the artist for a series titled *The New French Painters* published by the poet and critic Roger Allard. This was followed in 1925 by the publication of another book about Matisse's drawing with a preface by Waldemar George.[44] In his introduction to the volume, George gave audiences an overview of the development of Matisse's drawing, explaining the artist's return to naturalism in the 1920s and locating this as an evolution of his graphic thinking rather than a backwards step. One of the most important points made by George is an aside about the drawings of Matisse's 'mature' period. He suggests that the artist's works have a 'plastic weight' to them.[45] This observation is key to understanding Matisse's study of the human figure during the 1920s.

I mentioned in Chapter Two that as Fauvism developed, Matisse considered ways in which colour could be considered as a quasi-sculptural material to be metaphorically 'moulded' on a two-dimensional surface. George's point about the plasticity of drawing captured an idea that Matisse pursued in his painting of the 1920s, namely the relationship between sculptural form and flat surfaces.

Henri Matisse, *Large Seated Nude*, bronze, original model 1922–9, this cast 1930.

The way in which this experiment developed can be seen in the pairing of two important works, the sculpture *Large Seated Nude* (1922–9) and the painting *Decorative Figure Against an Ornamental Background* (1925–6).

Henriette Darricarrère, who had modelled for the *Odalisque* paintings, also posed for *Large Seated Nude*. Typically for Matisse, this sculpture finds counterparts in numerous drawings and lithographs from the period, including *Nude with a Blue Cushion Beside a Fireplace* (1925). In contrast to the rounded contours of the woman's body in the work on paper, the sculpted form is athletic, the unnaturally broad ribcage balancing interlocking legs and keeping the body finely poised. In the absence of background context (armchair, furniture covering and fireplace), the sculpture is an intricate study of weight and balance, the diagonal axis from the top of the head to the left foot creating a moment of suspension.

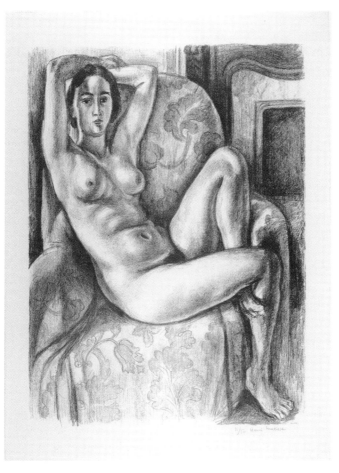

Henri Matisse, *Nude with a Blue Cushion Beside a Fireplace*, crayon transfer lithograph, 1925.

The contrast between the physique of the model in these different media is characteristic of Matisse's experimentation with form and gender during this period. John Elderfield points out compositional similarities between Matisse's works featuring female models and similarly posed classical sculptures of male subjects (for example, Matisse's *Nude with a White Scarf* of 1909 and the *Barberini Faun*, original created in the second century BC). He notes that critics have described differences between the musculature of the bodies as Matisse's 'feminization' of the male physique, but suggests that this approach underestimates the broader nature of the artist's engagement with the theme of gender. The better view, he argues, is to admit that Matisse's works tolerate 'alternative readings' which pull the viewer's attention in different directions and, most importantly, challenge binary conceptions of 'male' and 'female'.[46]

Elderfield convincingly shows how Matisse responded to artistic precedent while refusing to be constrained by it. Taking this argument further, the transgression of gender boundaries may also be viewed as crucial to a blurring of distinctions between media, in this case painting and sculpture. *Decorative Figure on an Ornamental Background* shows, once again, the speed with which Matisse worked through new compositional challenges. In contrast to the images of fashionable women and *Odalisques* of the immediately preceding years, this female nude was reminiscent of the more abstract figures that had featured in Matisse's painting prior to the end of the First World War. The rigidly straight lines of the woman's neck and back are echoed in the geometries of the background mirror and striped carpet. Yet they contrast with the curved pattern of the wallpaper and the rounded forms of the oranges in the foreground. Even more striking is the monumentality of the woman, the solidity of her foreshortened left leg and the carved abdominal muscles. Her sculptural presence contrasts with the flatness of the background, most noticeably the

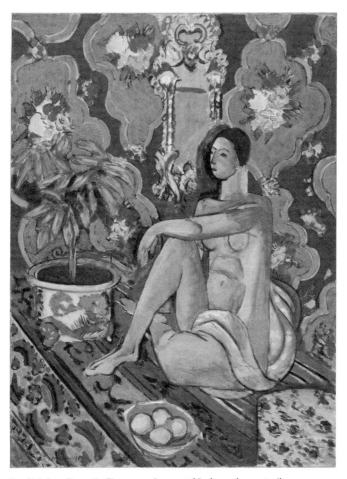

Henri Matisse, *Decorative Figure on an Ornamental Background*, 1925–6, oil on canvas.

carpet that seems to slide across the painting from left to right, and the architecture of the wall that wraps itself around the figure without perspectival differentiation. Sculptural monumentality is fused with the decorative surface of a two-dimensional canvas, marking the culmination of Matisse's pictorial experimentation of the 1920s.

In 1929, Matisse turned fifty and stopped easel painting. He would not return to the medium until 1934. Over a period of thirty years he had experimented with an array of styles and had evolved his own unique engagement with colour in and beyond Fauvism. He had produced works on monumental and small scales, absorbing and transforming motifs from the histories of European, African and Islamic art as well as themes from contemporary popular culture. He had successfully pursued experiments in a range of media, including drawing, printmaking, sculpture and stage design. Moreover, his works were exhibited regularly around the world, a critical framework had developed in response to his creativity and the market for his art was flourishing. By 1929, however, he was once again in search of new inspiration, claiming that he needed to find 'another space' in which to develop his dreams.[47] That other space was Tahiti, and Matisse set sail from Le Havre to Papeete via the United States aboard the *Île de France* on 27 February 1930.

5

Another Space

In 1927 Matisse was awarded first prize at the Carnegie International Exhibition in Pittsburgh. The painting in question, *Bouquet and Compotier*, was one of a series of small-scale paintings from 1925 that involved a repeated engagement with studio props: fruits, flowers, ceramics, mirrors and books. The works shared a palette of luminous pinks, yellows and blues and signalled Matisse's engagement with the achievements of earlier artists. The depiction of books on tables – their titles just legible – echoed the composition of paintings that Vincent van Gogh had made towards the end of the nineteenth century. Unusual perspectives on bowls of fruit, wine pitchers and coffee pots developed experiments with pictorial space that Paul Cézanne had pursued throughout his career. Indeed, a portrait sketch visible in the background of *Bouquet and Compotier* suggests the facial features of Cézanne and transforms the work into a homage to the older artist. While Matisse was fond of incorporating images of his own works into paintings, this detail recalled the composition of Camille Pissarro's *Portrait of Paul Cézanne* (1874) and Édouard Manet's *Portrait of Émile Zola* (1868), both of which featured symbols of artistic affiliation. As ever, Matisse was keen to place his creativity in the context of longer pictorial traditions and to use the works of others as a counterpoint to his own originality.

Matisse's prize-winning still-life seemed conservative in contrast to his earlier, more radical experiments with form, colour

and composition, prompting some American commentators to assert that the artist had turned his back on modernism.[1] Yet the painting communicated an important aspect of Matisse's recent practice: his Nice studio was not simply a place of fantasy or hedonistic pleasure, but one of contemplation. The contents of this and other still-lifes of the period, combined with Matisse's willingness to engage repeatedly with the same subject-matter, suggested that in this particular environment the artist could navigate a history of art while pursuing his own creative trajectory. The works also demonstrated Matisse's increasing interest in seriality and his impetus to study a range of subjects from diverse angles and in different colour schemes. This approach would become a mainstay of his practice in the following decade.

Although Amélie had accompanied her husband on many earlier trips – and, indeed, intended to participate in his latest round of travels – Matisse ultimately made his journey to the U.S. and Tahiti alone. Since Matisse had set up his primary studio in the South, husband and wife had spent time together in the family home in Issy-les-Moulineaux, in their Paris apartments on the Quai Saint-Michel and the Boulevard du Montparnasse and, on occasion, in Nice. Relations had, however, become strained. Amélie suffered periods of illness and depression that became increasingly severe during the late 1920s. The role she had played in her husband's career had diminished significantly since the early years of their relationship, when she contributed to the family's finances, served as a model and cared for the couple's three children. As Matisse became more successful, and his career more peripatetic, Amélie became more marginal to her husband's working life.

Tensions between husband and wife were exacerbated by other familial issues. The couple's eldest son, Jean, had decided to become an artist. Over the years, he had helped his father with business matters, often arranging loans for exhibitions, dealing with financial arrangements and supervising the production

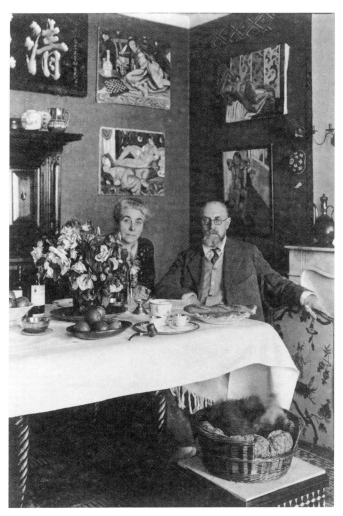

Henri and Amélie Matisse in their apartment, Place Charles-Félix, Nice.

of sculptures. Jean's decision to launch his own career as an artist encouraged Matisse to offer a wealth of educational and professional advice that was often unwelcome to a young man in search of his own creative and personal independence.

By contrast, Pierre and Marguerite remained more directly attached to the advancement of their father's career. In 1924 Pierre went to the U.S. with the intention of establishing himself as an art dealer. Having gained experience at the Galerie Barbazanges in Paris in the early 1920s and later with the Dudensing Gallery in New York, he launched the Pierre Matisse Gallery from offices in the Fuller Building at 41 East 57th Street in November 1931. Over the following years, Pierre would be instrumental in extending his father's reputation in the U.S., organizing exhibitions, advising curators and collectors, and facilitating acquisitions. As in the case of his elder son, however, Matisse also sought to exert a guiding hand in Pierre's business affairs, often giving strong advice as to exhibitions, pricing and invoicing strategies.

While Pierre and Jean contributed to the business of their father's art in many ways, Marguerite played a more direct role as a studio assistant throughout her adolescence and early adulthood. As she grew older, she became more involved in the business of Matisse's art practice, leading negotiations with collectors such as the Cone sisters, arranging contracts and dealing with printmakers and typesetters. Marguerite's marriage to the writer and art historian Georges Duthuit in 1923 marked a new chapter in both her life and her relationship to her father and his art. Duthuit had made a name for himself in academic circles with the publication of a work on Byzantine art, but his marriage to Marguerite opened a door to intimate knowledge about one of France's most well-known and admired contemporary artists. Duthuit was aware of the professional advantages to which this could lead. In the late 1920s, he gave public talks about his father-in-law's works at exhibitions mounted by Paul Guillaume and Bernheim-Jeune, wrote articles

and catalogue essays and, in 1949, published what would become an influential book-length study of Fauvism.[2]

Matisse put his professional persona to good use in furthering the careers of his children. Whether helping his son-in-law to obtain a job at the Louvre, lending paintings for exhibitions mounted by Pierre or simply providing allowances, Matisse gave his family a measure of financial stability that he had found lacking in the early stages of his own career. He also gave works (particularly signed artist's books) to his children and grandchildren knowing that these would become long-term sources of investment. Such acts of generosity offered the recipients a vital source of support, but they also encouraged Matisse in the belief that he had the right to influence the life choices of his children. Françoise Gilot summed up matters when she stated: 'He was a man from the north and a man of his generation. He probably felt it was his duty to act the way he did.'[3] Correspondence between family members confirms Matisse's self-image as the head of the household and, at times, a key arbiter of his children's decisions. This did not mean that his advice was always followed. Indeed, tensions typically ran high when his suggestions were unwelcome or patently ignored.

When Matisse set sail for the u.s. in February 1930, he left behind a bedridden wife, a dispersed family and a troubling sense of his own inability to pursue new ideas in easel painting. Travel was, as it had been in the past, a means by which he could put difficulties behind him and look for new sources of inspiration. His trip to the u.s. included stays in New York, Chicago, Los Angeles and San Francisco. On arrival in Manhattan, he was impressed by the 'sensation of space' generated by the towering skyscrapers with their 'great brilliant aluminum moldings'. This was a city, he later said, in which one could 'think comfortably'.[4] He felt so comfortable that he nearly abandoned his plan to travel to Tahiti, but eventually decided to complete the journey as arranged. From the perspective of the European art world, a Tahitian voyage

Matisse in Manhattan, *c.* 1930.

recalled Paul Gauguin's late works. Having lived and painted in
Tahiti throughout the 1890s, Gauguin settled in Atuona on Hiva-Oa
in the Marquesas Islands in 1901 and spent the rest of his life
there. His semi-fictional book about his painting and experiences
in Tahiti, *Noa Noa*, was published (in collaboration with the poet
Charles Morice) in 1901, but the intimate journals written during
the last year of his life, *Before and After*, only appeared in 1923.[5] Ideas
about Gauguin and the inspiration he had found in Tahiti were,
therefore, fresh in the public imagination at the time of Matisse's
own Polynesian journey.

Matisse was keen, however, to distinguish his trip from that of
his forbear. There were plenty of painters in Tahiti, he remarked,
who sought to imitate Gauguin and who painted 'the beauties
of the island with a heavy hand'.[6] He nevertheless sought out
Gauguin's son, Emile Marae a Tai, noting later that the young
man spoke no French, but was a 'superb man in his thirties with
powerful arms'.[7] While Matisse had spent much of the 1920s

painting the female nude, he now had a chance to contemplate male beauty more closely. During his explorations of the island in the company of a local couple, Pauline and Étienne Schyle, Matisse met the German film director Friedrich Wilhelm Murnau, who was working on his latest project, *Tabu*. In many respects, the film pursued a conventional story about a forbidden relationship between a young man and woman, but its panoramas of local life and, in particular, its celebration of male beauty created a viewing experience that differed from sexualized depictions of local women and colonial appropriations of Polynesian culture. Just as he had explored the sets of the Victorine film studios in Nice, Matisse now had a chance to observe how the illusionistic devices of cinema were constructed and executed on location. He sketched some of the scenes and stored up his impressions of the local landscape.

Although the trip to Tahiti opened a new range of visual experiences, Matisse produced little work there. Instead, he allowed the scenery to imprint itself on his imagination: 'With my eyes wide open I absorbed everything as a sponge absorbs liquid.'[8] These impressions did eventually find their way into Matisse's creative output. As John Klein has noted, Matisse's interest in decoration found a corollary in the patterns of locally produced textiles, and many features of the landscape would later appear in the artist's cut-outs and drawings.[9] In the early 1930s, however, there were two important works that drew upon the experiences of these Polynesian travels. They contrasted in scale and scope and were both private commissions.

The first took the form of Matisse's first substantial bookwork, his illustrations for poetry by Stéphane Mallarmé. While Matisse had produced some illustrations and book covers in the past, this commission from the Swiss publisher Albert Skira marked a new departure. Ambroise Vollard had popularized the 'artist's book' (*livre d'artiste*) in the early twentieth century when he encouraged leading artists and poets to collaborate on the creation

of innovative luxury editions. Capitalizing on the burgeoning market for prints and showcasing the work of contemporary artists, Vollard used the genre of the book to broaden the market for contemporary art and to create new artistic partnerships. Books were cheaper to buy than paintings and they appealed to bibliophile audiences as well as to art collectors. They were also produced in editions (often around 250 copies) and so could satisfy a demand that was healthy, but limited enough to suggest exclusivity.

Matisse turned to the medium of etching for his illustrations of Mallarmé's poetry. He had begun etching early in his career, his first works in the medium taking the form of a series of self-portraits produced between 1900 and 1903. By the 1930s, etching and lithography were closely connected to Matisse's drawing practice and captured some of the core ideas that informed the artist's approach to drawing. As Céline Chicha-Castex notes in her study of the technical features of these prints, Matisse typically drew into specially prepared varnished plates instead of cutting directly into a copper plate. This gave him greater control over the quality and thickness of the lines produced. When the drawing was complete, the plate was dipped in an acid bath, and the exposed copper was eroded. The remaining varnish could then be removed, the plate could be inked and a print pulled.[10] In the case of the Mallarmé volume, Matisse made his drawn lines as thin as possible, allowing images to range freely over the pages and maintaining expanses of white page around the texts. He passed on precise instructions to the Paris-based printmaker Roger Lacourière, as regards the position and final appearance of the images.

While Matisse singled out key motifs from Mallarmé's poetry, he did not illustrate the texts in a conventional way. As was the case with his approach to painting, he emphasized the subjectivity of his enterprise and his independence from the accompanying text:

'The book does not need to be completed by imitative illustration. Painter and writer must work together, without confusion, in parallel.'[11] While this can be understood as a comment on the style of the images that Matisse produced for his books, it also relates to their content. In the case of the Mallarmé volume, Matisse's Tahitian journey found expression in images that reference sea travel, the bay of Papeete and the lush foliage of the local landscape. None of these motifs had a direct connection to the themes of the accompanying poems, but they did resonate with Mallarmé's quest for an ideal realm of poetic expression. If Matisse had not found the 'other space' for which he longed during his trip to Tahiti, he nevertheless explored the aesthetic possibilities of such a space within graphic works that recollected the journey.

Adelyn D. Breeskin, curator (and later director) of the Baltimore Museum of Art, published one of the first reviews in English of the book in 1935. Just as Roger Fry had tried to explain the simplicity of Matisse's drawing nearly thirty years earlier, so too Breeskin felt the need to justify the 'ease and spontaneity' that seemed to characterize Matisse's graphic production.[12] Her description was carefully planned around the development of a key image in the Mallarmé book – the depiction of a swan. The article opened with a photograph of Matisse drawing from nature in the Jardin des Plantes in Paris, offering readers proof that the book's imagery had a basis in the world of tangible things. The essay then examined some naturalistic preliminary drawings and culminated with a reproduction of the pared-down, more abstract lines of the final image. This was, Breeskin argued, an artistic practice anchored in the real, even though it gave rise to forms that seemed to verge on the abstract. The elimination of 'non-essential' visual information fuelled this potent style of expression: 'the quality of the few final lines is such that it expresses all of the relations of volumes and masses of the more detailed drawings and has the added quality of summary strength.'[13] Breeskin's point was a good one and, indeed,

suggested a view of drawing – and, by extension, printmaking – as a uniquely concentrated form of expression. This was an idea that Matisse himself endorsed throughout his career.

In addition to a copy of the finished book, a suite of preliminary drawings, refused etchings (abandoned designs) and etching plates (the 'maquette') were acquired by Etta Cone in 1933 and were placed on long-term loan to the Print Department of the Baltimore Museum of Art. Etta's sister, Claribel, had died suddenly in 1929, but Etta continued the pair's collecting strategy – and commitment to Matisse – that had developed over the previous decade. Matisse visited Baltimore in 1930 and produced a posthumous portrait of Claribel and a portrait of Etta to accompany it. Marguerite negotiated the sale of the maquette to Etta on behalf of her father, and all parties understood the importance of the transaction to Matisse. He was pleased that his preparatory materials would be available to viewers and believed that access to this 'expanded' version of the work had the potential to provide audiences with a better understanding of his creative thinking.

As historians have noted, the Cone sisters played a vital role in furthering Matisse's reputation in the u.s. and also helped to deepen the critical framework for his art. By the 1930s, the Cone Collection comprised numerous prints and drawings, eighteen sculptures and 42 paintings. With its focus on works that Matisse produced after the First World War, the Cone Collection offered an important counterpoint to the artist's works exhibited in the Museum of Modern Art in New York. Arguably, it was the close connection that Matisse had to the Cone sisters (in particular Etta) and the conversations that he had with them over the course of their collecting activities that fostered a more detailed understanding of the visual experiments that he had undertaken during the 1920s and early 1930s.[14] As John O'Brian notes, Matisse typically pre-selected paintings that he offered to Etta during her trips to Europe. The business angle of these carefully choreographed sales

Henri Matisse, 'The Swan' from *Poems of Stéphane Mallarmé* (Albert Skira), etching, 1932.

proceedings were handled either by Marguerite or Pierre. Knowing that Etta would eventually leave her collection to the Baltimore Museum, Matisse was 'determined that it should represent him well'.[15]

The Cone sisters did, indeed, form their collection with an eye to posterity, and the 1934 catalogue – which included one of Matisse's portraits of Claribel as the frontispiece – offered an introduction to the sisters' approach to art acquisition. But it is also important to point out that, like the Steins, Shchukin and Morozov, the Cone sisters also lived with their art. Their Baltimore apartment was carefully arranged to integrate artworks into a coherent system of interior design. K. Porter Aichele goes so far as to suggest that Etta 'incorporated objects into her displays as contextual props to demonstrate her understanding of Matisse's theories and working process rather than her own ideas'.[16] The opulent settings depicted in Matisse's Nice-period works found, therefore, two collectors and taste-makers willing to live up to the promise of these visual fictions.

Matisse's other Tahiti-inspired work of the early 1930s was linked to his second trip to the u.s. in September 1930. On this occasion, he returned to Pittsburgh as a judge of the Carnegie Prize and was a member of the committee that awarded first prize to Picasso. It was during this stay that Matisse made contact with an individual who would become one of his most important patrons, the pharmaceutical magnate Dr Albert C. Barnes of Pennsylvania. Barnes was in the process of setting up a private museum designed to serve both artistic and educational purposes. Assembling an art collection that combined nineteenth- and twentieth-century European and American paintings with – among other things – medieval decorative art, pottery and textiles by Indigenous American peoples, furniture and African arts, Barnes aimed to create a unique visual environment that would encourage viewers to identify patterns, harmonies and ideas across stylistically different objects. The museum was housed in a bespoke gallery

in Merion (later moved to Philadelphia) and had a public mission to educate audiences, including Barnes's own employees, and to develop their appreciation of art. Barnes not only collected works by Matisse, but offered the artist an opportunity to design one of the centrepieces of the museum, a mural to be located above three full-length glass-panelled doors in the south wall of the building's main room.

Matisse had undertaken commissions for Shchukin's Moscow residence in 1909–10, but the Barnes commission was a more difficult undertaking in so far as it would be designed for, and integrated into, the complex architecture of the building. The position of the mural above the doors did not benefit from a direct source of light. It would, Matisse noted, need to be luminous in its own right. Furthermore, the design of the room meant that the mural would need to comprise three segments embedded in recessed arches. In an interview given to Dorothy Dudley in 1933, Matisse explained his idea for the composition and installation of the work:

> I saw that the surface to be decorated was extremely low, formed like a band. Therefore all my art, all my efforts consisted in changing apparently the proportions of this band. I arrived then, through the lines, through the colors, through energetic directions, at giving to the spectator the sensation of flight, of elevation, which makes him forget the actual proportions, much too short to crown the three glass doors – with the idea always of creating the sky for the garden one sees through the doors.[17]

Matisse was aware of the ways in which both the architecture of the building and the vista through the windows would impact on his composition. Measurements for the design needed to be precise, and Matisse required a large space in which to execute the painting itself.

Upon his return to Nice, Matisse rented a large warehouse at 8 rue Désiré-Niel in which to prepare his designs. He was equipped with detailed specifications of the spaces into which his work had to fit and settled on a theme that recalled a key motif from his earlier paintings, including the work that had been commissioned by Shchukin: dance. Matisse experimented with depictions of human bodies tumbling, extending their limbs and almost flying through space. With a piece of charcoal attached to a long bamboo stick, he created large-scale drawings that imposed a physical distance between him and the work-in-progress. In so doing, he was able to assume a position more closely linked to that of the viewer as the design took shape. He also used cut-outs to experiment with the forms of the dancers' bodies. White figures were positioned against a vibrant background of blue, black and pink stripes and triangles. The angularity of the background created a sharp contrast with the rounded features of the bodies, offsetting them and enhancing the impression of the dancers' mobility. Marcelin Pleynet has suggested that the Barnes mural echoed Matisse's trip to Tahiti in so far as it was, in itself, a kind of voyage: use of the dance motif enabled Matisse to reflect on his own earlier works, thereby transforming the 'other space' he had sought in Tahiti into a journey through his own creative history.[18]

After months of hard work, Matisse shipped the triptych to Merion. He was devastated when he discovered that the measurements of the panels were wrong by around a metre. Barnes did not hesitate to express his anger and disappointment, and it was agreed that Matisse would begin work again. Throughout 1932, Matisse worked intensively on the second version of the mural and had completed the new design by November of that year. Barnes came to Nice in January 1933 to inspect the revised work. It was formally similar to the first one in terms of palette and composition, but the number of dancers had been increased, and greater physical interaction between the figures enhanced the sense

Henri Matisse, *The Dance*, 1932, oil on canvas.

of movement. By May of that year, the new work was ready, and Matisse went to Merion to supervise its installation. This time, the proportions were correct, and a mollified Barnes declared that the mural was 'like the rose window of a cathedral'.[19] His comment was apt in so far as it anticipated the extension of Matisse's colouristic experiments in stained glass in the 1940s and '50s.

By the time he had completed the *Dance* mural, Matisse's reputation had been firmly established in international art-world circles for over two decades. Despite some carping comments from the Paris avant-garde, Matisse's naturalistic paintings of the 1920s now sat alongside his still-lifes, Moroccan-themed works and more abstract compositions in museums and private collections around the world. Barnes's own museum featured works that Matisse had produced in Morocco, as well as landscapes, still-lifes, *Odalisques*, family scenes and even the painting that had so annoyed Paul Signac before its acquisition by Leo Stein, *The Joy of Life* of 1905–6. The stylistic divergences that had challenged critics in the early years of Matisse's career could now be integrated into a cohesive narrative of individual creativity.

Barnes also contributed to the critical framework of Matisse's art. This took the form of a book, co-authored with Violette de Mazia, and dedicated to Leo Stein 'who was the first to recognize the genius of Matisse'.[20] Barnes and de Mazia's study emphasized

Matisse's relationship to various pictorial traditions, but also ventured a psychological portrait of the artist. Here was a man, they suggested, who has 'vitality, he has an open and flexible mind, great erudition, adventurousness of spirit'.[21] Emphasis on the painter's intellect served as a counterweight to the decorative features of his work. While the authors emphasized the positive values of Matisse's often 'picturesque' work, they were eager to identify this as part of a larger 'expressive force' with artistic precedent and intellectual merit.[22] By comparing the critical vocabularies that developed around Matisse's works as they entered the Museum of Modern Art, the Cone Collection and the Barnes Foundation, it is possible to see how different collectors and curators publicized a preferred image of Matisse that was designed to suit their own aesthetic tastes and collecting biases.

Matisse enjoyed a succession of important exhibitions in the early 1930s in Europe and the United States. Solo shows were held at the Thannhauser Gallery in Berlin (1930), the Galerie Pierre Loeb in Paris (1930), the Kunsthalle in Basel (1931) and the Galerie Georges Petit in Paris (1931). The latter included 141 paintings, a sculpture and a selection of prints and drawings and coincided with a special issue of the influential art magazine *Cahiers d'art* that featured essays by critics drawn from around the world. This was a cosmopolitan gathering of writers who showcased Matisse's development and reinforced the significance of his art within international collecting circles.

Cahiers d'art, founded in 1926 by the art critic Christian Zervos, was one of the most important art reviews in France. Zervos kept a tight rein on the magazine and acted as both its editor and artistic director. Each issue was a luxury production that combined lavish illustrations with contemporary poetry and critical writing. Over the course of the magazine's original run (1926–60), Matisse contributed numerous illustrations and was the subject of various issues and essays. The 1931 issue contained

texts written by an international group of authors, including Roger Fry (UK), Henry McBride (U.S.), Karel Asplund (Sweden), and Will Grohmann and Curt Glaser (Germany). Zervos's own contribution was an introductory essay that sought to demonstrate the 'organic evolution' of Matisse's art. Here was an artist, he argued, who had attained maximal freedom through the negotiation of tension between instinctive expression and 'a keen sense of reality'.[23]

That year also saw a further extension of Matisse's reputation in the U.S. Outdoing the exhibition of works on show in Paris, Alfred H. Barr Jr organized a retrospective at the Museum of Modern Art in New York that featured works spanning Matisse's entire career. The lengthy review of the exhibition published by the New York-based art historian Meyer Shapiro is noteworthy for its description of the evolution of Matisse's creativity and its relation to longer histories of art. According to Shapiro, the chronological presentation of Matisse's works showcased 'the radical transformation of art in the last thirty years'. He argued that this took the form of a shift from an Impressionist style to an abstract, decorative idiom that was, in turn, followed (in 1917) by a return to naturalism characterized by 'a drastic reduction of nature, by numerous distortions and the complete dissolution of perspective space'.[24] Whereas Matisse's stylistic variability had been viewed as a limitation in the years prior to the First World War, it was now understood to 'have a broad determination and a purposeful end'.[25] Shapiro positioned Matisse as an inheritor of the unusual angles, heightened colour schemes and spontaneity of Impressionist painting, while also emphasizing the artist's distinctive decorative tendency and innovative handling of pictorial space. Matisse had become a linchpin in a particular history of modernist art.

Shapiro rightly focused on Matisse's ability to integrate 'sculptural massiveness' into flattened – almost 'spaceless' – designs.[26] This was an experiment that Matisse would perform more dramatically in the mid-1930s, in particular in another

important work that would eventually find its way into the Cone Collection: *Large Reclining Nude* – or *Pink Nude* – of 1935. The painting featured a new model, a young Russian woman by the name of Lydia Delectorskaya. Lydia had worked with Matisse as a studio assistant during production of the Barnes mural. In 1933 she was hired as a companion to Amélie, who was suffering from periods of illness that confined her to bed, but from 1935 onwards her role changed to that of Matisse's model, assistant and secretary. In sum, she worked with Matisse for 22 years. The increasingly important role that Lydia played in Matisse's working life became a major source of tension between husband and wife during the 1930s. Indeed, Lydia also took over much of the key studio support that Marguerite had provided to her father prior to her marriage to Georges Duthuit.

In her memoirs, Lydia recalled that with her pale complexion and fair hair she was not Matisse's ideal 'type' as a model.[27] That changed in 1935 when, following the creation of an impromptu sketch, Matisse produced the canvas titled *The Blue Eyes*. Throughout

Lydia Delectorskaya, photographed by Matisse.

the 1930s and '40s, as Matisse turned his attention once again to easel painting, Lydia featured in some of the artist's most important works of the period, including *Woman in Blue* (1937), *The Dream* (1940) and *The Romanian Blouse* (1940). Although Matisse had shifted his interest from the theme of the *Odalisque,* he did not lose his enthusiasm for textiles and female fashion. His work of the late 1930s was embedded in the contemporary fashion industry and included depictions of models wearing a range of stylish clothing from evening dresses to embroidered blouses and leisurewear. In her memoirs, Lydia describes Matisse's trips to Paris to buy haute couture gowns, hats and fabrics for his studio 'sets'. It is clear that his models also had a say in how they wore these clothes, sometimes combining fabrics to form makeshift dresses in ways that would highlight the different textures and colours of the materials.[28]

Lydia's memoirs add significantly to the critical material about Matisse and his art. Although written from a personal perspective (albeit one that was mindful of Matisse's privacy), her recollections offer insight into the artist's working life: mornings dedicated to painting; a lunchtime siesta; afternoons of drawing; nights disturbed by insomnia. Fascinated by Matisse's regime, Lydia kept a notebook of her observations. Upon discovering it, however, Matisse could not contain his disappointment. Keen as ever to control the critical apparatus of his works, Matisse began dictating ideas to Lydia after his working sessions. The result was a book that brought together reproductions of finished works, preparatory drawings, photographs and comments by the artist. Short texts record matters such as the length of time for a sitting, the dates upon which Matisse worked on a particular project, the colours used for different elements of a work and the state in which canvases were left at the end of a working day. If the Mallarmé maquette showcased the evolution of a single work, the notes dictated to Lydia give a more comprehensive picture of what it is like to live as an artist.

It was also during the 1930s that Matisse integrated photography into his studio practice, documenting the evolution of works and creating a visual diary of pictorial problem solving. As Matisse noted in a discussion with Tériade in 1936, responding to different stages of a work was as important as the subject of the work itself: it was only through a continuous process of reworking and rediscovery that he would eventually achieve the final state of a piece and find himself 'liberated'.[29] One of the paintings for which this process was particularly useful was the *Pink Nude*. Twenty-two documented states show how Matisse developed his composition, reducing depth, altering the facial features of the figure and experimenting with different contours of the body (on some occasions accentuating angularity, on others shifting to rounded forms). The change to a tiled background of blue checks marked an important shift in Matisse's thinking. It was at this point that he settled on the pose of the figure and, as in his earlier etchings for the Mallarmé volume, eliminated naturalistic background elements. As the space around the figure was compressed, the model's body became increasingly monumental, the curves of her disproportionately large hips balanced by the angular position of muscular, elongated arms.

It is unsurprising that Matisse had been heavily invested in sculpture in the years prior to his work on *Pink Nude*. His large-scale series of *Backs* (1909–31) and the smaller bronzes *Venus in a Shell I and II* (1930–32) were concerned with the female nude and, in many ways, anticipated the pictorial experimentation of *Pink Nude*. The *Back* (which exists in four states plus an earlier version that is now lost) has a monumental form that is reminiscent of Cézanne's bathers. In *Back IV* the woman's body is bisected starkly by a long ponytail that extends to her upper thigh. Her raised arm and slightly tilted head suggest weariness, yet the sheer size of her form and the proportions of her limbs combine to create a powerful presence. The figure is recognizable as a human being,

Henri Matisse, *Large Reclining Nude* (*Pink Nude*), 1935, oil on canvas.

yet the background provides no physical or psychological context for the pose. In a further unsettling juxtaposition, the woman's long hair suggests softness and movement, yet has a spine-like solidity. Contrasting with their origins in a naturalistic clay sculpture from 1909, the culminating works in the *Backs* series are architectonic shapes that push the boundaries of the human body to their limits. As Jack Flam puts it, the sculptures comprise figures made 'from combinations of forms not actually descriptive of anatomical parts'.[30] The *Backs* impose themselves physically on the viewer while withdrawing psychologically.

As Shapiro noted in his essay of 1932, if Matisse used sculpture to experiment with the solid and monumental, he also considered how three-dimensional forms related to the flat surface of a canvas. While critics have traced connections between the lengthy genesis of the *Backs* and developments in Matisse's painting, it is also possible to consider *Pink Nude* as an investigation of the relationship between two- and three-dimensional media.[31] In this

Henri Matisse, *Back IV*, *c.* 1930, bronze.

case, the viewer is left to question how the monumental body of the woman is supported by, and coheres with, the rigorously flattened background. The blue check pattern, set against a larger sequence of white tiles along the top of the work, does not appear to support the figure. The viewer is left with the impression that the woman hovers in mid-air, the weight of her physical presence at odds with her position in the composition.

The relationship between paint and sculpture was not the only experiment between media in which Matisse engaged during the 1930s. His thoughts about dance had a chance to develop when the Ballets Russes invited him to design the costumes and stage sets for a new production, *Red and Black*. If Matisse had contemplated the possibilities of representing movement in the Barnes mural, this was an opportunity to put his ideas into practice. Work on the designs for this ballet also stimulated Matisse to test his own methods of composition. Recalling his preparations for the Barnes mural, Matisse used paper cut-outs to develop his thoughts and refine his ideas about staging. Cutting coloured pieces of paper, pinning them into place and moving them around a background support enabled Matisse to develop a mobile compositional practice that evolved with his thoughts. Eventually, this demonstration of movement in the production of a work would become a powerful expressive style in its own right, culminating in some of Matisse's most innovative works of the 1940s.

Throughout the 1930s, Matisse continued to innovate and experiment in painting, sculpture, drawing and costume design. His paintings developed some of the domestic settings on which he had focused during the 1920s, but his willingness to think across media and the stimulus of working with a new model gave energy to his creative process. Matisse's reinvention of his own practices, styles and interests made him increasingly a hero of European modernist art. In 1936 Christian Zervos published another special

issue of *Cahiers d'art* that was devoted to Matisse's work. On this occasion, the magazine showcased Matisse's drawing, opening with a tropical landscape from the artist's trip to Tahiti and following this with 35 recent drawings featuring depictions of women. Nude studies with chequered backgrounds recalled the setting of *Pink Nude*, and Matisse implicated himself into the frame of several drawings by depicting his reflection in mirrors. A particularly complex work featured a drawing of the model, a full-length reflection of the artist and model, and a glimpse of the artwork in the process of creation in the lower-left corner. This juxtaposition of different visual planes became the centrepiece of Zervos's introductory essay. The 'constraint of fact' provided by the real object was, he argued, necessary for Matisse's work. However, this commitment to the tangible world was tempered by the intrusion of 'illusory spaces' that created an expanded visual field around the artist and his model. Through the use of mirrors, Matisse becomes a character in his own creative universe – 'the spectator of his drawing' – and one element in a 'vision of totality'.[32]

Throughout the 1930s Matisse's art garnered increasingly nuanced critical attention both in France and abroad. In 1936 the City of Paris acquired the first (abandoned) version of the Barnes mural through the efforts of the then director of the Petit Palais Museum, Raymond Escholier.[33] Later that year, Tériade contributed an essay on Fauvism to his new journal *Minotaure* in which he historicized the movement and Matisse's role in it.[34] Matisse gave interviews to journalists and art historians in France, Germany and the u.s., and Escholier published a biography of the artist in April 1937.

Not all publicity, however, was appreciated by the artist. In 1933, Gertrude Stein published *The Autobiography of Alice B. Toklas*, a fictional work in which she presented her own life viewed through the eyes of her partner, Alice B. Toklas. Several of the artists in Stein's circle felt betrayed by the revelation (and, in many cases, invention) of private conversations that were said to have taken

place years earlier at the rue de Fleurus. They were also troubled by inaccurate commentaries on their careers and by the numerous caricatures that featured in the book. In these reminiscences, Matisse is portrayed as status-conscious and insecure, while Amélie is described as a 'very straight dark woman with a long face and a firm large loosely hung mouth like a horse'.[35]

In February 1935 Matisse and a group of artists and writers, including Georges Braque and Tristan Tzara, published their own *Testimony Against Gertrude Stein*, a short pamphlet in which they rebutted various descriptions and assertions. In a manner that recalled his legal training, Matisse adopted an unemotional tone and confined himself to correcting statements of fact – including as to the appearance of his wife. In the introduction to the pamphlet, the writer and critic Eugene Jolas asserted that Stein's text was nothing more than 'tinsel bohemianism' likely one day to symbolize 'the decadence that hovers over contemporary literature'. For the politically engaged Tzara, the work was nothing less than a form of exploitation that had been transposed from the realm of business to the world of ideas.[36]

Continuing his own forays into the critical environment, Matisse published an important essay in 1935, 'On Modernism and Tradition'. Published in English in the London-based magazine *The Studio*, the essay was Matisse's first foray into print since his 'Notes of a Painter' of 1908. He used the essay as an opportunity to reflect on the early years of his art training. More importantly, however, he stressed the significance of being understood as part of an aesthetic lineage: 'It would be wrong to think that there has been a break in the continuity of artistic progress from the early to the present-day painters. In abandoning tradition the artist would have but a fleeting success, and his name would soon be forgotten.'[37] His comments echoed Apollinaire's early art criticism, including its references to Matisse as a painter whose innovation was tempered by an

engagement with existing models of creativity. In presenting himself in this way, Matisse simultaneously accepted his position as a leading practitioner of ambitious art and undermined critics who attacked pictorial innovation on the grounds of its unintelligibility. The past could be used strategically as a framework for experimental creative practices.

While the critical framework of Matisse's art became increasingly sophisticated and his reputation more widespread, his personal life became more turbulent. In 1936 Matisse and his wife gifted Cézanne's *Three Bathers* to the Petit Palais Museum in Paris. Disposal of the painting that symbolized the early years of their marriage and the struggles that they had endured together presaged a dramatic shift in the couple's relationship. Nearly a decade earlier, Pierre had written a letter to his father noting the importance of this painting to the family:

> I can never forget the day, in Clamart during the war, when for the first time I realized what an importance the Cézanne *Bathers* had assumed in what was at that time the little circle of my life. Do you remember how spontaneously, and with a single voice, we rejected the idea of sending it to the Bernheims for sale?
>
> Doubtless this was in part because we were so used to seeing it. But it was also that, with its going, we should have lost an indispensable part of our family. As children, we knew nothing of the sacrifices that the Cézanne had represented for you both. Nor had we been witness to the steadfast faith that Mama had manifested. But we had a horror of seeing the family dismembered, and of the dispersal, piece by piece, of all the things that had held it together.[38]

Pierre understood the symbolic value of Cézanne's *Bathers* and the anchoring role it had played in the development of his father's career. The decision to sell the work in 1936 was, therefore, a step

that resonated with each member of the family. A few years after the sale of the painting, Matisse and his wife formally separated.

The upheavals in Matisse's personal life were, however, only part of the difficulties he faced towards the end of the 1930s. In 1937, many of his works were confiscated from German museums after they had been designated as 'degenerate art' by the Nazis. In June 1939, one of his most important paintings from the first decade of the century, *Bathers with a Turtle*, was presented at auction in Lucerne, having been removed from the Folkwang Museum. Matisse's son Pierre was instrumental in determining the fate of the painting. Acting on behalf of the U.S. collector Joseph Pulitzer Jr, Pierre acquired the work and arranged its transport to Pulitzer's home in St Louis, Missouri. It would later become one of the key works in the collection of the Saint Louis Art Museum.

Matisse's gallerist of the later 1930s was the Paris-based Paul Rosenberg. Rosenberg had played a key role during the early decades of the century in bringing works by Picasso and Braque to the market. His representation of Matisse began in 1936 and he organized successful solo exhibitions of the artist's works at his gallery in 1937 and 1938. At the approach of war, Rosenberg shipped some of the works in his collection to London and New York, but the majority of them remained in Paris. Upon the occupation of Paris in June 1940, the safety of Rosenberg and his family, like that of other Jewish members of the population, came under threat. Fleeing first to Lisbon, Rosenberg, together with his wife, his daughter and son-in-law, arrived in New York in September 1940. The artworks he was forced to leave behind – including several paintings by Matisse – were looted by the Nazis, with efforts for their restitution continuing into the twenty-first century.

Matisse's son Pierre returned to the U.S. to manage his art dealership in 1939; Jean was mobilized; and – as Matisse would only later discover – Marguerite and Amélie would become active in

the Resistance. Matisse stored the bulk of his works in the Banque de France during the conflict. Having spent time in Paris during April 1940 to finalize his separation from Amélie, Matisse set off with Lydia for the South. Finding themselves part of the panicked 'exodus' from Paris, they negotiated their way through crowds of distressed families and individuals fleeing a city that was now under Nazi Occupation.

After a short stay in Bordeaux and other cities in the South, Matisse and Lydia were back in Nice by August. Matisse had options to leave France: he considered travelling to Rio de Janeiro, was offered a teaching position at Mills College in California and had the possibility of safe passage to the U.S. as part of Varian Fry's Emergency Rescue Committee. Ultimately, however, Matisse decided to remain in France. In a letter to Pierre Bonnard of 17 October 1940 he stated that he could not imagine 'fleeing' the country and that, for the time being at least, he would retain Nice as his base.[39]

It is doubtful, however, that Matisse could have travelled at this time. Throughout 1940 he had been suffering from intestinal pains and, in 1941, was diagnosed with a duodenal tumour. Marguerite arranged for emergency treatment in Lyon, and on 20 January 1941 the 71-year-old Matisse underwent a colostomy at the Clinique du Parc. He suffered a pulmonary embolism following the operation, and his life lay in the balance for over a week. He had made arrangements for the possibility of his death in the weeks prior to the operation, arranging for the division of his estate between his children and for the donation of his last paintings to the City of Paris and to the French State.[40]

As war unfolded in Europe and the Pacific, the bedridden Matisse gradually recuperated from his operation with Marguerite and Lydia by his side. It was a slow, but remarkable, recovery. By January 1942, when he was back in Nice, Matisse wrote to his old friend Albert Marquet with news of his good health. The operation

had 'rejuvenated' him, and he was determined to make the most of the remaining time that had been given to him: 'I had so fully prepared my departure from life that I now seem to be in a second life.'[41] True to his word, Matisse embarked on some of the most adventurous and memorable work of his career over the next decade.

6

Drawing with Scissors

It is tempting to think that artists produce works in isolation and
that their creativity unfolds in the rarefied space of the studio.
While the American Pop artist Andy Warhol championed the idea
of the studio as a 'factory' in the 1960s, it had long been the case
that artists employed assistants and specialists to help them meet
the practical demands of realizing their creative visions. Matisse's
working style was no different, and he often relied on teams of
professionals in the execution of his works. His models helped to
prepare canvases and materials, and he benefitted from the input
of professional printmakers, typographers, writers, publishers,
weavers, architects and suppliers in order to bring diverse projects
to fruition. In this context, the 'studio' needs to be understood in
an extended sense. It is less a single physical space than a sphere of
production that involves a network of individuals, each of whom
plays a specific role in the realization of an artwork.

This collaborative practice came to the fore in the 1940s when
Matisse worked intensively on the production of luxury limited-
edition artist's books. In order to make these works, Matisse
liaised with expert printmakers and typographers in Paris during
processes that were long and exacting. He typically created
numerous preliminary drawings, cutting up printed texts and
pasting them into scrapbooks to experiment with designs for page
layouts. He would then deliver his drawings and designs to the
printmaker; the font and layout of the text would be agreed; grades

and sizes of paper were chosen; and multiple drafts of images and texts were printed until the artist was satisfied with the result.

Matisse experimented with a variety of printmaking techniques for his books, including etching, linocut, lithography and aquatint. One of the most celebrated individuals with whom he collaborated was the master printmaker Fernand Mourlot. In a large studio on the rue de Chabrol in Paris, Mourlot and his assistants worked on books, exhibition posters, catalogues and limited-edition prints for leading artists of the period, including Picasso, Chagall, Braque, Miró, Léger and Giacometti. In his memoirs, Mourlot recalled Matisse as a respected but demanding client: 'He knew what he wanted and there was no means of dissuading him.'[1]

Regular patterns of working with specialists such as Mourlot came under pressure when Matisse had to face the realities of being an artist in a country under Nazi Occupation. Although he lived in the so-called Free Zone in the South of France, exhibition opportunities were limited, travel was restricted, high-quality paper was in short supply and rationing was in place. Writing to Pierre Bonnard in September 1940, Matisse grumbled: 'there is such a subdued mood here, a general anxiety created by everything being said and repeated (without great foundation I'm sure) about the imminent occupation of Nice that I'm very affected by this contagion and my work is difficult, unproductive.'[2] Typically for Matisse, concerns about wider political events were filtered through the lens of their impact on his art.

It was during this constrained period that Matisse's graphic production flourished. Working on surfaces including paper, walls and even his bedroom ceiling, Matisse experimented with different drawing styles and created as much from his imagination as from the studio props around him. Having produced his Mallarmé volume in 1932 and, the subsequent year, a set of illustrations to accompany a u.s. edition of James Joyce's *Ulysses*, Matisse focused in earnest on textual illustration during and immediately after the

war years. Between 1940 and 1947 he produced five major artist's books and laid the foundation for works to which he would return later in his career.

The first book that engaged him after his operation was autobiographical in nature. Commissioned by Albert Skira in 1941, the work was to comprise Matisse's personal reminiscences and views about art. This took the form of a series of interviews – or conversations – with the writer and critic Pierre Courthion. The plan was to produce a luxury volume in which text would be accompanied by photographs, drawings and an original linocut print by the artist.[3] Records of these interviews offer insight into Matisse's personal history, his motivations and influences, and his ideas about particular works. He described the impetus behind the project in the draft preface:

> For me the book will mark an important moment in my life: the sort of physical resurrection that I feel, which really is a resurrection. Because things seem very different from three or four years ago, with all the thinking that I have done, on my own, during this sort of retreat I've had here.[4]

Following completion of the ninth interview, however, Matisse suddenly withdrew from the project. Whether fearing that he had revealed too much in conversation or that the discussions were so banal that they would detract from his art, he blocked publication and negotiated return of the manuscript. As was typical, he had included a clause in the contract providing that publication of the final text was subject to his approval. After considerable input from both publisher and interviewer, Skira was not prepared to relinquish the project lightly. Yet Matisse refused to back down and went so far as to petition his surgeon to attest to the instability of his mental condition in the days following surgery when the project was first mooted.[5]

Matisse never again ventured into such personal territory. Instead, the books on which he focused during the Second World War signalled his interest in writers of previous generations: Charles Baudelaire, Pierre de Ronsard, Marianna Alcoforado and Charles d'Orléans. In an attempt to compensate Skira for loss of the interviews, Matisse embarked on illustrations of love poetry by the sixteenth-century poet Pierre de Ronsard. This project allowed him to return to a theme that he had explored throughout his career: the female nude. In this case, however, Matisse was self-conscious of his position as an older artist celebrating female beauty and amorous adventure. Writing to his friend André Rouveyre, the 71-year-old Matisse worried: 'At my age! In my condition, what will they think of me?'[6] Yet Matisse found a solution to this problem. By incorporating poems that were written from the perspective of the ageing poet – who was troubled by his own lack of virility – Matisse tempered the theme of desire with expressions of anxiety. The result was a book that subtly combined word and image to negotiate eroticism and impotence, youthful exuberance and mortality.

Matisse tightly controlled the process of book production, taking decisions as to the selection of texts and the style of illustration. This involved matters of literary interpretation and close consideration of the ways in which verbal and visual media could combine to create meaning. He elaborated on these ideas in an essay titled 'How I Made My Books' commissioned by Skira in 1946:

> I do not distinguish between the construction of a book
> and that of a painting and I always proceed from the
> simple to the complex, yet I am always ready to reconceive
> in simplicity. Composing at first with two elements, I
> add a third insofar as it is needed to unite the first two
> by enriching the harmony – I almost wrote 'musical'.[7]

The essay written for Skira – and the context in which it appeared – is a good example of the cross-fertilization of criticism, marketing and self-reflection in which Matisse had come to engage. The book was essentially a catalogue that showcased the emergence of the artist's book (including works published by Skira himself) from the end of the nineteenth century to the date of publication. The cover featured a linocut by Matisse from his recent book *Pasiphaé* (with a text by Henry de Montherlant) published in 1944 and the artist's essay 'How I Made My Books'. The foreword was written by Claude Roger-Marx, son of the critic Roger Marx who had supported Matisse earlier in the century. For bibliophiles, the catalogue was a handy overview of the history of the *livre d'artiste*; for the publisher, it was a good piece of advertising; for Matisse, it cemented a connection between his name and a genre on which he had focused intensely over the previous five years.

In a further piece of marketing material produced by Skira in 1948, the publisher reproduced the preparatory states of one of Matisse's designs for his Ronsard volume and a series of photographs showing Matisse working with Mourlot and the typesetter George Girard. Skira emphasized the length and complex nature of production as well as the levels of collaboration needed to realize the book (including a nod to his own creative input). He concluded: 'The result that we finally achieved is the work of combined goodwill and common effort that no obstacle could discourage and that animated a single notion of perfection.'[8] Production of a luxury book was a joint effort, but – as Skira was also keen to point out – the end result was a work by Matisse himself, evidenced by the presence of the artist's original signature on each numbered edition. In a letter to Matisse of December 1943, Skira emphasized the importance of Matisse's guiding presence when the final prints were to be pulled – an arrangement that both suited Matisse and vouchsafed a clear connection between the finished book and the hand of the artist.

Working in the genre of the *livre d'artiste* brought Matisse into contact with a range of individuals who could publicize his work and enhance the critical framework for it. While Skira's publicity material used art criticism for marketing ends, poets and writers typically sought to reveal something distinctive about Matisse's art and to cement their own connection to the artist in the minds of readers. By the 1940s, it was prestigious for a writer to work with Matisse as one of France's leading painters. The Matisse archives in Paris contain letters from numerous writers who worked – or hoped to work – with the artist on a substantial book or who petitioned for the contribution of even a single image for a book cover or frontispiece. Montherlant wrote florid requests to see his name 'united' with that of the artist; each of Tristan Tzara and Luc Decaunes described the sheer 'joy' at the idea of having their texts illustrated by Matisse; and André Rouveyre envisaged collaboration with Matisse as the deepest expression of their 'fraternity'.[9] If Matisse had often suffered criticism from avant-garde writers during the early decades of the century, by the 1940s he was widely sought after by members of that very cohort.

It was during the Second World War that Matisse came into contact with a poet who would create one of the most enduring images of him and his work: Louis Aragon. Aragon had been associated with Dada and Surrealism earlier in the century and, in 1941, asked Matisse for some unpublished drawings to appear alongside an essay he intended to publish in the magazine *Poésie*. Aragon finally met the artist in Cimiez in December of that year, and the circumstances of war set the tone for their early relationship. Aragon was a member of the Resistance and was in hiding in the South of France with his wife, the fellow poet, communist and *résistante* Elsa Triolet. As Triolet was a Russian immigrant of Jewish descent, the danger of her deportation was very real.

Having been forced into clandestine publishing during the Occupation, Aragon published his first essay about Matisse

Photograph of Louis Aragon by Henri Manuel, 1936.

– 'Matisse or Greatness' – in *Poésie* in 1941 under the pseudonym Blaise d'Ambérieux. As Aragon had hoped, the essay was accompanied by a series of ink drawings specially selected by the artist. Aragon gave an overview of Matisse's life and works, but the essay went beyond conventional art criticism. For Aragon, Matisse was a positive symbol of France, his drawing resembled a song and his art represented a quiet victory of the French spirit over Nazism.[10]

Historians have debated the circumstances of Matisse's daily life during the war. It has been noted that his works continued to be included in Paris exhibitions during the Occupation, whereas those of many contemporaries (including Picasso) were censored. One of Matisse's dealers, Louis Carré, sold two of the artist's drawings to the Museum of Modern Art in Paris in 1941, and the following year Matisse gave two interviews about his art on Vichy Radio.[11] Matisse also worked closely with Montherlant, a writer who published in the collaborationist press and expressed his enthusiasm for a rebirth of France under Nazi rule. These activities did not make Matisse complicit with the Occupation. Nor did they align him with those artists and writers (including Montherlant) who negotiated with Nazi officials for preferential treatment. Rather, as Laurence Bertrand-Dorléac argues, by focusing intensely on his own work during the war years, Matisse sought to distance himself from political reality as a 'recourse against the tragedy of history'.[12] Even Aragon noted that the war was not a topic that one tended to broach in Matisse's company.[13] Indeed, Matisse stopped selling his work after 1943, preferring to keep his latest paintings for Pierre to sell in New York.[14]

For writers whose works were censored and for those who participated in the Resistance, Matisse was an artist who epitomized the resilience of the nation. As a French painter who engaged with, and had become part of, France's visual and literary heritage, his works spurred a patriotic rhetoric that was designed to counter the

false nationalism of Vichy. In Aragon's view, Matisse's illustrations of poems by the late medieval French duke and poet Charles of Orléans and use of the fleur-de-lys motif in his painting constituted a 'luminous protest in the name of our country'.[15] In 1942 Pierre Courthion described the 'heroic serenity' of Matisse whose art had the capacity to 'illuminate the world with the spiritual image' of France.[16] Continuing the theme of light, Gaston Diehl wrote of the 'luminous serenity' of Matisse's works, and Tristan Tzara identified the artist as one of the 'luminous figures' of the twentieth century.[17]

In addition to his engagement with French literary history, Matisse also used colour in such a way that it could be recognized as a positive patriotic statement. His painting *La France* of 1939 depicts a beautifully dressed young woman in an armchair. Her elongated arms stretching around the extended support of the chair recall the curves of the sculpture *La Serpentine* from 1909. As historians have pointed out, this painting (like other of Matisse's works of the period) has a blue–white–red scheme that evokes the colours of the French flag and was recognized at the time as a patriotic statement. The same palette dominated a work that would become one of Matisse's most popular paintings in the years after the war, *The Romanian Blouse* of 1940 (modelled by Lydia). Claudine Grammont has noted that the latter was not just admired by art audiences, but influenced directors of New Wave cinema of the 1960s (Jean-Luc Godard and Éric Rohmer), as well as the fashion designer Yves Saint-Laurent, who created a series of blouses inspired by it in 1981.[18]

Matisse worked intensively during the war. Although coping with bouts of illness that left him bedridden, he produced paintings as well as prints and drawings. The large-scale *Nymph in the Forest* (1935–42) recollected imagery from his illustrations for Joyce's *Ulysses*, and he also worked on a series of still-lifes that anticipated some of his daring interiors painted later in the decade. The energy that Matisse put into his work is remarkable in light of

the events that were affecting both the country and his own family. Matisse had lost contact with both his wife and Marguerite. While Pierre, Georges Duthuit and Matisse's young grandson, Claude, were based in New York during the war, Jean was mobilized and later worked with the local Resistance in Antibes.[19] Matisse's letters to fellow artists mix expressions of concern for his family with discussions of his latest works. Transitions are abrupt and the tone of the letters gives credence to Aragon's hint that Matisse often simply tried to block out the realities of the conflict.

Between 1941 and 1954, Aragon wrote intensively about Matisse, eventually combining his essays into a unique piece of critical writing titled *Henri Matisse: A Novel*. Published in 1971 in two volumes and comprising photographs of Matisse and reproductions of paintings, drawings and sculptures, the book was an eye-catching edition. Aside from its qualities as an object, it was also a unique piece of critical writing. Aragon acknowledged in the opening pages that the book was full of digressions and that it 'resembled nothing other than its own disorder'.[20] In the ensuing essays, he describes the evolution of his relationship to Matisse, offers interpretations of the artist's works and contemplates the creative and critical contexts from which those works emerged.

Aragon was an attentive observer of Matisse's creative practice. His essays introduce readers to the contents and furnishings of Matisse's working environment and draw connections between various props and the paintings in which they featured. He apologizes for casting his book as a 'novel', but it is clear that the term served an important strategic end. This was a book that purported to create an innovative critical language for Matisse's art or, as Aragon tantalizingly puts it, 'an imaginary language'.[21] Neither straightforward criticism, nor biography, nor fiction, the book is simultaneously public and personal, analytical and impressionistic. By combining these different tendencies, Aragon tried to craft a form of expression that would match Matisse's own

creativity and encourage a similar imaginative openness on the part of readers.

The book also offered a counter-statement to conventional styles of critical writing. In this regard, Aragon felt that his undertaking had direct appeal to Matisse:

> Matisse sometimes displayed great annoyance at the language that critics used to write about him and this pushed me to say many things that did not fall on deaf ears: that there is no spoken or written language of painting; that it is madness to want to give the equivalent of the painted object when painting is already a way of speaking about something.[22]

Aragon's comments capture the dilemma of art writing: namely, how to speak about art in a way that is not simply an accretion to the relevant work or practice? How is it possible to go beyond description, formal analysis and context? Aragon's solution was to write poetically around and with Matisse's art, embedding himself in his subject's working practices, gestures, studio environment and ways of seeing.

Part of this process involved Aragon posing for a portrait by Matisse and experiencing what it was like to be observed closely by the artist. Instead of producing one work, Matisse created over 35 drawings, progressing from charcoal sketches to single-line drawings, each of which captured Aragon in a slightly different pose. It was a process that recalled the increasing levels of simplification that Matisse had practised in his illustrations for Mallarmé's poetry in 1932. Yet it created an unsettling effect on the sitter. The portraits unfolded before Aragon's eyes like a unique 'cinematography', a series of images that generated similar, yet dissimilar, selves and that offered more complete information about his persona than any mirror image.[23]

This method of serial working was a mainstay of Matisse's practice during the 1940s and became a subject in its own right

in an album of drawings published by Martin Fabiani in 1943, *Drawings: Themes and Variations*. Featuring 158 depictions of individuals and still-lifes organized around seventeen 'themes', this unbound volume (with an introduction by Aragon) was designed to showcase Matisse's most recent ideas about drawing. By seeing the artist's repeated treatment of selected themes, the viewer would be able to trace gestural and stylistic changes in each set of variations. This was the practical demonstration of a research process that Matisse had approached in written form in his 'Notes of a Painter on His Drawing' of July 1939. This essay had been the centrepiece of a special issue of *Le Point*, a magazine devoted to literature and the arts. The volume was lavishly illustrated with photographs of Matisse and reproductions of his works. It contained a short introduction by the poet Jules Romains, an essay by René Huyghe (conservator of the Louvre), recollections by the Fauvist painter Jean Puy, and essays by art critics George Besson and Raymond Cogniat.

'Notes of a Painter on His Drawing' encapsulated key ideas that had recurred in critical writing about Matisse over the preceding two decades. In the essay, Matisse explained that drawing was 'the purest and most direct translation of his emotion'. Developing analyses that had been advanced by Adelyn D. Breeskin and Roger Fry years earlier, Matisse described a compositional process that began with charcoal drawings containing ample shading and smudged contours and that progressed to a simplified form of 'plastic writing'. Although the final drawings may appear sparse in comparison to the earlier studies, they are modulated, Matisse explains, by different densities of line and their relation to the surrounding whiteness of the paper.[24]

Matisse's emphasis on the direct expression of his emotion countered assertions made at the beginning of the century by André Gide and Maurice Denis that his compositions were the application of a preconceived theory. Matisse concludes his essay with an emphatic statement on this subject: 'To sum up, I work

without theory. I am conscious only of the forces I use, and I am driven by an idea that I really only grasp as it grows with the picture.'[25] By the 1940s, Matisse had persuaded his audiences of this view of his art. The point was illustrated in a film that François Campaux made of Matisse in the act of drawing in 1946 and the essay 'Indirect Language and the Voices of Silence' published by the philosopher Maurice Merleau-Ponty in *Les Temps Modernes* in 1952. According to Merleau-Ponty – and reinforcing Matisse's descriptions of his own creativity – the artist's compositional choices occurred at the very moment of their execution and not prior to it: the conditions that governed the movement of Matisse's hand 'were only defined and imposed by the intention of executing that particular painting which did not yet exist'.[26]

In his discussion of *Drawings: Themes and Variations*, Aragon contributed to this line of critical thinking about Matisse by focusing on the theme of seriality and describing the unfolding sequences of images as Matisse's 'cinema of sensation'.[27] Anticipating Merleau-Ponty's discussion, Aragon presented the artist's drawing as something that flowed independently of directed thought. He asserted that in the sequential images comprising the volume, the drawn line was formed without any 'intervention of the painter to correct the hand'.[28]

The twinned concepts of 'instinct' and 'spontaneity' had become key terms in the critical vocabulary associated with Matisse's art by the 1930s. The theme of 'instinct' had first been proposed by Guillaume Apollinaire in his 1907 essay published in *La Phalange*. In 'Automatism and Illusory Space' of 1932, Christian Zervos described Matisse's creativity as an act during which the artist was 'not fully conscious of his action' – a state that verged on 'delirium'.[29] In 1938, Tzara worked with Matisse on a book of poetry that the poet hoped would express a creative affinity beyond 'directed or intentional will'.[30] For Jean Puy writing in 1939 for the special issue of *Le Point* mentioned above, Matisse's best works

were those guided by the artist's own unique 'temperament' or 'instinct'.[31] In 1952 Rouveyre united the aesthetic of Apollinaire and Matisse under the aegis of a 'primordial' creative force.[32] Aragon's portrayal of Matisse's spontaneous drawing style contributed, therefore, to a much longer tradition of critical thinking about spontaneity that had developed – and would continue to develop – around the artist and his works.

Drawings: Themes and Variations was completed in 1942 shortly before the Nazi Occupation extended to the whole of France. Aragon received the proofs from Lydia as he boarded the last train out of Nice.[33] Despite his ongoing involvement in the Resistance, he published his contribution to the volume ('Matisse-in-France') under his real name. By the following year, Matisse had retreated further inland to the Villa le Rêve in the small village of Vence. Nestled at the base of the Baou mountain, the house was surrounded by palms, cypresses and olive trees. With Lydia's help, Matisse turned the upper storey into a studio and populated it not just with paintings and materials, but with objects and textiles he had collected over the course of a lifetime, works by other artists, books, doves and two pet cats. According to Aragon, it was a fairytale palace full of plants and birds.[34] This seemingly ideal environment could not, however, be kept wholly separate from the realities of war.

In a letter to Charles Camoin of 5 May 1944 Matisse shared the devastating news that his wife and daughter had been arrested. He described this as 'the greatest shock of his life' and, typically, one that he hoped to survive by focusing even more intensely on his art.[35] Amélie had been working for a clandestine newspaper and sentenced to a six-month term in the prison at Fresnes on the outskirts of Paris; Marguerite, more closely involved with British intelligence, had been arrested, tortured by the Gestapo and sent for deportation to a female concentration camp in Ravensbrück, Germany. She narrowly escaped death in August 1944 when the

Matisse at Villa le Rêve, Vence, 1948.

train in which she was being transported was derailed. After
a period of hiding in northeastern France, she was eventually
reunited with her father in January 1945. Matisse's letters to
Rouveyre express the extent of the artist's relief and shock upon
seeing his daughter again: 'I've been so completely overwhelmed
by everything that I've heard since the arrival of my daughter that
I haven't been able to write a word to you.'[36] When Rouveyre and
Zervos finally met Marguerite after her ordeal, they each wrote to
Matisse about her remarkable recovery and serene appearance – an
almost 'supernatural beauty', as Zervos put it.[37]

That beauty was captured in a series of drawings and lithographs
that Matisse produced of his daughter in 1945. Marguerite had
modelled for her father throughout her entire life, the first of
more than thirty portraits of her dating from 1901. Yet she had
disappeared from Matisse's art since her marriage to Georges
Duthuit in 1923. The drawings that Matisse created of her in 1945

were not simply the record of her appearance at that particular moment in time. They summed up a relationship that had evolved through, and been primarily expressed by, art. They were the last portraits that Matisse would produce of his daughter.

In July 1945 the critic André Warnod published an essay on the front page of the French journal *Arts* that triumphantly announced the return of Henri Matisse to Paris. It was Matisse's first extended stay in the capital for several years and it coincided with a retrospective at the Salon d'Automne that included 37 paintings, many of which the artist had produced during the war. Making a more political statement, an article by Léon Degand titled 'Matisse in Paris' (accompanied by a self-portrait of the artist) appeared on the front page of *Les Lettres françaises*, the official newspaper of the National Writers' Committee that had been founded by two members of the Resistance, Jacques Decour (executed by the Nazis) and Jean Paulhan. The positive implications of placing Matisse's image directly below the title of a former clandestine newspaper could not have been stronger: the artist's return to Paris symbolized the nation's cultural rebirth. In the conclusion of his article, Degand identified Matisse's art as a blueprint for an optimistic France that – like one of the artist's paintings – was now suffused with light and colour.[38]

The image of Matisse as an artist who had symbolized French artistic tradition in the face of Nazi threat gathered force during the 1940s. In 1945 Raymond Cogniat published a review of Pierre Courthion's *Le Visage de Matisse* (1942) and described Matisse as an artist who had refused to submit to the Nazi occupiers.[39] In 1947 an essay by the literary critic Roger Caillois titled 'War and Celebration' positioned Matisse's art within discourses of post-war cultural recovery. In the same year, several of Matisse's *livres d'artiste* were included in an exhibition devoted to French publishing that identified books as 'sacred spaces' of the spirit.[40] As late as 1971, Aragon positioned Matisse as the linchpin of a political

narrative: 'The majority of French people were desperate, and I saw him as a surprising figure of hope in desperation. If one looks at his painting, it bears witness to his remarkable way of mastering not just everyday problems, but also great pain.'[41]

While Matisse's own post-war reputation was secure, the artist was aware of the difficulties involved in negotiating the turbulent French cultural climate during the years immediately following the Liberation. Several of his former associates, including André Derain, Maurice de Vlaminck, Kees van Dongen, Othon Friesz and André Dunoyer de Segonzac, were among a group of artists who had undertaken an official visit to Germany in 1941 and were blacklisted after the war. Meanwhile the 'purges' led by the National Writers' Committee were polarizing the literary community, as individuals were charged with different levels of collaboration and suffered punishment ranging from ostracism to execution.

While two of Matisse's friends and supporters, Aragon and Paul Éluard, were members of the National Writers' Committee, other artists within Matisse's orbit found themselves on the wrong side of post-war judgements. Although not officially censured, Jean Cocteau's reputation was tarnished by his friendships with high-ranking Nazi officials and his enthusiasm for works by the German sculptor Arno Breker. Henry de Montherlant, with whom Matisse had worked on the artist's book *Pasiphaé* in 1944, was found guilty of collaboration and subjected to a publishing ban. Although this was applied retrospectively, the humiliation of being identified as a collaborator was very real. Matisse's dealer in the 1940s and publisher of *Pasiphaé*, Martin Fabiani, was found guilty of trafficking in looted art. Matisse severed ties with Fabiani and also distanced himself from Montherlant after the Liberation, but he was also troubled by the virulence of the purges. The sculptor Aristide Maillol had, like Cocteau, supported an exhibition of Breker's sculpture in Paris 1942 and had also posed for Breker in

1943. When Maillol was denounced as a collaborator after the war, Matisse expressed concerns about such judgements in a letter to Camoin.[42] At a time when calls for retribution proliferated and differing political factions led demands for justice, Matisse preferred to draw a line under the events of the past.

Post-war French art audiences had many opportunities to experience Matisse's art. While the Salon d'Automne of 1945 included a retrospective of his works, the inaugural exhibition of the Galerie Maeght on the Left Bank in December of that year offered special insight into the artist's working practice. Aimé Maeght (a close friend of Pierre Bonnard) had become part of Matisse's circle in 1943 when he left occupied Paris and took refuge in the South. Having run a printing business in Cannes and a small gallery to accompany it, he was supported by Matisse and Bonnard when he moved to Paris after the Liberation. The gallery's inaugural show featured only six paintings by Matisse, but accompanied these with enlarged, framed black-and-white photographs of each work at different phases of production. Working closely with Maeght, Matisse created an interpretative framework for his paintings through a form of visual storytelling. The studio process that he had been documenting with Lydia over the previous years now had a venue for public presentation. In his review for *Les Lettres françaises*, Léon Degand described his experience of inhabiting different moments of Matisse's creative process, including its 'oscillations, ruptures, recoveries, transitory relations, and culmination'.[43] The exhibition was a success, and Maeght gained a firm foothold in a Paris art world that was seeking to re-establish its position in the international art market.

At the same time, a different drama was unfolding across the English Channel. In an exhibition that sought to cement cultural bonds between two recently allied countries, the Victoria and Albert Museum staged 'Picasso and Matisse', an exhibition supported by La Direction Générale des relations culturelles of

France and the British Council. The exhibition, which opened in London before travelling to Manchester and Glasgow, perpetuated the image of the two artists as complementary leaders of the avant-garde. The catalogue essay by Christian Zervos warned viewers that they might be 'disconcerted' by Picasso's adventurous treatment of the human form in works of the 1940s. By contrast, the essay by Jean Cassou, director of the Musée national d'art moderne in Paris, claimed that the range of Matisse's works included in the exhibition (spanning 1896 to 1944) displayed an 'intensity of beauty' that was matched by 'an intensity of mind'. They were, he concluded, examples of a specifically 'French genius'.[44] Despite such hyperbole, members of the British public were unconvinced by either the style of the art on show or the selection of artists. A lively debate played out in the press, with letters to the editor of *The Times* complaining of an 'invasion' of foreign painters, 'bewilderment', the 'pointless distortion of forms' and, in the case of Picasso's works, the very 'disintegration of civilization'.[45] As art was increasingly claimed for the purpose of advancing competing national agendas, *The Times* was able to reassure audiences in February 1946 that Room 41 of the Victoria and Albert Museum would next hold an exhibition of works by the English painter best known for his Romantic landscapes, John Constable.

The juxtaposition of works by Matisse and Picasso gathered pace during the immediate post-war years. The two artists were paired in exhibitions at the Palais des Beaux Arts in Brussels and the Stedelijk Museum in Amsterdam in 1946, and their works featured in the more politically motivated 'Art and Resistance' exhibition at the Musée d'art moderne de la Ville de Paris in the same year. Although neither of them had been directly involved in the war, Matisse and Picasso emerged as pre-eminent artists who represented the survival of a preferred – though still actively debated – French cultural narrative and a living history of the avant-garde.[46] The support of writers who had joined the

Communist Party was central to this post-war success. While Picasso had been a party member since 1944, Matisse remained aloof from direct political action. Nevertheless, writers such as Aragon and Éluard, who were both members of the Party and powerful influencers of post-war cultural politics, extended the critical framework of Matisse's and Picasso's art into a political arena and thereby embedded the artists' works in broader discussions of cultural identity and nationhood.

In April 1947 Matisse returned to the Villa le Rêve and turned his energies to the medium with which he had been so closely associated throughout his career: painting. The period 1946–8 witnessed a new flourishing of Matisse's engagement with paint in what have become known as the 'Vence interiors'. Works in this group were large in scale and ambitious in composition. Matisse took inspiration from the 'palette of objects' in his studio and integrated motifs into bold, geometrical compositions bursting with exuberant colour. As in his paintings produced prior to the First World War, Matisse created canvases that were in dialogue with each other, integrating images of his own paintings into scenes and recycling motifs across works. *The Pineapple* (1948) appears in the background of *Large Red Interior* (1948), and one of the studio props about which Matisse was most enthusiastic, his nineteenth-century rocaille armchair, moved from the background of *Interior in Yellow and Blue* (1946) to take centre stage in *The Rocaille Armchair* (1946). In the latter, Matisse imposes a close-up viewpoint that plunges into the object, transforming the chair into an organic form that threatens to encircle the viewer. According to Picasso there was 'not even a suggestion of verticality or horizontality' in the composition. It was a bold work, but one that gave him vertigo.[47]

The diversity of Matisse's output and his ongoing willingness to experiment in different media make it difficult to identify a 'late style' in his works. As the artist approached eighty years old,

Henri Matisse, *The Rocaille Armchair*, 1946, oil on canvas.

however, his Vence interiors were, in some measure, a summation
of his ideas about painting. These remarkable surfaces brimming
with energy affirmed the decorative value of art and a lifelong
commitment to the expressive potential of colour. Developing
the experiments with pictorial space that Matisse had engaged in
throughout his career, these closed interiors unfold into layered

expanses of pigment and pattern that defy the imposition of a single perspective. Matisse's collection of Kuba textiles (from what is now the Democratic Republic of the Congo) strongly influenced the composition of these paintings. Photographs from the 1940s evidence the artist's attraction to the bold geometries and repeated patterns of these embroidered panels that he had collected since the 1920s and that now decorated his bedroom walls.[48] In *Red Interior (Still-life on a Blue Table)* of 1947, a recurring zigzag motif extends from an interior wall to the floor and through an open window, thereby undermining spatial order and eroding distinctions between interior and exterior. As Ellen McBreen points out, Matisse did not use his Kuba textiles as elements in a traditional still-life but rather as 'a theoretical principle for creating subjective space'.[49]

In an assertion of the material presence of the Vence interiors, the painter's brushmarks are evident as they compete with the white ground of the canvas. This 'thing-like' quality of the surfaces was something that Pierre Matisse was keen to emphasize when he exhibited the works at his New York gallery in 1949. He took the decision to show the paintings unframed – an act that, for Matisse, would have recalled Ambroise Vollard's exhibition of Cézanne's paintings in 1895. In a review of the exhibition, the u.s. critic Clement Greenberg declared Matisse to be 'the greatest living painter'. With their invention of Cubism, Picasso and Braque may have produced 'the most important pictures so far of our century', Greenberg stated, but Matisse was the 'complete painter', the 'quiet, deliberate, self-assured master who can no more help painting well than breathing'.[50]

While Matisse had continued his commitment to painting, drawing and printmaking during the 1940s, it was also during this decade that he turned to a medium for which he would become renowned: paper cut-outs. As discussed in previous chapters, Matisse had used cut-outs as a compositional device during the 1930s. Thinking through his designs for theatrical sets and working

on the Barnes mural, he had experimented with the combinatorial possibilities of cut-outs, pinning and re-pinning pieces of paper into place and testing their different visual effects. In the 1940s, however, he used cut-outs as a medium in their own right. Cutting directly into coloured paper was the culmination of Matisse's drawing practice: instead of making a mark on paper, lines could be created by cutting directly into colour. As Aragon noted, drawing with scissors was a liberation – 'the negation of all academic training' – and signalled the resolution of Matisse's commitment to both colour and draftsmanship.[51]

Matisse created cut-outs for works in different scales, ranging from books and magazine covers to murals that took up entire walls and rooms. These works gave rise to various technical issues and, once again, necessitated collaboration with studio assistants and specialists. Detailed studies have been made of the ways in which Matisse created these works. It is known that he used different types of scissors (including tailoring and paper scissors) and that these typically had long blades.[52] Traces of the act of cutting are visible, particularly with rounded shapes, highlighting the gestural production of the resulting works.[53] By leaving evidence of his manipulation of the scissors, Matisse brought the process of cutting close to that of drawing: each style of production is intimately linked to the artist's physical gestures and responds to the slightest movement of the hand. Matisse used different sizes of paper and insisted that the paper be coloured by hand with 'gouache', a water-based opaque paint. Studio assistants mixed colours and applied them to the paper, often in multiple coats, occasionally leaving fingerprints as they manipulated the wet surfaces.[54]

One of the most famous works that showcased Matisse's efforts in this medium was his artist's book *Jazz*. Created as an album of loose-leaf pages and published by Tériade in 1947 in an edition of 250 (plus twenty copies that were not for sale and one hundred

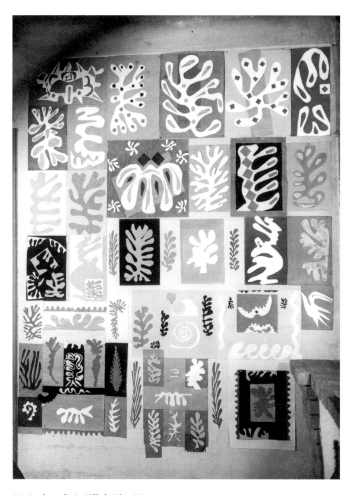

Matisse's studio in Villa le Rêve, Vence, 1948.

albums containing only the images), the work combined an essay by Matisse – written in a monumental cursive script – with a series of illustrations. Rather than structuring the text as a formal essay, Matisse styled it as a loosely connected set of remarks that complemented the images and formed a 'sonorous ground' for them.[55] The book was originally titled 'Circus' (and, indeed, circus motifs recur throughout its pages), but Matisse eventually opted for a musical title. The improvisatory nature of jazz was akin to the mobile compositional practice that had motivated the book's creation. The title thus communicated to audiences a sense of energy associated with a style of music that privileged spontaneity.

Jazz necessitated the input of numerous specialists. One of the main challenges was how to reproduce the colours of the cut-outs faithfully. After much experimentation, Edmond Vairel had the idea of printing the pages with the same inks (by Linel) that had been used to paint the original cut-outs. Matisse could then honestly claim in the book that the work was a faithful rendering of his design. The manuscript pages were printed by Draeger Brothers, and Tériade and Angèle Lamotte oversaw the production process themselves. The result was an album of prints that showcased Matisse's ongoing commitment to colour alongside his innovative experimentation with paper.

An exhibition of the work took place at the Pierre Bérès gallery in Paris in 1947, but Matisse was unhappy with the result and went so far as to call it a failure. In addition to problems concerning how the work would be displayed, Matisse worried about the medium of cut-outs (too childish) and the visual impact of their transposition from an album of prints to a gallery display (a lack of sensitivity).[56] Adopting his habitual role of confidant and flatterer, Rouveyre reassured his friend in the most complimentary terms: 'Almost the whole of art is included in the divinely free exercise between your personality, your paper, your scissors and the wonder of your conjuring trick.'[57]

Despite Matisse's concerns, *Jazz* swiftly became one of his most popular works. In addition to its display in Paris and New York shortly after publication, the work was included in Matisse's Philadelphia retrospective in 1948 and met with great success. Pierre sent his father congratulatory telegrams from New York, mentioning that *Harper's Bazaar* wanted to reproduce an image from the book on their April cover. Matisse refused the request.[58] As John O'Brian has noted, critics focused on the brilliant colours of the book and its circus themes, arguing that it had the 'capacity to furnish serenity and pleasure'.[59] This was a rhetoric that unified Matisse's career under the banner of colour and optimism: the vibrant palette of the *fauve* had become a symbol of joy in a post-war climate. As Matisse put it himself in 1947:

One can provoke light by the invention of flat planes, as one uses harmonies in music. I used color as a means of expressing my emotion and not as a transcription of nature. I use the simplest colors. I don't transform them myself, it is the relationships that take care of that. It is only a matter of enhancing the differences, of revealing them. Nothing prevents composing with a few colors, as in music that is built on only seven notes.[60]

While Matisse confined his cut-outs to the space of the page in *Jazz*, the following years saw their development into large-scale works and into different media. *Large Decoration with Masks* (1953) was transferred to a ceramic wall mural, while *Mimosa* (1950–51) became a limited-edition rug woven by Alexander Smith Inc. in New York. Some of the designs for these and other works recalled the trip to Tahiti that Matisse had made in 1930. A pair of murals, *Oceania, The Sea* and *Oceania, The Sky* (1946), developed from wall decorations that Matisse had conceived for his apartment on the Boulevard du Montparnasse. The murals contained familiar lagoon motifs from *Jazz* combined with images of marine life and birds.

Just as the cut-outs for *Jazz* had to be transferred into a durable form, so too the question arose as to how to transform the pinned cut-outs into a mural. In this case, Matisse worked with the textile specialist Zika Ascher, who had travelled from Prague to London in 1939 to set up his own business. It was Ascher's job to create a base for the mural out of a beige linen that was designed to match the colour of the walls in Matisse's apartment. The cut-outs could then be screen-printed onto the background fabric in white ink.

Reinforcing Albert H. Barnes's championing of Matisse's interest in decoration, many of these late works were designed to harmonize with architecture and to create specific atmospheres in domestic or public settings. Coloured cut-outs increasingly populated Matisse's own studios and living spaces in Nice and Paris, in some cases with paper figures spilling from walls onto floors. Acrobatic figures, floral and marine motifs and masks dominated these designs. A sequence of cut-outs, *The Velvets* (1947), once again combined Matisse's interest in the structure of Kuba embroideries (with individual panels sewn together), but comprised seaweed motifs and colours familiar from *Jazz*. As Anne Coron aptly puts it, the work created 'a musical score through colour'.[61] As innovative as they were, these fragile works did not, however, find a ready market.

The question of how to conserve Matisse's cut-outs has posed difficulties since their production. In 1948 Matisse rejected an offer from a wealthy ship owner to place an entire wall of cut-outs under glass in his luxury liner.[62] Transferring them to more durable forms such as prints or mounting them on paper and fabric were preferable solutions. From 1952 Matisse worked with a firm of Paris art suppliers, Lucien Lefebvre-Foinet, to develop a technique for mounting the cut-outs on fabric supports. The large-scale *Creole Dancer* of 1950 – inspired by the choreography of Katherine Dunham – was one of the first works to be mounted by the firm, and the ensuing process of transferring other cut-outs was supervised by Lydia and Marguerite.[63]

If Matisse's cut-outs were not immediately embraced by the art market, they also confounded gallery audiences. In an exhibition at Pierre Matisse's New York Gallery in 1949, the cut-outs failed to sell or to impinge on critics' minds. The works fared more favourably in an exhibition at the Musée national d'art moderne in Paris, but they did not find their way into the museum's collection.[64] An important moment came in 1959 when Franz Meyer at the Kunsthalle in Bern, Switzerland, staged an exhibition that included *Jazz* and thirty of the large-scale cut-outs, some of which had never been seen before. Aragon recollected the sense of astonishment caused by seeing so many of these works in a single space.[65] Meyer's catalogue introduction suggested that the experience of seeing these works was like entering a 'garden of paradise'.[66] Writing two years later for an exhibition at the Museum of Modern Art in New York, Monroe Wheeler framed the works more theatrically. Matisse was not simply drawing with 'two matched blades of steel', he was also 'biting the form as a wild beast might seize upon its prey; caressing the contour, though with hard metal, as gently as a lover's hand'.[67] The history of Fauvism could still be drawn upon to enliven critical writing.

In 1947 Matisse became reacquainted with a former model, Monique Bourgeois. Bourgeois had been one of Matisse's nurses in the early 1940s and had later entered a Dominican convent. During a visit to Nice in 1947, she shared with Matisse some ideas for stained glass windows that were destined for a chapel to be built in Vence. This visit was followed by a meeting between Matisse and a young Dominican novice, Monseigneur Rayssiguier, who elaborated on the plans and suggested that the artist design the Chapel of the Rosary. It was an opportunity for Matisse to transform his experiments with colour and light into an immersive physical environment. He was motivated to accept the commission less by religious reasons than by the chance to develop his cut-outs in a new direction. Over the next two years, the design of the Vence

Chapel would become his primary occupation. It was a work, he said dramatically, for which he had been chosen by fate.[68]

Conclusion

The invitation to design the Chapel of the Rosary positioned Matisse in debates that extended beyond the typical remit of art criticism. In the years immediately prior to the Second World War, the French Catholic Church had become concerned with the poor quality of art in its sacred spaces. Led by two members of the Dominican Order, Marie-Alain Couturier and Raymond Régamey, a Sacred Art Movement formed to tackle this problem. Among its activities, the Movement commissioned a range of contemporary avant-garde artists to design murals, stained glass windows and other objects that served as part of the Catholic liturgy. The initiative was controversial, and debates ranged from whether or not commissioned artists should be devout to questions about the kind of art (figurative or abstract) that was best suited to sacred spaces. Many of these discussions played out in the journal *L'Art sacré*, a publication that served as an important vehicle of mediation between the Church, audiences and members of the art world.[1]

Father Couturier had trained as an artist and believed strongly that the Church had a duty to offer parishioners art that was both spiritually uplifting and relevant to the present. While sacred commissions offered artists the possibility of extending their creativity into a new domain, they also played a powerful role in modernizing the Catholic Church and, in the years after the Second World War, embedding it in discourses of nationhood. Couturier

became involved in Matisse's project for the Vence Chapel, offering advice on liturgical aspects of the design and negotiating internal Church politics.[2] Detailed conversations and correspondence about the design unfolded between Matisse, Couturier and Rayssiguier between 1947 and 1954 and were published in 1993.[3]

The final project comprised much more than designs for stained glass windows. First, the elevation and architecture of the building itself had to be determined. Second, Matisse was concerned to create an internal environment that harmonized light and colour and that balanced spaces in and around the Chapel. He produced 22 stained glass windows; three ceramic wall murals (featuring Saint Dominic, the Virgin and Child, and the Stations of the Cross); four smaller ceramic compositions; three ceramic water stoups; a carved wooden door for the confessional; the altar and its furnishings; an exterior spire; a pattern for the roof tiles; and a set of vestments for members of the clergy. As John Klein has noted, many aspects of the design went far beyond Matisse's own skills and necessitated the input of architects and specialists in various crafts. This was, Klein argues, a 'path of trial and error and self-education', much of which Matisse relished.[4]

In a short statement about the design of the Chapel that was published in *France Illustration* in December 1951, Matisse explained his key ideas. In a paragraph worth quoting in full, he notes how the colours of the stained glass were designed to interact with the glazed white tiling that served as a support for his drawings:

These stained-glass windows are composed of three carefully chosen colors of glass, which are: an ultramarine blue, a bottle green, and a lemon yellow, used together in each part of the stained-glass window . . . The lack of transparency in the yellow stops the mind of the spectator and keeps it within the interior of the chapel, thus forming the foreground of

a space that begins in the chapel and then passes through the blue and green to lose itself in the surrounding gardens. Thus when someone inside can look through the glass and see a person coming and going in the garden, only a meter away from the window, that person seems to belong to a completely separate world from that of the chapel.[5]

Beginning with the idea that pigments could be juxtaposed to create musical harmonies, Matisse argued that colour could function as drawing, writing, sculpture, architecture and light. These ideas recalled his commitment to Fauvism in the first decade of the century, and he remained true to the expressive potential of colour as he extended his experiments beyond easel painting. In the case of the Chapel, colour was a medium from which to generate a unique array of shifting spatial dimensions. If Matisse had travelled to Tahiti in the 1930s in the hope of finding 'another space' in which his dreams could unfold, his turn to architecture was another development of that quest.

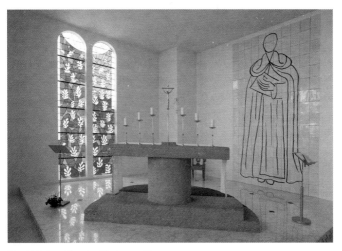

Henri Matisse, Chapel of the Rosary, Vence.

In a book published in 1960, the New York-based photographer Alexander Liberman elaborated on this theme. Liberman gathered together photographs he had taken of artists living in France who had, in his view, contributed to a 'modern renaissance' in twentieth-century painting and sculpture. While many of these photographs had appeared on the pages of *Vogue* (the magazine for which Liberman worked), the book united imagery with essays, interviews and discussions of the artists' works. Liberman's narrative of his visit to Matisse's apartment on the Boulevard du Montparnasse in Paris emphasized 'the vitality of youth and the wisdom and knowledge of age' that suffused the artist's late creativity.[6] But Liberman also describes the metamorphosis of Matisse's studio at the Hotel Régina in Nice into a working model of the Vence Chapel. In this private world, Matisse pasted coloured paper onto imaginary windows that he had drawn on the studio walls in order to test the effect of shapes and colours; samples of stained glass were attached to the window panes themselves. For Liberman, this working practice produced a singular result:

> In balancing primary colors, blue and yellow, with green, he [Matisse] found that the resulting light created within the white box of the chapel would be rose violet. Matisse was attempting to advance beyond painting, by imprinting on the senses of the spectator colors that did not exist in reality but only in the mind.[7]

By the time the Vence Chapel was created, Matisse's reputation as a colourist had long been established in the minds of his audiences. For Liberman, however, the artist went beyond mere physical experiments with pigment. Rather, in his late works he freed colour from sensory perception and released it into a transcendent realm.

For André Rouveyre, the Vence Chapel was 'sanctuary' that had the power to affect 'the traditional visual consciousness of Christians around the entire world'.[8] As John Klein has pointed

out, while many writers of the period (Matisse included) liked to present the project as the culmination of the artist's career, the work did, in fact, serve as the basis for many other works.[9] As early as 1948, Canon Jean Devémy invited Matisse to create a mural for the Church of Notre-Dame-de-Toute-Grâce in Assy – a venture that included several avant-garde artists of Matisse's generation. In July 1951 he completed a design for a stained glass window (*Chinese Fish*) for Tériade's private residence in Saint-Jean-Cap-Ferrat. This was followed by designs for windows titled *Christmas Eve* for *Life* magazine, *The Vine* for a villa owned by Pierre Matisse also in Saint-Jean-Cap-Ferrat and *Wild Poppies* for a Dominican convent in Lyon. In 1953 stained glass windows were produced for a mausoleum commissioned by American patrons Albert and Mary Lasker (two of Pierre Matisse's clients), and in 1954 Matisse designed a rose window for the Union Church of Pocantico Hills, New York, a work that was commissioned by Nelson A. Rockefeller in memory of his mother Abby Aldrich Rockefeller. In many respects, therefore, the Vence Chapel was a project that spurred variations in other architectural and creative contexts.

Although Matisse had spent his working life in Paris and the South of France, he had not forgotten the town in which he was born. In 1951, Le Cateau-Cambrésis planned to honour him with a primary school in his name and a museum dedicated to his art. Matisse contributed designs for stained glass windows (*The Bees*) for the school and donated 82 works to form the basis of the museum's permanent collection. Further works by Matisse and other modernists were added over subsequent decades. Alice Tériade's donation of her husband's collection and archives was a significant addition and testified to the long and productive relationship between publisher and artist.[10] Matisse was represented at the opening of the museum by Jean and Marguerite and sent a written statement to be read at the event. The text was a short reflection on his decision to become an artist in defiance

of family pressures. He explained that once set on the path of an artistic career, he had pursued it with determination: 'I immersed myself "head down" in work, following the principle that was repeated to me throughout my youth and that was expressed in the words "hurry up".'[11]

It was not only northern France that benefitted from Matisse's contribution to local cultural life. Between 1945 and 1946, he had worked with his friend Pierre Bonnard and the artist Jean Cassarini to open a museum of contemporary art in Nice. Together, they co-founded the Union Méditerranéenne pour l'Art Moderne, and Cassarini staged exhibitions of works by artists based in or around Nice, starting with 'Matisse and Nice' in 1946. Matisse created posters to promote the cultural life of the city and in 1950 accepted an honorary directorship of the Galerie des Ponchettes on the Quai des États-Unis. The gallery held a retrospective of his works the same year, and Nice crowned the artist 'citizen of honour'.[12] Through these activities in northern and southern French cities, Matisse ventured into a new realm – that of art institutions – for the purposes of shaping his legacy.

Honours proliferated for Matisse in the late 1940s and early 1950s. In addition to exhibitions and commissions in France and abroad, he was promoted to Commander of the Legion of Honour in 1947 and won the grand prize at the Venice Biennale (at which he represented France) in 1950. In 1951 he had a large exhibition at the National Museum in Tokyo, for which he contributed a short catalogue preface. In 1951–2 Alfred H. Barr Jr curated a retrospective of his works at the Museum of Modern Art in New York that travelled to Cleveland, Chicago and San Francisco. Matisse was about to celebrate his 82nd birthday, but Barr reassured audiences that this had not impacted on either the nature of the exhibition or the artist's creative energy. Matisse's mind was full of plans for new projects and, in consequence, the exhibition was 'merely a report of progress, of magnificent achievement not yet completed'.[13]

Among the last images of Matisse are sketches by the sculptor Alberto Giacometti. Giacometti had worked closely with Pierre Matisse throughout the 1940s, and Pierre had been responsible for organizing exhibitions of the sculptor's works in New York. In the early 1950s a proposal was made by the Department of Coins and Medals in Paris to create a commemorative medal of Matisse. While Matisse was originally to have designed this himself, he delegated the task to Giacometti in 1954. Giacometti happily took up the suggestion and went to stay with Matisse in Nice towards the end of June 1954. Giacometti produced numerous sketches of the artist and a series of more detailed pencil portraits. Some of the sketches were made on covers of the literary review *Les Temps modernes* and created a curious interplay of word and image. Small portraits of Matisse spill over the text and into the margins, as if Giacometti needed the distraction of other elements on the page in order to focus more closely on his subject. In the larger images, Matisse is depicted in a wheelchair and in bed, on one occasion with pencil and paper in hand. The intensity of the process was characteristic of Giacometti's portraiture practice, a 'great adventure', as he put it, during which the artist sees 'something unknown arise each day, in a single face'.[14] Disagreement between Giacometti and the technicians at the Department of Coins and Medals meant that the medal was never produced according to the artist's conception.[15] The sketches testify, however, to a dialogue between Matisse and a younger artist that was reminiscent of the visits Matisse had paid to Renoir in the South of France over thirty years earlier.

On 3 November 1954 – five months after Giacometti's visit – Matisse died of a heart attack. He was buried in Cimiez in a tomb designed by his son Jean. Services were held in Nice and in Paris, and numerous homages followed in the French, English and u.s. presses. The *New York Times* announced the death of 'one of France's greatest painters', and an obituary by André Chastel published in

Le Monde suggested that future generations would compare Matisse to Manet.[16] *Paris-Match* devoted a photo feature and essay to the memory of the artist's work on 13 November. Influenced by the strong connection between Matisse, Louis Aragon and Paul Éluard, the French Communist press declared Matisse to have been among the greatest artists in the world and one who had upheld French traditions in his works. Yet, as Claudine Grammont notes, this rankled with some readers of *Les Lettres françaises* who continued to think of Matisse as an essentially bourgeois artist.[17]

The critical framework that had developed around Matisse's work during his lifetime developed swiftly in the years after his death. This was fuelled in part by museums, but also by the poets and publishers with whom Matisse had enjoyed close relationships. In 1958 Pierre Reverdy published a long essay about the artist in the journal *Verve*. Titled 'Matisse in Light and Happiness', the essay reinforced themes that had been associated with the artist over the latter decades of his career: colour, serenity and luminosity. For Reverdy, Matisse had stripped pictorial art from 'insignificant chatter', thereby creating an intense visual experience that combined shock, pleasure and wonder.[18]

Aragon continued to champion Matisse's works, revising and republishing his own essays and giving interviews about his friendship with the painter. A series of radio interviews given to Jean Ristat in 1971 coincided with the publication of *Henri Matisse, roman* and contextualized the genesis of the book. Aragon reflected on the difficulties of constructing a work that was capable of conveying his complex relationship to the artist and lamented the quicksand of memory that threatened attempts to bring those connections to life. Writing in 1968, Aragon described the necessarily fluid nature of his writing as deriving from the fact that 'the man [Matisse] is silent, because I can no longer hear his voice, because he has ceased to be a presence only to become a question'.[19]

While writers contributed to the development of Matisse's reputation and emphasized the ongoing relevance of his art, the work of Marguerite Duthuit cannot be underestimated when considering the artist's legacy. From her earliest childhood, Marguerite had devoted herself to her father's practice and she continued to do so long after his death. Archival materials in Paris and New York reveal the extent to which she negotiated with museums and dealers keen to exhibit Matisse's art. Her dealings extended to writers who had worked with Matisse and wanted to bring to fruition illustrated books that had not been completed. Marguerite was sensitive to the contexts in which her father's works were likely to appear and, in many cases, dealt firmly with those who sought to benefit financially from their former relationship to the artist.

Although Lydia had been Matisse's closest companion for two decades, she was not present at the artist's funeral. Tensions persisted between her and members of the family (who blamed her for the rift between husband and wife), and Lydia was not viewed as part of the 'official' story of Matisse's creative life. While Matisse's children managed the artist's archives, Lydia did, however, make important contributions to Matisse's posthumous reputation. In addition to donating works from her personal collection to Russian museums, her books published in 1986 and 1996 brought the artist's studio practice to life and gave an important insight into the genesis of individual works.

Matisse's critical afterlife was fashioned not just by writers, curators, family members and close associates, but, most importantly, by other artists. In 1912 André Salmon had provocatively declared Matisse's art to be 'sterile' with only a few followers in the Paris suburbs and perhaps among German and Russian artists.[20] Having pitted Matisse and Picasso as opponents in the early twentieth century, Salmon wrote as a supporter of Cubism, but his prediction about Matisse's legacy was wrong.

Upon Matisse's death, Picasso lost one of his closest and most long-standing interlocutors. He famously declared to his biographer Roland Penrose that Matisse had left him his *Odalisques* 'as his legacy'.[21] Indeed, by the end of 1954, Picasso had begun work on a series of canvases featuring an Orientalist theme, though they were, in fact, derived primarily from Eugène Delacroix's *Women of Algiers in their Apartment* (1834) rather than from Matisse's paintings of the 1920s. Compositions by the Cuban painter Wifredo Lam (including *The Window I* of 1935 and *The Table* of 1939) clearly interface with Matisse's works of 1912 to 1917 in terms of both their palette and composition, while Françoise Gilot identified the Russian-born painter Nicolas de Staël as an inheritor of Matisse's vibrant colour harmonies.[22] The U.S. artist Richard Diebenkorn displayed an even closer engagement with Matisse in terms of his drawing style, palette, composition and use of cut-outs. For the curator Steven A. Nash, this was an aspect of Diebenkorn's creativity that made him 'the one major post-Second World War American artist most tied to European traditions' in the development of his own expressive style.[23]

Towards the end of his life, Matisse found himself alienated from post-war abstract painting. In an interview with André Verdet of 1952 he stated: 'As for the so-called abstract painters of today, it seems to me that too many of them depart from a void. They are gratuitous . . . they defend a *non-existent* point of view.'[24] As this book has shown, Matisse understood his art to be anchored in reality and motivated by his subjective response to it. This remained the case even as he expressed that reality through non-mimetic shapes and forms. For Matisse, this commitment to the object was antithetical to the drip paintings of Jackson Pollock or the colour-field works of Mark Rothko and Barnett Newman.

This did not, however, mean that Matisse's approach to art making became redundant. From the 1960s to her death in 2018, the American multimedia artist Betty Woodman produced large-scale murals and installations that extended Matisse's commitment

to both objects and decoration. In Woodman's *A Single Joy of Song* (2017) brightly coloured background panels interface with three-dimensional ceramics that seem to have sprung from the canvas to share the space occupied by the viewer. If much of Matisse's Nice-period work experimented with ways in which three-dimensional objects could cohere with two-dimensional surfaces, Woodman's multimedia works brought that enterprise to life by integrating painting and sculpture into a single artefact.

Matisse's still-lifes also influenced the work of Scottish painter Anne Redpath. A key member of a group of mid-twentieth-century painters known as The Edinburgh School, Redpath's integration of textiles into her compositions (*The Indian Rug (or Red Slippers)*, *c*. 1942) combined with the use of unusual angles on her subjects (*Still-life with Teapot on Round Table*, *c*. 1945) are reminiscent of Matisse's arrangement of domestic objects in still-lifes created from 1911 to the early 1940s.

The British artist David Hockney has gleefully admitted to 'plundering' works by both Matisse and Picasso.[25] While Hockney's graphic work of the late 1970s owes much to Matisse's draftsmanship, it is the artist's use of intersecting planes of brilliant colour to disrupt perspective and to reconfigure space that demonstrates a direct connection to the work of his French predecessor. The landscape in Hockney's diptych *A Visit with Mo and Lisa, Echo Park* (1984) unfolds in different directions, as sections of paint are pieced together in a pseudo-collage. In addition to the work's use of brilliant primary colours, vegetal forms reminiscent of Matisse's lagoon motifs appear on each panel and serve as a counterweight to the angular construction of the built environment.

Younger generations of contemporary artists continue to engage with Matisse's work. Laurie Raskin (u.s.) and Pascal Martin (France) have created 'homages' to Matisse in print and collage respectively, while John Nolan (Republic of Ireland) and Christina

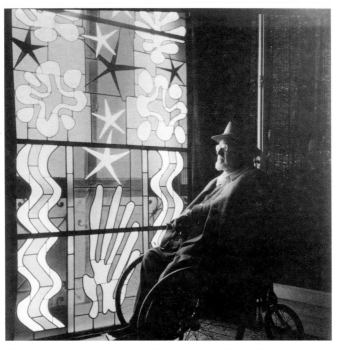

Matisse with the stained glass window *Christmas Eve*, Hotel Régina, Nice, 1952.

Penrose (U.S.) have used the artist's paintings as an inspiration for the creation of still-lifes. One of the most innovative engagements with Matisse's work has come from the U.S. artist Ellen Gallagher. In an ironic take on Matisse's Nice-period paintings, Gallagher produced her own *Odalisque* in 2005 for an exhibition at the Freud Museum in London. Derived from the photograph of Matisse sketching the model Zita in his studio at 1, Place Charles-Félix, Nice, in 1928 (see p. 109), Gallagher manipulates the image such that Matisse is turned into Freud while Gallagher herself becomes the odalisque. The resulting image is both playful and insightful. Capturing the critical anxiety generated by Matisse's Nice-period works and questioning the sexual politics of the studio, Gallagher

playfully embeds a psychoanalytic viewpoint in her photograph while making that perspective complicit with the staginess of the composition. In this case, the artist/model in the work becomes the active subject who fixes a wary eye on the fictional artist/analyst.

In his review of the Vence interiors, drawings and cut-outs exhibited at Pierre Matisse's New York gallery in 1949, Clement Greenberg wrote: 'We complain – and with a good deal of reason – about the age we live in, but I feel that we ought also to rejoice occasionally that we live in the same one as Matisse.'[26] Greenberg's statement remains relevant today. As this book has hoped to show, the relentless innovation and exuberance of Matisse's art produced over a long lifetime continues to serve as an inspiration to artists and to provide fertile material for enjoyment and critical investigation by audiences. To some extent, therefore, we continue to inhabit the same age as Matisse. For this reason alone, there is cause to rejoice occasionally.

References

Introduction

1 Matisse recounts the acquisition of the work in Henri Matisse with Pierre Courthion, *Chatting with Henri Matisse: The Lost 1941 Interview*, ed. Serge Guilbaut, trans. Chris Miller (London, 2013), p. 66.

2 'Interview with Jacques Guenne', in *Matisse on Art*, ed. Jack Flam (Berkeley, CA, 1995), p. 80.

3 Matisse, 'On Cézanne's *Three Bathers*', in *Matisse on Art*, ed. Flam, p. 124.

4 Edmond Campagnac, 'De Cézanne à Matisse', *Le Matin*, 25 July 1937, p. 4.

5 Duncan Phillips, *New York Times*, 23 February 1913. Phillips later founded the Phillips Memorial Gallery (now the Phillips Collection, Washington, DC) and acquired several of Matisse's works for the collection.

6 'Interview with Clara T. MacChesney', in *Matisse on Art*, ed. Flam, p. 69.

7 Hilary Spurling, *The Unknown Matisse: A Life of Henri Matisse*, vol. I: *1869–1908* (London, 2000) and *Matisse the Master: A Life of Henri Matisse*, vol. II: *1909–1954* (London, 2006); Catherine Bock-Weiss, *Henri Matisse: A Guide to Research* (New York and London, 1996); Claudine Grammont, ed., *Tout Matisse* (Paris, 2018); Henri Matisse, *Écrits et propos sur l'art*, ed. Dominique Fourcade (Paris, 2005); Flam, *Matisse on Art*. Unless otherwise noted, translations are by the author.

1 Seeds

1 Serge Guilbaut, ed., *Chatting with Henri Matisse: The Lost 1941 Interview*, trans. Chris Miller (London, 2013), p. 35.

2 Théophile Gautier, 'Francisco Goya y Lucientes', *Le Cabinet de l'amateur et le l'antiquaire*, I (1842), pp. 337–45; Charles Baudelaire, *Oeuvres complètes*, 2 vols, ed. Claude Pichois (Paris, 1976), vol. II, p. 570; Joris-Karl Huysmans, 'Goya et Turner', *Certains* (Paris, 1889), p. 200.

3 Charles Yriarte, *Goya: Sa Biographie* (Paris, 1867), p. 81.

4 See Janis Tomlinson, *Francisco Goya y Lucientes, 1746–1828* (London, 1994), pp. 291–5.

5 Guilbaut, ed., *Chatting with Henri Matisse*, pp. 39 and 35.

6 Harrison C. White and Cynthia A. White, *Canvases and Careers: Institutional Change in the French Painting World* (New York, 1965), pp. 114–15.

7 Guilbaut, ed., *Chatting with Henri Matisse*, p. 37.

8 'On Modernism and Tradition', in *Matisse on Art*, ed. Jack Flam (Berkeley, CA, 1995), p. 121.

9 Ambroise Vollard, *En écoutant Cézanne, Degas, Renoir* (Paris, 2008), p. 64.

10 Guilbaut, ed., *Chatting with Henri Matisse*, pp. 62 and 65.

11 Ambroise Vollard, *Paul Cézanne* (Paris, 1915), pp. 55, 76 and 106.

12 For further details see Constance Cain Hungerford, 'Meissonier and the Founding of the Société Nationale des Beaux-Arts', *Art Journal*, XLVIII/1 (1989), pp. 71–7.

13 Raymond Boyer, 'L'Art et la beauté aux Salons de 1898', *L'Artiste: Revue de l'art contemporain*, I (January to March 1898), pp. 102–3 and 105.

14 Ibid., p. 103.

15 Santillane (pseud.), 'Les Artistes et l'état', *Gil Blas*, 26 April 1897, pp. 1–2.

16 René Maizeroy, 'Le Salon du Champ-de-Mars', *Gil Blas*, 26 April 1897, p. 1.

17 'Interview with Jacques Guenne', in *Matisse on Art*, ed. Flam, pp. 79–80.

18 Hilary Spurling, *The Unknown Matisse: A Life of Henri Matisse,* vol. I: *1869–1908* (London, 2000), p. 115.

19 Guilbaut, ed., *Chatting with Henri Matisse*, p. 137.

20 Moreau's Symbolism and his treatment of mythological themes made him the antithesis of Impressionism's predilection for everyday subject-matter and outdoor painting. He was targeted in Édmond Duranty's essay *The New Painting* of 1876. See Duranty, *La Nouvelle Peinture*, ed. Marcel Guérin (Paris, 1946), pp. 23–4.

21 Matisse, letter to Albert Marquet, 28 February 1898, in *Matisse–Marquet Correspondance 1898–1947*, ed. Claudine Grammont (Paris, 2008), p. 21.

22 Paul Signac, *D'Eugène Delacroix au Néo-Impressionnisme* (Paris, 1911), p. 1.

23 Ibid., p. 38.

24 Ibid., p. 7.

25 Guilbaut, ed., *Chatting with Henri Matisse*, p. 48.

26 'Notes of a Painter on His Drawing', in *Matisse on Art*, ed. Flam, p. 131.

27 Jules and Edmond de Goncourt, *Études d'Art: Le Salon de 1852 – La Peinture à l'Exposition de 1855* (Paris, 1893), pp. 138–9.

28 Guilbaut, ed., *Chatting with Henri Matisse*, p. 51.

29 'Interview with Georges Charbonnier', in *Matisse on Art*, ed. Flam, p. 193.

30 Guilbaut, ed., *Chatting with Henri Matisse*, p. 55.

31 Ibid., p. 56.

32 Ibid., p. 52.

2 The Wild Man and the Professor

1 Manifeste de la Société des Artistes Indépendants, *Le Moniteur des Arts*, 17 October 1884.

2 Anon (or Roger Marx), 'XVIIe exposition de la société des "artistes indépendants"', *Chronique des arts et de la curiosité*, 4 May 1901, p. 138.

3 Gustave Coquiot, 'Le Salon des Indépendants', *Gil Blas*, 20 April 1901, p. 2.

4 Alfred H. Barr Jr, *Matisse: His Art and His Public* (New York, 1951), p. 49.

5 For an account of Weill's career, see Marianne Le Morvan, *Berthe Weill 1865–1951: La petite galeriste des grands artistes* (Orléans, 2011).

6 For details of Level's operation, see Michael C. Fitzgerald, *Making Modernism: Picasso and the Creation of the Market for Twentieth-century Art* (Berkeley, CA, 1995), pp. 15–18.

7 For a report of the auction, see Seymour de Ricci, 'La "Peau de l'Ours"', *Gil Blas*, 3 March 1914, p. 4.

8 The right was introduced in France in 1920.

9 Fitzgerald suggests that Level's scheme was inspired by Matisse's earlier plan. See *Making Modernism*, p. 273, fn. 19.

10 Roger Marx, 'Préface', *Exposition des oeuvres du peintre Henri Matisse*, exh. cat., Galerie Vollard, 6 rue Laffitte (Paris, 1904), p. 5.

11 Louis Vauxcelles, 'Notes d'art, Exposition Henri Matisse', *Gil Blas*, 14 June 1904.

12 Charles Saunier, 'Les petites expositions', *Revue universelle*, IV (1904), p. 537.

13 Roger Marx, 'Exposition Henri Matisse', *La Chronique des arts et de la curiosité*, 18 June 1904, p. 196.

14 Rebecca A. Rabinow, 'Vollard and Matisse', in *Cézanne to Picasso: Ambroise Vollard, Patron of the Avant-Garde*, Gary Tinterow, Rebecca Rabinow et al., exh. cat., The Metropolitan Museum of Art, New York (New York, 2006), p. 131.

15 Gary Tinterow, with research by Asher E. Miller, 'Vollard and Picasso', in *Cézanne to Picasso: Ambroise Vollard, Patron of the Avant-garde*, Tinterow, Rabinow et al., p. 110.

16 Ambroise Vollard, *Souvenirs d'un marchand de tableaux* (Paris, 2007), p. 225.

17 'Statements to Tériade', in *Matisse on Art*, ed. Jack Flam (Berkeley, CA, 1995), p. 201.

18 John Elderfield, *Henri Matisse: A Retrospective* (New York, 1992), pp. 35–7.

19 'On Fauvism and Colour', in *Matisse on Art*, ed. Flam, p. 84.

20 Ibid.

21 Alastair Wright, *Matisse and the Subject of Modernism* (Princeton, NJ, 2004), pp. 18 and 21–5.

22 Louis Vauxcelles, 'Le Salon des Indépendants', *Gil Blas*, 23 March 1905, p. 1.

23 'On Fauvism and Colour', in *Matisse on Art*, ed. Flam, p. 84.

24 André Derain, *Lettres à Henri Matisse suivies de La Pensée moderne et la peinture*, ed. Rémi Labrusse and Jacqueline Munck (Paris, 2017), p. 14.

25 'Statement to Tériade', in *Matisse on Art*, ed. Flam, p. 84.

26 Vollard, *Souvenirs d'un marchand de tableaux*, p. 226.

27 Louis Vauxcelles, 'Le Salon d'Automne', *Gil Blas* (supplement), 17 October 1905, p. 2.

28 Marcel Nicolle, 'Le Salon d'Automne', *Journal de Rouen*, 20 November 1905, p. 4.

29 Joséphin Péladan, 'Le Salon d'Automne et ses retrospectives Le Greco et Monticelli', *L'Instantané, Supplément illustré de la Revue hébdomadaire*, 17 October 1908, no. 42, p. 373.

30 Ibid., p. 361.

31 André Gide, 'Promenade au Salon d'Automne', *Gazette des Beaux-Arts*, 1 December 1905, pp. 483–4.

32 Vollard, *Souvenirs d'un marchand de tableaux*, p. 151.

33 Fernande Olivier, *Picasso et ses amis* (Paris, 2001), p. 115.

34 Louis Vauxcelles, 'Le Salon des Indépendants', *Gil Blas*, 20 March 1907, p. 1.

35 Yve-Alain Bois, 'On Matisse: The Blinding', *October*, LXVIII (Spring 1994), p. 105; Arthur Danto, *The Abuse of Beauty: Aesthetics and the Concept of Art* (Chicago, IL, 2003), pp. 35–6.

36 Camille Mauclair, *Trois crises de l'art actuel* (Paris, 1906), p. 286.

37 Gelett Burgess, 'The Wild Men of Paris', *Architectural Record*, May 1910, pp. 400–414 (p. 401).

38 For further detail, see Lisa Mintz Messinger, ed., *Stieglitz and His Artists: Matisse to O'Keeffe*, exh. cat., The Metropolitan Museum of Art, New York (New Haven, CT, and London, 2011), pp. 32–9.

39 Carol Duncan, 'Virility and Domination in Early Twentieth-century Vanguard Painting', *Artforum* (December 1973), pp. 30–39. Reprinted and revised by Duncan in *Feminism and Art History: Questioning the Litany*, ed. Norma Broude and Mary D. Garrard (London and New York, 1982), pp. 293–313.

40 Ibid., pp. 300–301.

41 Burgess, 'The Wild Men of Paris', p. 414.

42 Ibid., p. 404.

43 Danto, *The Abuse of Beauty*, p. 36.

44 Ibid., pp. 403–4.

45 Matisse, 'Statement to Tériade', in *Matisse on Art*, ed. Flam, p. 204.

46 Pierre Daix, *Pour une histoire culturelle de l'art moderne: Le XXe siècle* (Paris, 2000), pp. 56–7. For a discussion of Matisse's acquisition of the sculpture and of the reception of African art in France during the early

decades of the twentieth century see John Warne Monroe, *Metropolitan Fetish: African Sculpture and the Imperial French Invention of Primitive Art* (Ithaca, NY, and London, 2019), pp. 36–42.

47 Ellen McBreen, 'Art africain', in *Tout Matisse*, ed. Claudine Grammont (Paris, 2018), p. 39.

48 Ellen McBreen, *Matisse's Sculpture: The Pinup and the Primitive* (New Haven, CT, 2014), pp. 8–9.

49 Guillaume Apollinaire, 'Henri Matisse', in *Oeuvres en prose complètes*, ed. Pierre Caizergues and Michel Décaudin (Paris, 1991), vol. II, pp. 100–103.

50 Ibid., p. 101.

51 'Notes of a Painter', in *Matisse on Art*, ed. Flam, p. 41.

52 'Sarah Stein's Notes', in *Matisse on Art*, ed. Flam, pp. 44–52.

53 Ibid., p. 45.

54 The full manuscript of Weber's 'Speech on his Class with Henri Matisse' can be found in the Smithsonian Archives of American Art: www.si.edu/object/max-weber-speech-his-class-henri-matisse%3AAAADCD_item_15702, accessed 25 July 2019.

3 Friends and Rivals

1 Marc Chagall, *My Life*, trans. Dorothy Williams (London, 2018), p. 102.

2 See Hilary Spurling, *Matisse the Master: A Life of Henri Matisse*, vol. II: *1909–1954* (London, 2006), p. 38.

3 André Salmon, 'Henri Matisse', *Paris-Journal*, 15 February 1910.

4 Jacques Rivière, 'Une Exposition de Henri Matisse', *Nouvelle revue française*, 16 April 1910, pp. 531–4.

5 J.-F. Schnerb, 'Exposition Henri Matisse', *La Chronique des arts et de la curiosité*, 19 February 1910, p. 59.

6 Octave Mirbeau, *Correspondance avec Claude Monet*, ed. Pierre Michel and Jean-François Nivel (Charente, 1990), p. 225.

7 Apollinaire, 'Prenez garde à la peinture! Le Salon des artistes indépendants. Six mille toiles sont exposées', *Oeuvres en prose complètes*, ed. Pierre Caizergues and Michel Décaudin (Paris, 1991), vol. II, pp. 141–2.

8 John Elderfield, 'Moving Aphrodite: On the Genesis of *Bathers with a Turtle* by Henri Matisse', in Yve-Alain Bois, John Elderfield and Laurie

A. Stein, *Henri Matisse: Bathers with a Turtle* (Saint Louis, MO, 1998), pp. 20–49.

9 Elderfield, 'Moving Aphrodite', pp. 23–33; Claudia Rousseau, '"Une femme s'honore par son silence": Sources et signification de *Baigneuses à la tortue* de Matisse', *Revue de l'Art*, 92 (1991), pp. 79–86.

10 For a detailed discussion of Shchukin's relationship to Matisse, see Natalya Semenova with André Delocque, *The Collector: The Story of Sergei Shchukin and His Lost Masterpieces*, trans. Anthony Roberts (New Haven, CT, and London, 2018).

11 'Notes of a Painter' and 'How I Made My Books', in *Matisse on Art*, ed. Jack Flam (Berkeley, CA, 1995), pp. 10 and 167; André Verdet, *Prestiges de Matisse* (Tesserete, 2011), p. 40.

12 Apollinaire, 'Le Salon d'Automne', *Oeuvres en prose complètes*, vol. II, p. 228.

13 André Salmon, *La jeune peinture française* (Paris, 1912), p. 19.

14 Serge Guilbaut, ed., *Chatting with Henri Matisse: The Lost 1941 Interview*, trans. Chris Miller (London, 2013), pp. 30–31.

15 Avinoam Shalem, 'The 1910 Exhibition "Meisterwerke muhammedanischer Kunst" Revisited', in *After One Hundred Years: The 1910 Exhibition 'Meisterwerke muhammedanischer Kunst' Reconsidered*, ed. Andrea Lerner and Avinoam Shalem (Leiden, 2010), pp. 3–16.

16 Louis Vauxcelles, 'Le Salon d'Automne', *Gil Blas*, 30 September 1911, p. 2.

17 Jack Flam, 'Introduction', in *Matisse on Art*, ed. Flam, p. 9.

18 'Interview with Ernst Goldschmidt', in *Matisse on Art*, ed. Flam, p. 62.

19 Letter from Camoin to Matisse, 14 August 1913, in *Correspondance entre Charles Camoin et Henri Matisse*, ed. Claudine Grammont (Paris, 1997), p. 49.

20 For a detailed discussion of this work and other paintings and drawings that Matisse produced during his stays in Tangier, see Jack Cowart, Pierre Schneider, John Elderfield, Albert Kostenevich and Laura Coyle, *Matisse in Morocco: The Paintings and Drawings, 1912–1913*, exh cat., The National Gallery of Art (Washington, DC, 1990).

21 Oliver Shell, 'Seeing Figures', in *Matisse: Painter as Sculptor*, ed. Dorothy Kosinski, Jay McKean Fisher and Steven Nash, exh. cat., Dallas Museum of Art and Nasher Sculpture Garden, San Francisco Museum of Modern Art and Baltimore Museum of Art (New Haven, CT, and London, 2007), pp. 58–9.

22 René Jean, 'Exposition Henri Matisse (Galerie Bernheim)', *Chronique des Arts et de la curiosité*, 19 April 1913, p. 125.

23 Apollinaire, 'Henri Matisse', *Oeuvres en prose complètes*, vol. II, pp. 571–2.

24 Louis Vauxcelles, 'Exposition Louis Charlot et Matisse', *Gil Blas*, 20 April 1913, p. 4.

25 André Salmon, *Souvenirs sans fin, 1903–1940* (Paris, 2004), p. 198.

26 Frances Spalding, *Roger Fry: Art and Life* (Berkeley, CA, 1980), pp. 161–3.

27 Christopher Reed, ed., *A Roger Fry Reader* (Chicago, IL, 1996), p. 113.

28 Ibid., p. 114.

29 Arthur B. Davies, 'The Statement', in *Documents of the 1913 Armory Show: The Electrifying Moment*, ed. Arthur B. Davies et al. (Tucson, AZ, 2009), p. 1.

30 Kenyon Cox, 'The New Art', in *Documents of the 1913 Armory Show*, ed. Davies et al., pp. 21–2.

31 'Interview with Clara MacChesney', in *Matisse on Art*, ed. Flam, p. 69.

32 Ibid.

33 For further details, see Spurling, *Matisse the Master*, p. 163.

34 Stephanie d'Alessandro and John Elderfield, *Matisse: Radical Invention, 1913–1917*, exh. cat., Art Institute of Chicago (Chicago, IL, 2010), pp. 248–9.

35 Ibid., pp. 298–9.

36 Salmon, *Souvenirs sans fin*, p. 916.

37 d'Alessandro and Elderfield, *Matisse: Radical Invention*, pp. 306–8.

38 Letter from Camoin to Matisse, July 1916, *Correspondance entre Charles Camoin et Henri Matisse*, ed. Grammont, p. 101.

39 Hilary Spurling, 'Laurette: Line and Color', in *Matisse: In Search of True Painting*, ed. Dorthe Aagesen and Rebecca A. Rabinow, exh. cat., The Metropolitan Museum of Art, New York (New York and New Haven, CT, 2012), pp. 101–4.

40 See Mary Ann Meyers, *Art, Education, and African-American Culture: Albert Barnes and the Science of Philanthropy* (Abingdon, 2017).

41 Salmon, *La jeune peinture française*, p. 15.

42 Alfred Stieglitz, 'Editorial', *Camera Work*, August 1912, n.p.

43 Gertrude Stein, 'Matisse', *Camera Work*, August 1912, pp. 24–5.

44 Ibid., pp. 29–30.

45 Laurel Recker gives a full account of these issues in 'Pitting "Matisse" against "Picasso": Gertrude Stein's Companion Portraits', *Arizona Quarterly*, LXXII/4 (Winter 2016), pp. 27–52.
46 Apollinaire, 'Picasso', *Oeuvres en prose complètes*, vol. II, pp. 874–5.
47 *Les Arts à Paris*, 1, 15 March 1918.
48 Ibid., p. 19.
49 Ibid., p. 9.
50 Letter from Matisse to Rouveyre, 2 March 1918, in *Correspondance avec André Rouveyre*, ed. Hanne Finsen (Paris, 2001), p. 30.
51 Jeffery K. Taubenberger and David M. Morens, '1918 Influenza: The Mother of all Pandemics', in *Emerging Infectious Diseases*, XII/1 (January 2006), pp. 15–22.

4 Hedonism

1 Letter to Charles Camoin, 23 May 1918, in *Correspondance entre Charles Camoin et Henri Matisse*, ed. Claudine Grammont (Paris, 1997), p. 124.
2 Françoise Gilot and Carlton Lake, *Life with Picasso* (London, 1990), p. 251.
3 'Interview with Ragnar Hoppe', in *Matisse on Art*, ed. Jack Flam (Berkeley, CA, 1995), p. 75.
4 'Black is a Colour', in *Matisse on Art*, ed. Flam, p. 166.
5 On Matisse's comments regarding Renoir's determination to work, see 'Propos rapportés par Louis Gillet', February 1943, in *Écrits et propos sur l'art*, ed. Dominique Fourcade (Paris, 2005), pp. 289–90.
6 For critical interpretations of Renoir's late bathers see Tamar Garb, *Bodies of Modernity: Figure and Flesh in Fin-de-siècle France* (London, 1998), pp. 160–61 and 176–7; Linda Nochlin, *Bathers, Body, Beauty: The Visceral Eye* (Cambridge, MA, 2006), p. 48. For discussion of the role of women in Renoir's later years, see Barbara Ehrlich White, *Renoir: An Intimate Biography* (London, 2017), pp. 321–48. See also Roger Benjamin, 'Why did Matisse Love Late Renoir?', in *Renoir in the Twentieth Century*, ed. Claudia Einecke and Sylvie Patry, exh. cat., Los Angeles County Museum of Art and Philadelphia Museum of Art (Ostfildern, 2011), pp. 136–43.
7 See, for example, 'Henri Matisse: Une palette d'objets', June to September 2016, Musée Matisse, Nice; 'Matisse in the Studio', August to November 2017, Royal Academy of Arts, London.

8 Louis Aragon, *Henri Matisse, roman* (Paris, 2006), pp. 307–8.

9 Gilot and Lake, *Life with Picasso*, p. 66.

10 Georges Ribemont-Dessaignes, 'Salon d'Automne', *391*, 9 (1919), p. 2;
 Jean Cocteau, 'Déformation professionelle' (12 May 1919), reprinted in
 Le Rappel à l'ordre (Paris, 1948), p. 98.

11 Clement Greenberg, 'Review of an Exhibition of the School of Paris
 Painters', in Clement Greenberg, *The Collected Essays and Criticism*,
 ed. John O'Brian, 3 vols (Chicago, IL, 1986), vol. II, p. 89.

12 See also Dominique Fourcade's rehabilitation of the years 1916 to 1930
 in Matisse's oeuvre in 'An Uninterrupted Story', in Jack Cowart and
 Dominique Fourcade, *Henri Matisse: The Early Years in Nice, 1916–1930*,
 exh. cat., National Gallery of Art, Washington, DC (Washington, DC,
 and New York, 1986), p. 53.

13 Arthur Danto, *The Abuse of Beauty: Aesthetics and the Concept of Art*
 (Chicago, IL, 2004), p. 114.

14 Ibid.

15 David Carrier, 'The Beauty of Henri Matisse', *Journal of Aesthetic
 Education*, XXXVIII/2 (Summer 2004), pp. 80–87.

16 See Hilary Spurling, *Matisse the Master: A Life of Henri Matisse*, vol. II:
 1909–1954 (London, 2006), pp. 16–33; Jack Flam, *Matisse and Picasso:
 A Story of their Rivalry and Friendship* (New York, 2003), p. 86.

17 Carrier, 'The Beauty of Henri Matisse', p. 83.

18 See also John Elderfield, *Pleasuring Painting: Matisse's Feminine
 Representations* (London, 1996), p. 19, and Ellen McBreen, 'The Studio
 as Theater', in Ellen McBreen and Helen Burnham et al., *Matisse in the
 Studio*, exh. cat., Royal Academy of Arts (London, 2017), p. 132.

19 Alfred H. Barr Jr, *Henri Matisse: Retrospective Exhibition*, exh. cat.,
 Museum of Modern Art, New York (New York, 1931).

20 See Susan Sidlauskas, 'Contesting Femininity: Vuillard's Family
 Pictures', *Art Bulletin*, LXXIX/1 (March 1997), pp. 85–111; Katherine
 M. Kuenzli, *The Nabis and Intimate Modernism: Painting and the
 Decorative at the Fin-de-siècle* (London and New York, 2010),
 pp. 10–15.

21 Barr, *Henri Matisse: Retrospective Exhibition*, pp. 20–21.

22 Marilynn Lincoln Board, 'Constructing Myths and Ideologies in
 Matisse's "Odalisques"', *Genders*, 5 (Summer 1989), pp. 21–49.

23 'Statement to Tériade', in *Matisse on Art*, ed. Flam, p. 86.

24 Colin Crisp, *The Classic French Cinema, 1930–1960* (Bloomington, IN, 1997), pp. 118–19.

25 See Matisse's comments to Gaston Diehl, to his son Pierre and to Francis Carco in *Écrits et propos sur l'art*, ed. Dominique Fourcade (Paris, 2005), pp. 152 and 165.

26 Gaylyn Studlar, '"Out-Salomeing Salome": Dance, the New Woman, and Fan Magazine Orientalism', in *Visions of the East: Orientalism in Film*, ed. Matthew Bernstein and Gaylyn Studlar (London, 1997), pp. 99–129.

27 Countess de Saint Sauveur, 'Trois semaines au Maroc', *Vogue*, 1 July 1920, p. 22.

28 'Interview with Ragnar Hoppe', in *Matisse on Art*, ed. Flam, p. 76.

29 Lydia Delectorskaya, *Contre Vents et Marées: Peinture et livres illustrés de 1939 à 1943* (New York, 1996), p. 227.

30 Sharon Marcus, *Between Women: Friendship, Desire, and Marriage in Victorian England* (Princeton, NJ, 2007), pp. 8–9.

31 John Russell, *Matisse: Father and Son* (New York, 1999), p. 107.

32 My interpretation of this work differs from that of Elderfield, who interprets Darricarrère as a substitute for Matisse himself. See Elderfield, *Pleasuring Painting*, p. 36.

33 Louis Laloy, 'Les Ballets Russes à l'Opéra: Le Chant du Rossignol', *Comœdia*, 4 February 1920, p. 1.

34 Paul Nash, 'The French Exhibition at the Mansard Gallery', in *Writings on Art*, ed. Andrew Causey (Oxford, 2001), pp. 43–5.

35 Ibid., p. 43.

36 Marius de Zayas, *How, When, and Why Modern Art Came to New York*, ed. Francis M. Naumann (Cambridge, MA, 1996), p. 7.

37 William Carlos Williams, 'A Matisse', in *The William Carlos Williams Reader*, ed. M. L. Rosenthal (New York, 1994), pp. 394–5 (p. 394).

38 Ibid., p. 394.

39 Ibid., p. 395.

40 Charles Vildrac, 'Introduction', in Henri Matisse, *Cinquante dessins par Henri-Matisse* (Paris, 1920), pp. 5–6.

41 'Notes of a Painter on His Drawing', in *Matisse on Art*, ed. Flam, p. 131.

42 Tristan Tzara, 'Review of Pierre Reverdy's *Les Ardoises du toit* and *Les Jockeys camouflés*', *Dada* (Anthologie Dada), 4–5 (15 May 1919), p. 26.

43 Roger Fry, 'Line as a Means of Expression in Modern Art',
Burlington Magazine for Connoisseurs, XXXIII/189 (December 1918),
pp. 201–3 and 205–8.

44 Henri Matisse, *Dessins*, Preface by Waldemar George (Paris, 1925).

45 Ibid., p. 15.

46 Elderfield, *Pleasuring Painting*, pp. 1–2.

47 'Statement to Tériade: On Travel', in *Matisse on Art*, ed. Flam, p. 88.

5 Another Space

1 See John O'Brian, *Ruthless Hedonism: The American Reception of Matisse*
(Chicago, IL, 1999), pp. 24–5.

2 Georges Duthuit, *Les Fauves*, ed. Rémi Labrusse (Paris, 2006).

3 Françoise Gilot, *Matisse and Picasso: A Friendship in Art* (London,
1990), p. 244.

4 'Statement to Tériade: On Travel', in *Matisse on Art*, ed. Jack Flam
(Berkeley, CA, 1995), pp. 90–91.

5 A facsimile edition had, however, been produced in 1918 in Leipzig. For
discussion of Gauguin's writings, see Linda Goddard, *Savage Tales: The
Writings of Paul Gauguin* (New Haven, CT, and London, 2019).

6 'Statement to Tériade: On Travel', in *Matisse on Art*, ed. Flam, p. 90.

7 Ibid.

8 'Oceania', in *Matisse on Art*, ed. Flam, p. 169.

9 John Klein, 'Matisse After Tahiti: The Domestication of Exotic
Memory', *Zeitschrift für Kunstgeschichte*, LX/1 (1997), pp. 44–89.

10 Céline Chicha-Castex, 'Les techniques de Matisse', in *Matisse et la
gravure: l'autre instrument*, ed. Patrice Deparpe, exh. cat., Musée
départemental Matisse, Le Cateau-Cambrésis (Milan, 2015), pp. 59–69.

11 Henri Matisse, 'Note à l'adresse de Raymond Escholier', *Écrits et propos
sur l'art*, ed. Dominique Fourcade (Paris, 2005), p. 214.

12 Adelyn D. Breeskin, 'Swans by Matisse', *American Magazine of Art*,
XXVIII/10 (October 1935), p. 628.

13 Ibid.

14 See also Jay McKean Fisher, 'Mallarmé's Poésies', in *Graphic Passion:
Matisse and the Book Arts*, ed. John Bidwell, exh. cat., The Morgan
Library and Museum, New York (University Park, PA, and New York,

, pp. 19–41; Jack Flam, *Matisse in the Cone Collection: The Poetics of Vision* (Baltimore, MD, 2013).

O'Brian, *Ruthless Hedonism*, p. 88.

16 K. Porter Aichele, *Modern Art on Display: The Legacies of Six Collectors* (Newark, DE, 2016), p. 152.

17 'Interview with Dorothy Dudley', in *Matisse on Art*, ed. Flam, p. 110.

18 Marcelin Pleynet, *Henri Matisse* (Paris, 2002), pp. 202–3.

19 'Interview with Dorothy Dudley', in *Matisse on Art*, ed. Flam, p. 113.

20 Albert C. Barnes and Violette de Mazia, *The Art of Henri Matisse* (Merion, PA, 1933), Dedication.

21 Ibid., p. 19.

22 Ibid., pp. 22–3.

23 Christian Zervos, 'Henri-Matisse: Notes on the Formation and Development of his Work', trans. Charles J. Liebmann Jr, *Cahiers d'art* (U.S. edn, New York, 1931).

24 Meyer Shapiro, 'Matisse and Impressionism: A Review of the Retrospective Exhibition of Matisse at the Museum of Modern Art, New York, November 1931', *Androcles*, I/1 (February 1932), p. 21.

25 Ibid.

26 Ibid., p. 32.

27 Lydia Delectorskaya, *L'apparente facilité . . ., Henri Matisse: peintures de 1935–1939* (Paris, 1986).

28 Ibid., p. 231.

29 Comments reported in 'Constance du Fauvisme', in Tériade, *Écrits sur l'art*, ed. Esther Baumann (Paris, 1996), pp. 478–9.

30 Jack D. Flam, 'Matisse's Backs and the Development of His Painting', *Art Journal*, XXX/4 (Summer 1971), p. 358.

31 Albert E. Elsen, *The Sculpture of Henri Matisse* (New York, 1971), pp. 182–97; Flam, 'Matisse's Backs', p. 358.

32 Christian Zervos, 'Automatism and Illusory Space', *Cahiers d'art*, III/5 (1936), facsimile edition in *Henri Matisse, Drawings, 1936*, trans. Richard Howard (London, 2005), n.p.

33 A preliminary state of the mural (discovered in 1990) is also on display in the Musée d'Art Moderne de la Ville de Paris.

34 Tériade, 'Constance du Fauvisme', pp. 477–9.

35 Gertrude Stein, *The Autobiography of Alice B. Toklas* (London, 2001), p. 41.

36 Georges Braque, Eugene Jolas, Maria Jolas, Henri Matisse, André Salmon and Tristan Tzara, *Testimony Against Gertrude Stein* (The Hague, 1935), pp. 2 and 13.

37 'On Modernism and Tradition', in *Matisse on Art*, ed. Flam, p. 121.

38 Quoted in John Russell, *Matisse: Father and Son* (New York, 1999), p. 55.

39 Jean Clair and Antoine Terrasse, ed., *Bonnard/Matisse Correspondance* (Paris, 2001), p. 78.

40 See Hilary Spurling, *Matisse the Master: A Life of Henri Matisse*, vol. II: *1909–1954* (London, 2006), pp. 398–400.

41 Letter to Marquet, 16 January 1942, in *Matisse–Marquet Correspondance*, ed. Claudine Grammont (Paris, 2008), p. 143.

6 Drawing with Scissors

1 Fernand Mourlot, *Gravés dans ma mémoire: Cinquante ans de lithographie avec Picasso, Matisse, Chagall, Braque, Miro . . .* (Paris, 1979), p. 116.

2 Letter to Pierre Bonnard, 7 September 1940, in *Bonnard/Matisse: Correspondance 1925–1946*, ed. Jean Clair and Antoine Terrasse (Paris, 2001), p. 74.

3 Serge Guilbaut, ed., *Chatting with Henri Matisse: The Lost 1941 Interview*, trans. Chris Miller (London, 2013), pp. 8–9.

4 Ibid., p. 24.

5 Ibid., p. 13.

6 Matisse, letter to André Rouveyre, 8 December 1941, in *Matisse–Rouveyre Correspondance*, ed. Hanne Finsen (Paris, 2001), p. 83.

7 'How I Made My Books', in *Matisse on Art*, ed. Jack Flam (Berkeley, CA, 1995), p. 168.

8 Albert Skira, *Vingt ans d'activité* (Geneva, 1948), p. 14.

9 Letter from Henry de Montherlant to Matisse, 14 May 1938 (Henri Matisse Archives, Issy-les-Moulineaux, 380514a.1); letter from Tristan Tzara to Matisse, 2 May 1948 (ibid., 480502); letter from Luc Decaunes to Matisse, 8 April 1947 (ibid., 470408).

10 Louis Aragon, *Henri Matisse, roman* (Paris, 2006), p. 20.

11 For further discussion, see Laurence Bertrand-Dorléac, 'Ignoring History', in *Chatting with Henri Matisse*, ed. Guilbaut, pp. 235–47;

Claudine Grammont, 'Guerre' in *Tout Matisse*, ed. Claudine Grammont (Paris, 2018), pp. 400–402.

12 Ibid., p. 241.

13 Aragon, *Henri Matisse, roman*, p. 230.

14 Emmanuelle Polack and Claudine Grammont, 'Marché de l'art', in *Tout Matisse*, ed. Grammont, p. 505.

15 Louis Aragon, *Sur Henri Matisse: Entretiens avec Jean Ristat* (Paris, 1999), pp. 69–70.

16 Kathryn Brown, *Matisse's Poets: Critical Performance in the Artist's Book* (New York, 2017), p. 110.

17 Ibid.

18 Claudine Grammont, 'La Blouse roumaine', in *Tout Matisse*, ed. Grammont, pp. 105–6. See also John Klein, *Matisse and Decoration* (New Haven, CT, and London, 2018), p. 97.

19 See Hilary Spurling, *Matisse the Master: A Life of Henri Matisse*, vol. II: *1909–1954* (London, 2006), p. 412.

20 Aragon, *Henri Matisse, roman*, p. 13.

21 Ibid., p. 31.

22 Ibid., p. 63.

23 Ibid., p. 484.

24 'Notes of a Painter on His Drawing', in *Matisse on Art*, ed. Flam, pp. 130–32.

25 Ibid., p. 132.

26 Maurice Merleau-Ponty, 'Indirect Language and the Voices of Silence', in *The Merleau-Ponty Reader*, ed. Ted Toadvine and Leonard Lawler (Evanston, IL, 2007), pp. 241–82 (p. 247).

27 Aragon, *Henri Matisse, roman*, p. 100.

28 Ibid., p. 101.

29 Christian Zervos, 'Automatism and Illusory Space', facsimile edition, *Henri Matisse, Drawings 1936*, trans. Richard Howard (London, 2005).

30 Tristan Tzara, letter to Henri Matisse, 2 May 1948, Henri Matisse Archives, Issy-les-Moulineaux, 480502.

31 Jean Puy, 'Matisse', *Le Point* (July 1939), p. 28.

32 André Rouveyre, *Apollinaire, Illustrations de Henri Matisse* (Paris, 1952), p. 19.

33 Spurling, *Matisse the Master*, p. 413.

34 Aragon, *Henri Matisse, roman*, p. 22. For further details of the Villa
 le Rêve see Marie-France Boyer, *Matisse at Villa le Rêve*, trans. Anna
 Bennett (London, 2004).

35 Letter to Charles Camoin, 5 May 1944, *Matisse–Camoin Correspondance*,
 ed. Claudine Grammont (Paris, 1997), p. 200.

36 Letter to André Rouveyre, 19 January 1945, *Matisse–Rouveyre
 Correspondance*, ed. Finsen, p. 301.

37 Letter from Christian Zervos to Henri Matisse, 23 December 1944,
 Henri Matisse Archives, Issy-les-Moulineaux, 441223; Letter to Henri
 Matisse, 20 January 1945, *Matisse–Rouveyre Correspondance*, ed. Finsen,
 p. 301.

38 Léon Degand, 'Matisse à Paris', *Les Lettres françaises*, 6 October 1945,
 pp. 1 and 4.

39 Brown, *Matisse's Poets*, p. 110.

40 Georges Duhamel, 'Preface', *Cent ans d'édition française: 1847–1947*,
 exh. cat., La Galerie Mazarine (Paris, 1947), p. 10.

41 Aragon, *Sur Henri Matisse*, p. 31.

42 Letter to Charles Camoin, 16 November 1944, *Matisse–Camoin
 Correspondance*, ed. Grammont, p. 212.

43 Léon Degand, 'Ambiance expressionniste', *Les Lettres françaises*,
 28 December 1945, p. 4.

44 Christian Zervos, 'Picasso', trans. Dr and Mrs C. A. Hackett, and Jean
 Cassou, 'Matisse', trans. R. H. Myers, in *Matisse Picasso*, exh. cat.,
 Victoria and Albert Museum, London (London, 1945), n.p.

45 *The Times*, 17 December 1945, p. 5; 15 December 1945, p. 5; 21 December
 1945, p. 5.

46 Yve-Alain Bois discusses the pairing of works by Matisse and Picasso
 in post-war exhibitions and notes some of the negative reactions
 to Picasso as an 'ambassador' of France in the conservative press in
 Matisse et Picasso (Paris, 2001), pp. 180–89.

47 Françoise Gilot, *Matisse and Picasso: A Friendship in Art* (London,
 1990), p. 151.

48 See Ellen McBreen, 'Matisse at Work', in *Matisse in the Studio*, ed. Ellen
 McBreen and Helen Burnham et al., exh. cat., Royal Academy of Arts
 (London, 2017), pp. 26–8; John Mack, 'Making and Seeing: Matisse
 and the Understanding of Kuba Pattern', *Journal of Art Historiography*,
 no. 7 (December 2012), pp. 1–19; Hilary Spurling et al., *Matisse et la*

couleur des tissus, exh. cat., Musée départemental Matisse, Le Cateau-
Cambrésis (Paris, 2004).

49 McBreen, 'Matisse at Work', p. 28.

50 Clement Greenberg, 'Review of an Exhibition of Henri Matisse', in *The
Collected Essays and Criticism*, ed. John O'Brian, 3 vols (Chicago, IL,
1986), vol. II, p. 292.

51 Aragon, *Henri Matisse, roman*, pp. 822–3.

52 Karl Buchberg, Markus Gross and Stephan Lohrengel, 'Materials and
Techniques', in *Henri Matisse: The Cut-outs*, ed. Karl Buchberg et al.,
exh. cat., Tate Modern (London, 2014), p. 256.

53 Ibid., p. 259.

54 Ibid., p. 255.

55 Henri Matisse, *Jazz*, trans. Sophie Hawkes (New York, 1992), p. xxvii.

56 Letter to André Rouveyre, 25 December 1947, *Matisse–Rouveyre
Correspondance*, ed. Finsen, p. 478.

57 Letter to Henri Matisse, 5 January 1948, *Matisse–Rouveyre
Correspondance*, ed. Finsen, p. 480.

58 Telegram from Pierre Matisse to Henri Matisse, January 1948, Pierre
Matisse Archives, Morgan Library and Museum, New York, File 186.38.

59 John O'Brian, *Ruthless Hedonism: The American Reception of Matisse*
(Chicago, IL, 1999), pp. 142–9.

60 'The Path of Color', in *Matisse on Art*, ed. Flam, p. 178.

61 Anne Coron, 'Small Paper Cut-outs', in *Matisse: A Second Life*,
ed. Hanne Finsen, trans. James Mayor and Christine Schultz-Touge,
exh. cat., Louisiana Museum, Humlebaek (Paris, 2005), p. 186.

62 Ibid.

63 Buchberg, Gross and Lohrengel, 'Materials and Techniques', p. 261.

64 For further detail, see Coron, 'Small Paper Cut-outs', p. 188.

65 Aragon, *Henri Matisse, roman*, pp. 626–7.

66 Franz Meyer, 'Introduction', *Henri Matisse: Les grandes gouaches
découpées*, exh. cat., Kunsthalle, Bern (Bern, 1959).

67 Monroe Wheeler, *The Last Works of Henri Matisse: Large Cut Gouaches*,
exh. cat., Museum of Modern Art, New York (New York, 1961), p. 10.

68 'The Chapel of the Rosary', in *Matisse on Art*, ed. Flam, p. 197.

Conclusion

1 For details see Antoine Lion, 'Art sacré et modernité en France: le rôle du P. Marie-Alain Couturier', *Revue de l'histoire des religions* (online), I (2010), https://journals.openedition.org/rhr/7567; Aidan Nichols OP, 'The Dominican and the Journal L'Art sacré', *New Blackfriars*, LXXXVIII/1013 (January 2007), pp. 25–45.

2 John Klein, *Matisse and Decoration* (New Haven, CT, and London, 2018), pp. 160–63.

3 Henri Matisse, M.-A. Couturier and L.-B. Rayssiguier, *La Chapelle de Vence: Journal d'une création* (Paris and Geneva, 1993).

4 Klein, *Matisse and Decoration*, p. 162.

5 'The Chapel of the Rosary: On the Murals and Windows', in *Matisse on Art*, ed. Jack Flam (Berkeley, CA, 1995), p. 198.

6 Alexander Liberman, *The Artist in His Studio* (London, 1960), p. 21.

7 Ibid., p. 22.

8 André Rouveyre, letter to Henri Matisse, 7 December 1951, in *Matisse–Rouveyre Correspondance*, ed. Hanne Finsen (Paris, 2001), p. 611.

9 Klein, *Matisse and Decoration*, p. 182.

10 See Alice Tériade, Dominique Szymusiak, Michel Anthonioz and Nicolas Surlapierre et al., *Tériade et les livres de peintres*, exh. cat., Musée départemental Matisse, Le Cateau-Cambrésis (Le Cateau-Cambrésis, 2002).

11 Henri Matisse, 'Message à sa ville natale', in *Écrits et propos sur l'art*, ed. Dominique Fourcade (Paris, 2005), p. 320.

12 See Rosemary O'Neill, *Art and Visual Culture on the French Riviera 1956–1971: The École de Nice* (New York, 2017), pp. 31–40.

13 Alfred H. Barr Jr, 'Introduction', *Henri Matisse*, exh. cat., Museum of Modern Art, New York (New York, 1951), p. 3.

14 'Entretien avec André Parinaud', in Alberto Giacometti, *Écrits*, ed. Mary Lisa Palmer and François Chaussende (Paris, 1997), p. 279.

15 See also Françoise Gilot, *Matisse and Picasso: A Friendship in Art* (London, 1990), pp. 308–13.

16 *New York Times*, 4 November 1954; André Chastel, 'Henri Matisse', *Le Monde*, 4 November 1954. For details of other press reports of Matisse's death, see Claudine Grammont, 'Mort', in *Tout Matisse*, ed. Claudine Grammont (Paris, 2018), pp. 549–50.

17 Ibid., p. 550.

18 Pierre Reverdy, *Oeuvres complètes*, 2 vols, ed. Étienne-Alain Hubert (Paris, 2010), vol. II, p. 1342.

19 Louis Aragon, *Henri Matisse, roman* (Paris, 2006), p. 15.

20 André Salmon, *La jeune peinture française* (Paris, 1912), p. 60.

21 Roland Penrose, *Picasso: His Life and Work* (New York, 1973), p. 406.

22 Gilot, *Matisse and Picasso*, pp. 317–18.

23 Steven A. Nash, 'An American Voice with European Accents', in Sarah C. Bancroft, Steven A. Nash and Edith Devanay, *Richard Diebenkorn*, exh. cat., Royal Academy of Arts, London (New York, 2015), pp. 50–53.

24 'Interview with André Verdet', in *Matisse on Art*, ed. Flam, p. 217.

25 Quoted in Christopher Simon Sykes, *David Hockney: The Biography, 1975–2012* (New York, 2014), p. 124.

26 Clement Greenberg, 'Review of an Exhibition of Henri Matisse', in *The Collected Essays and Criticism*, ed. John O'Brian, 3 vols (Chicago, IL, 1986), vol. II, p. 294.

Select Bibliography

Aagesen, Dorthe, and Rebecca Rabinow, ed., *Matisse: In Search of True Painting*, exh. cat., The Metropolitan Museum of Art, New York (New York and New Haven, CT, 2012)

Aragon, Louis, *Sur Henri Matisse: Entretiens avec Jean Ristat* (Paris, 1999)

—, *Henri Matisse, roman* (Paris, 2006)

Barnes, Albert, and Violette de Mazia, *The Art of Henri Matisse* (Merion, PA, 1963)

Barr, Alfred H. Jr, *Henri Matisse: Retrospective Exhibition*, exh. cat., Museum of Modern Art, New York (New York, 1931)

—, *Matisse: His Art and His Public* (New York, 1951)

Benjamin, Roger, *Matisse's 'Notes of a Painter': Criticism, Theory, and Context, 1891–1908* (Ann Arbor, MI, 1987)

Bidwell, John, with contributions by Michael M. Baylson, Frances Batzer Baylson, Sheelagh Bevan and Jay McKean Fisher, *Graphic Passion: Matisse and the Book Arts*, exh. cat., The Morgan Library and Museum, New York (University Park, PA, and New York, 2015)

Bock-Weiss, Catherine, *Henri Matisse: A Guide to Research* (New York and London, 1996)

—, *Matisse: Modernist Against the Grain* (University Park, PA, 2009)

Bois, Yve-Alain, *Matisse et Picasso* (Paris, 2001)

Brown, Kathryn, *Matisse's Poets: Critical Performance in the Artist's Book* (New York, 2017)

Buchberg, Karl, Nicholas Cullinan, Jodi Hauptman and Nicholas Serota, eds, *Henri Matisse: The Cut-outs*, exh. cat., Tate Modern (London, 2014)

Courthion, Pierre, *Le Visage de Matisse* (Lausanne, 1942)

Cowart, Jack, and Dominique Fourcade, *Henri Matisse: The Early Years in Nice, 1916–1930*, exh. cat., The National Gallery of Art, Washington, DC (Washington, DC, and New York, 1986)

Cowart, Jack, et al., *Matisse in Morocco: The Paintings and Drawings, 1912–1913*, exh. cat., The National Gallery of Art (Washington, DC, 1990)

d'Alessandro, Stephanie, and John Elderfield, *Matisse: Radical Invention 1913–1917*, exh. cat., Art Institute of Chicago (Chicago, IL, 2010)

Delectorskaya, Lydia, *L'apparente facilité . . . , Henri Matisse: peintures de 1935–1939* (Paris, 1986)

—, *Henri Matisse: Contre vents et marées* (Paris, 1996)

Deparpe, Patrice, ed., *Matisse et la gravure*, exh. cat., Musée départemental Matisse, Le Cateau-Cambrésis (Milan, 2015)

Dumas, Ann, and Hilary Spurling, *Matisse and the Model*, exh. cat., Eykyn Maclean, LP (New York, 2011)

Elderfield, John, *The Drawings of Henri Matisse* (London, 1984)

—, *Henri Matisse: A Retrospective* (New York, 1992)

Finsen, Hanne, ed., *Matisse: A Second Life* (Paris, 2005)

Flam, Jack, *Matisse: The Man and His Art, 1986–1918* (Ithaca, NY, and London, 1986)

—, *Matisse and Picasso: A Story of their Rivalry and Friendship* (New York, 2003)

—, *Matisse in the Cone Collection: The Poetics of Vision* (Baltimore, MD, 2013)

—, ed., *Matisse on Art* (Berkeley, CA, 1995)

Flam, Jack, Rémi Labrusse, Hilary Spurling and Dominique Szymusiak, *Matisse et la couleur des tissus*, exh. cat., Musée départemental Matisse, Le Cateau-Cambrésis (Paris, 2004)

Flam, Jack, Xavier Girard, Jean Leymarie, Henri Matisse and Dominique Szymusiak, *Matisse et Tériade*, exh. cat., Musée départemental Matisse, Le Cateau-Cambrésis (Arcueil, 2002)

Gilot, Françoise, *Matisse and Picasso: A Friendship in Art* (London, 1990)

Grammont, Claudine, ed., *Tout Matisse* (Paris, 2018)

Guichard-Meili, Jean, *Matisse: Paper Cutouts*, trans. David Macey (London, 1984)

Guilbaut, Serge, ed., *Chatting with Henri Matisse: The Lost 1941 Interview*, trans. Chris Miller (London, 2013)

Klein, John, *Matisse Portraits* (New Haven, CT, and London, 2001)

—, *Matisse and Decoration* (New Haven, CT, and London, 2018)

Lieberman, William S., *Matisse: 50 Years of his Graphic Art* (London, 1957)

McBreen, Ellen, *Matisse's Sculpture: The Pinup and the Primitive* (New Haven, CT, and London, 2014)

McBreen, Ellen, and Helen Burnham et al., *Matisse in the Studio*, ext. cat., Royal Academy of Arts (London, 2017)

Matisse, Henri, *Écrits et propos sur l'art*, ed. Dominique Fourcade (Paris, 2005)

Matisse, Henri, M.-A. Couturier and L.-B. Rayssiguier, *La Chapelle de Vence: Journal d'une création* (Paris and Geneva, 1993)

Monod-Fontaine, Isabelle, and Dominique Szmusiak, *Matisse: Fleurs, Feuillages, Dessins,* exh. cat., Musée départemental Matisse (Le Cateau-Cambrésis, 1989)

Monod-Fontaine, Isabelle, Anne Baldessari and Claude Laugier, *Matisse*, exh. cat., Musée national d'art moderne, Centre Pompidou (Paris, 1989)

Murrell, Denise, 'La femme noire dans l'art de Matisse et la Harlem Renaissance', in *Le Modèle noir de Géricault à Matisse*, Cécile Debray, Stéphane Guégan, Denise Murrell and Isolde Pludermacher et al., exh. cat., Musée d'Orsay (Paris, 2019), pp. 318–35

O'Brian, John, *Ruthless Hedonism: The American Reception of Matisse* (Chicago, IL, 1999)

Rabinow, Rebecca A., 'The Legacy of La rue Férou: "livres d'artiste" created for Tériade by Rouault, Bonnard, Matisse, Léger, Le Corbusier, Chagall, Giacometti, and Miró', PhD thesis, New York University, 1995

Richardson, Brenda, et al., *Dr Claribel and Miss Etta: The Cone Collection of the Baltimore Museum of Art* (Baltimore, MD, 1985)

Russell, John, *Matisse: Father and Son* (New York, 1999)

Schneider, Pierre, *Matisse*, trans. Michael Taylor and Bridget Strevens Romer (New York, 1984)

Spurling, Hilary, *The Unknown Matisse: A Life of Henri Matisse*, vol. I: *1869–1908* (London, 2000)

—, *Matisse the Master: A Life of Henri Matisse*, vol. II: *1909–1954* (London, 2006)

Szymusiak, Dominique, and Jean Guichard Meili, *Matisse et Baudelaire*, exh. cat., Musée départemental Matisse (Le Cateau-Cambrésis, 1992)

Szymusiak, Dominique, and Marie-Thérèse Pulvénis de Séligny et al., *Lydia D. Lydia Delectorskaya Muse et Modèle de Matisse*, exh. cat., Musée départemental Matisse, Le Cateau-Cambrésis (Le Cateau-Cambrésis and Nice, 2010)

Verdet, André, *Prestiges de Matisse* (Tesserete, 2011)

Westheider, Ortrud, et al., *Matisse: People, Masks, Models*, exh. cat.,
 Staatsgalerie Stuttgart (Munich, 2008)
Wright, Alastair, *Matisse and the Subject of Modernism* (Princeton, NJ, 2004)

Acknowledgements

I am grateful to Georges Matisse at the Henri Matisse Archives in Issy-les-Moulineaux for his generous provision of archival photographs for the purposes of this publication. I would also like to thank the numerous institutions who supplied digital files of works in their collections. In some cases, museums reduced or waived their fees for the reproduction of these works and I am particularly grateful to them for their support of art-historical scholarship. These institutions include the Baltimore Museum of Art; the Barnes Foundation; the Fitzwilliam Museum of Art; the State Hermitage Museum, St Petersburg; the Minneapolis Institute of Art; Le musée de Grenoble; the Saint Louis Art Museum; the San Francisco Museum of Modern Art; and the Sundsvall Museum, Sweden. I presented ideas from various chapters of the book at the Royal Academy of Arts, London, the Saint Louis Art Museum, and the department of French and Italian at Tulane University, and I greatly appreciated exchanging thoughts about Matisse's art with scholars, curators and audiences at those institutions. My special thanks is reserved for Alan Thomas, whose unflagging encouragement and enthusiasm have sustained the writing of this book.

Copyright and Photo Acknowledgements

The author and publishers wish to express their thanks to the sources listed below for providing digital files of photographs and artworks and for granting permission to reproduce these materials in this book. Brief details of the owners or custodians of artworks are also listed below. Every reasonable attempt has been made to identify the owners of copyright. Errors or omissions will be corrected in subsequent editions.

All artworks by Henri Matisse – © Succession H. Matisse/DACS 2021

Art Institute of Chicago, photo Bridgeman Images: p. 91; The Baltimore Museum of Art, MD, The Cone Collection: pp. 58, 65, 107, 122, 123, 137, 147; The Barnes Foundation, Philadelphia/photos © 2021 The Barnes Foundation: pp. 56, 94, 95, 104, 141; Bibliothèque nationale de France, Paris: p. 101; photo © Fitzwilliam Museum, Cambridge: p. 42; Glasshouse Images/Alamy Stock Photo: p. 196; Granger Historical Picture Archive/ Alamy Stock Photo: pp. 6, 55; Hackenberg-Photo-Cologne/Alamy Stock Photo: p. 187; photos courtesy Henri Matisse Archives: pp. 18, 31, 63, 81, 89, 109, 129, 144; The Metropolitan Museum of Art, New York, photo © The Metropolitan Museum of Art/Art Resource/Scala, Florence: p. 116; photos Minneapolis Institute of Art, MN: pp. 83, 113; Musée d'Orsay, Paris, photo © RMN–Grand Palais/Hervé Lewandowski: p. 48; Musée Matisse, Nice-Cimiez, photo © Peter Willi/Bridgeman Images: p. 176; Musée national d'art moderne, Centre Pompidou, Paris, photo © Fine Art Images/ agefotostock: p. 37; Musée national d'art moderne, Centre Pompidou, Paris, photo © Centre Pompidou, MNAM-CCI, Dist. RMN–Grand Palais/Philippe Migeat: p. 125; Museum of Modern Art, New York, photo © Tomas Abad/